Art: For Whom and For What?

ART
FOR
WHOM
AND
FOR
WHAT?

Brian Keeble

SOPHIA PERENNIS

First published by Golgonooza Press, 1998
3 Cambridge Drive, Ipswich IP2 9EP, UK
First USA edition, Sophia Perennis, 2005
Copyright © Brian Keeble 1998

Typeset by Goodfellow & Egan, Cambridge
Series editor: James R. Wetmore

For information, address:
Sophia Perennis, PO Box 611
Hillsdale NY 12529
sophiaperennis.com

Library of Congress Cataloging-in-Publication Data

Keeble, Brian
Art for whom and for what / Brian Keeble.
—1st US paperback ed.

p. cm.

Includes index.
ISBN 1 59731 003 4 (pbk: alk. paper)
ISBN 1 59731 060 3 (cloth: alk. paper)
1. Art and religion. 2. Spirituality in art.
3. Art—Philosophy. I. Title.

N72.R4K43 2005
700'.1—dc22 2004027283

To the anonymous craftsman

Contents

Illustrations (between pages 44–45).

WORKS BY SAMUEL PALMER

Reproduced by courtesy of the Ashmolean Museum, Oxford.

1. *The Rest on the Flight into Egypt*, c.1824–25, 323 x 294mm, mixed media.

2. *A Rustic Scene*, 1825, 197 x 236mm, mixed media.

3. *The Valley with a Bright Cloud*, 1825, 184 x 278mm, mixed media.

4. *Early Morning*, 1825, 188 x 232mm, mixed media.

5. *Late Twilight*, 1825, 180 x 238m, mixed media.

6. *The Skirts of a Wood*, 1825, 174 x 277mm, mixed media.

7. *The Valley thick with Corn*, 1825, 184 x 275mm, mixed media.

Reproduced by courtesy of the Tate Gallery, London.

8. *A Hilly Scene*, c.1826, 209 x 136mm, mixed media.

God does not put to rest our desire for knowledge precisely
in as much as he is God or as a particular nature existing in
its own right, but rather in as much as he is the highest cause
of things, whose knowledge causes being, because that is how
he is the principle and light of all that is known, just as
art is the principle and light of all artifacts.

Albert the Great

If she [the soul] could know God without the world the
world would not have been made for her sake. The world
was contrived on her account for training and bracing
the eye of the soul to endure divine light.

Meister Eckhart

Introduction

It is only possible to answer for the final
truth of principles, not for the direct success of plans.
John Ruskin

O_N the face of it nothing could be more futile than to bring into
question both the direction and apparently unstoppable impetus of
our modern technological society. It is, after all, this by now global
process that has delivered a great many material rewards to a sig-
nificant proportion of the world's population. But to sound a note of
misgiving about the final outcome of this process is no longer novel.
The dissection and analysis of why and where modern, secular man's
dream of an earthly paradise of material prosperity has gone wrong is
by now part and parcel of the very industry of enquiry on which that
dream proceeds. Today, there is hardly any area of human thought
and conduct that is not subjected on a daily basis to the most rig-
orous and painstaking analysis, an analysis that all too often ends by
sounding alarm bells of misgiving as to the wisdom of the whole
enterprise.

Indeed, slowly but surely the idea that the whole process is itself a
means of instituting a fundamentally anti-human, even diabolic,
form of life and imposing it upon whole masses of the earth's
population seeps into the consciousness of an ever greater number
of people from all walks of life. Ought we to be surprised by this?
When we are faced on all fronts by examples of the wilful pollution
and destruction of our natural environment, of vast currents of
human injustice suffered for the supposed necessity of economic
survival, of the ineptitudes of political gesturing that mask the far
greater powers of social manipulation of capitalist enterprise—not

to mention the sub-human banality of much in our midst that passes for culture—we are surely entitled to pause and ask ourselves what has gone wrong.

We know, if we care to give the matter any thought, that the world was once otherwise, and in ways that allowed man the opportunity (even at its most constrained) to live his life in a habitat both natural and man-made, for which he is fitted by his physical aptitudes, his psychological constitution and his spiritual destiny. What for millennia have been considered the innate features of his earthly existence are more and more seen to be displaced in the contemporary environment that is the post-industrial world. In the pressured and artificial urban habitat that is characteristic of modern cities, and which is gradually becoming the inevitable destination of populations world-wide, man's physical aptitudes are less and less given their natural expression, his psychological constitution shows every sign of breaking down faced with the imposed strain, and his spiritual destiny is simply abolished by a conspiracy of silence. Which is nothing less than to say that man himself—for whom this state of affairs has been pursued—seems likely to be obliterated by the very process set in train for his benefit.

The studies presented here are intended as a modest contribution to a task we ignore at our future peril: to enquire into why and how this state of affairs has come about. They do not present the systematic exposition of a thesis meant to arrest the progressive decline of all that has been meant, for virtually the whole of human history by, for instance, such terms as 'God', 'spirit', 'soul', 'art' 'work', even the notion of 'the human self-image', and the realities that correspond to them. But if not systematically, then I must hope that the reader finds these studies cumulatively to contain a thesis capable of penetrating issues that persist in the face of conditions that, were those issues not founded upon perennial truths, would long ago have ceased to be of interest to anybody. The justification for the use made here of the *philosophia perennis*—that body of wisdom and sapiential doctrine that underpins these studies—resides in the power of its truth to summon in the human heart and mind those resonances of affinity and significance that link men and women of all ages and differing climes and to bring them to a common recognition of their unchanging,

spiritual destiny. In so far as these studies appeal to this *sophia* they do so not arbitrarily, as one might choose one philosophical system in preference to another and work within its terms, but because, as Ananda K. Coomaraswamy once observed, writing to Aldous Huxley, the 'self-authenticating intelligibility' of the *philosophia perennis* 'explains more things than are explained elsewhere'. It remains the case, doubtless all the more 'awkward' for modern man for being so evident, that there has always been an incomparably greater degree of unanimity as to ultimate values in the revealed traditions than has ever been the case with modern philosophy and science. Given the nature of the issues involved it could never have been otherwise.

If the vast array of theories and conjectures that represents the imposing edifice of modern scientific knowledge can be taken to indicate the final triumph of human knowledge, a final scaling of the heights of true wisdom, then we have no choice but to conclude that our ancestors were, to say the least, immoderately deceived. We are forced to accept by sheer weight of evidence that all the great saints, mystics, philosophers, poets and artists were, in the unanimity of their acceptance of the divine origin of things, of seeing man as made in the divine image and as having by his very nature a spiritual destiny, were quite simply wrong. And so any talk of spiritual attainment, any proposition of an analogous nature that supposes there is a corres-pondence between heavenly and earthly levels of reality is sheer poppycock, and the departments of the humanities in our univer-sities should have as their primary concern the task of dismantling this insubstantial and fraudulent construction of misbelief in order to offer us something better.

If all this was in fact true then what might we expect to find in the culture that surrounds us and which is the expression, in its own sphere, of that secular, scientific mentality. Surely we might expect to find, to give just a few examples more or less at random, students in the departments of philosophy at our universities having put aside the *Summa Theologica* (once a student textbook) because, having mastered it, they had passed on to something superior and more all-encompassing. We would expect to see our leading archi-tects building structures to equal in beauty and magnificence the Gothic cathedrals, the Alhambra, cities like Siena and Isphahan. We might expect to be reading poets on a par with Homer, Rumi, Dante

and Shakespeare in the depth and breadth of their understanding of the whole human predicament.

It should be all too evident that the time has not yet come for us to reject the spirituality and culture of the past as being a misguided enterprise based on inadequate modes of intelligence. In the absence of a metaphysic that conclusively demonstrates the inadequacy of a Shankara, an Ibn Arabi, a Meister Eckhart, perhaps we might be forgiven for concluding that in modern man the human race has not finally reached its full stature by the attainment of a wisdom superior to that of his ancestors. Indeed, given the multidimensional crisis that confronts him at every turn, there is ample evidence that modern man has regressed into a gradually narrowing articulation of reality that causes even his best endeavours to pale into insignificance when compared to the cultural riches of the past. We have to recognise that in these 'monuments of unaging intellect' (as W. B. Yeats called the greatest artistic achievements of the past) we are summoned to a final term whose attainment effectively means— supreme paradox!—our humanity is only properly fulfilled in being transcended. If we will not live by that perennial truth which has always served to direct man to his ultimate goal then we must suffer the lingering death of a thousand transient falsehoods of our own fabrication. These studies are meant to challenge some of these falsehoods as they have been applied to the sphere of human making.

The ancient and widespread tradition of the handicrafts as instruments of livelihood and devotion, conceived and elevated to the level of a spiritual discipline, allowed man to live for millennia in harmony with himself, in harmony with his fellow men and in harmony with nature. The industrial system, on the contrary, after only two centuries, has been seen to set man against himself, man against man and man against nature. It threatens crisis in all directions. So much so that it is surely worth reminding ourselves that the whole history of the human race has taken place, that is to say has been *lived*, according to meanings and values which by their very nature make human life precisely what it is (and to which any given level of technological innovation neither adds nor subtracts) without the machine that will be invented tomorrow: the machine that tomorrow we will be persuaded is of vital necessity for our future survival and well-being.

All human existence has to address the central questions that surround man's brief existence on an earth that manifestly is *not* the ultimate term of his destiny—an experience of life that unceasingly confronts us with innumerable paradoxes and poses an unending stream of questions that demand answers. The fact that there are powerful economic and social forces of persuasion—forces to which we need not grant a deterministic inevitability—should not lead us to believe that these paradoxes and questions can only be resolved by our acquiescence to each and every next stage of development of the technological juggernaut.

The signs are that we should no longer delude ourselves that the momentum of progress such a development harbours takes us one step nearer the moment of our necessary self-enlightenment. It is time to renounce the futile task of trying to identify life itself with that dynamic sequence of events that is history. It is time to seek our rightful place in the order and stability of the Real by means of an interior cognizance that takes account of the timeless and eternal roots of temporal, external levels of reality. These studies are meant to serve this radical call for a change in the use of the mind. There is nothing new in this. Blake, Ruskin, Morris, Gill and many others have responded to the call. G. K. Chesterton in *The Outline of Sanity* wrote:

> Before we begin any talk of the practical problem of machinery, it is necessary to leave off thinking like machines. It is necessary to begin at the beginning and consider the end. Now we do not necessarily wish to destroy every sort of machinery. But we do desire to destroy a certain sort of mentality. And that is precisely the sort of mentality that begins by telling us that nobody *can* destroy machinery. Those who begin by saying that we *cannot* abolish the machine, that we must use the machine, are themselves refusing to use the mind.

Shifting the weight of emphasis away from the outward rewards of human labour, and towards the well-springs of human motivation, these studies, each from its different angle of approach to its subject, ask what it is a man and a woman may get *by* working rather than what they might get *from* working. This approach becomes necessary once we ask the question, what is the benefit of any outward

effort once we stop confusing its value with the price it will fetch in the marketplace? To challenge the industrial conception of labour in this way is all the more necessary if we are to loosen the stranglehold of that type of mentality which presupposes that the manipulation of matter for productive ends is a right that takes precedence over man's being as such. In the eyes of such a bias, as its advocates would claim, the right to be productive is called for for the sake of human survival. It must be admitted that there is a degree of logic to this bias which, in theory, lends it a certain truth. But in practise it is the law of the brute, a law that effectively denies the deepest dimension of our being. And if such a right is practised in isolation from, and to the exclusion of all other values then, as the modern world looks set to prove, that right becomes a tyranny that will, in the end, hardly permit the survival it was meant for.

Seeing that man is a creature who at all times and in all places has to confront the same primordial question, 'Who am I?' (a question that inescapably poses two others, 'From whence did I come?' and 'Whither am I bound?), the only fitting counter-proposal with which to challenge the notion of *laissez-faire* expansionism—for that is what it amounts to—must be, 'Seek ye first the Kingdom of Heaven and all these things shall be added unto you'.

Clearly this injunction calls for an act of internalization seeing that the 'Kingdom of Heaven is within'. So the question of what possible role the 'outwardness' and 'materiality' of productive effort should play in our fitting survival becomes one of asking, 'the survival of who?' Work is a mode of objectivising the soul whereby man—who as a 'fallen' being is not yet a perfectly integrated being— may conform the world of his outward action to the inner state of his being. In this connection there is a certain appropriateness to calling the domain of work the 'theatre of redemption' for *homo faber*. A man is only able to know who he is to the degree he knows how to *be* what he does. The perfect identity of thought and action (in the sphere of outward action this is analogous to the union of the knower and the known in the sphere of inner contemplation) takes place where the subject is objectivised in a form that perfectly realises the subject's unity of being. We all desire the 'heaven' of the perfectly accomplished piece of work, the perfectly coordinated action in which an 'unseen hand' seems to lift us to a level beyond our customary,

average, achievement. It is this inspired moment that underpins the whole question of the possible spiritual content of work, a moment comprehensively betrayed by the industrial process whose sole concern is for the economic advantage of the final product regardless of the means employed. The *raison d'être* of mechanisation is to displace the workman precisely because it envisages the worker as a creature who has nothing to lose by being freed from the exertions of labour. In a machine milieu the only human 'content' of work is the expenditure of effort. Towards the end of his life Eric Gill concluded that it was not on the grounds of its general 'beastliness, vulgarity, inefficiency, anti-socialness [and] ugliness' that the industrial commercial world should be denounced but because of its fundamental '*unholiness*'!

Much of the underlying cause of our present predicament is due to habits of thought that tend to isolate from one another the spiritual and material, a distinction that isolates the mental (or psychological) and the physical. As a further consequence of the unnatural separation we think of art and work as serving two different human needs. This being so, we can no more look to the world of art[1] in any hope of finding things freer from the dichotomies that undermine the world of work and industry, the causes and conditions of which these studies are meant to address.

Any modern artist or craftsman who, by whatever path, comes to the realisation that there is a necessary affinity between work, art and spirituality is immediately confronted by two problems—the one entailed by the other. The realisation of such an affinity will lead on to an instinctive sense that certain creative possibilities are likely to be beneficial to spiritual development while others are likely to be detrimental. In other words, he will feel an instinctive need for some guidance in negotiating the difficult territory over which is discovered how the aesthetic and spiritual are bound together in such a way as to give a natural expression to their mutuality. But in the modern world such guidance is absent owing to the almost complete lack of unanimity of values on all levels; spiritual, social, psychological, cultural and aesthetic.

1. See also the author's Editorial, in *Temenos* 6, (London, 1985), pp.5–11.

This first 'external' problem leads on to a second 'internal' prob-
lem; that one has no option but to seek a resolution of the first prob-
lem on an individual basis—as a matter of personal choice. And so
the whole situation is compounded.

Strictly speaking it is not possible for the modern artist or crafts-
man to function as a traditional artist—that is one whose livelihood
at the practical level gives a natural expression to and is the integral
application of truths and principles of a Divine origin. For that, ulti-
mately, is what the affinity between work, art and spirituality is. But
the absence of unanimous values and the subsequent resort to
matters of personal taste inevitably introduces a note of personal
identity that is foreign to the sacred milieu of tradition. If we
examine the widest range of representative examples of traditional
artefacts, from cities and architecture to the most common everyday
objects, we cannot fail to notice the complete absence of that artistic
individualism that is the hallmark of their modern counterparts. The
individual identity of the artist in the traditional context is a factor
of negligible importance in the production of works of art. Even
further, our understanding of the traditional cultures leads us to
acknowledge that they exist primarily as a means to align the soul of
man to the cosmic scale of his destiny. Their function is to orientate
his earthly existence to values and meanings that validate his identity
with the supra-human rather than with the accidents of his empirical
personality.

To this end the traditional artist is provided with ample guidance
and precept both spiritually and artistically. Compared with the
modern artist, who has to 'go it alone', the traditional artist refers to
established precedent at every step of the way in matters theoretic
and practical. Whether written or orally transmitted he inherits a
virtual manual to guide his every movement according to conven-
tions that free him from the impulses of a nebulous spontaneity that
urges him to do something new, to accomplish something uncalled-
for in order to make his mark in society. In a sense the modern artist
is also given a 'manual', even if by default, but it is marked 'do your
own thing'. The modern artist is on his own when it comes to dis-
covering what psychological and practical possibilities he might
implement in seeking a closer alliance of art with the sacred.

Some of the following studies attempt to chart the causes and

weight and prevailing conditions of this situation. Yet others attempt to understand the way in which individual figures have come to terms with the inevitable rupture of art from the sacred in the present state of things. Given the complexity of our predicament with respect to all the issues involved there can be no question here of offering a formula for resolving the perplexities we are faced with. Nor is it within the bounds of possibility that an individual artist could transform a situation that goes beyond the sphere of art itself. In the sphere of art there are no absolutes. No society has ever been, or is ever likely to be, in whatever measure, 'saved' by art. We should emphatically reject such a thesis whenever it is explicitly or implicitly present in much contemporary cultural analysis and debate. Similarly, there can be no question of 'going back'. Any supposed 'golden age' of our history is as irrecoverable as any part of our past lives.

The term 'tradition', as it is used throughout this book, refers to that body of truths, both principial and doctrinal, that are ultimately of Divine origin and which are mediated to man through the revealed religions, their avatars, prophets and spiritual masters. It has been the vocation of certain authors to demonstrate the universality of this body of knowledge as the primordial means by which the immutable, sacred nature of the True and the Real is disclosed to man. It should be beyond dispute that there has never been a true civilisation or culture which has not been, in a manner appropriate to the portion of humanity to which it is addressed, the extension and application of the sacred knowledge that is tradition. This knowledge, in accordance with its very nature, binds man to God through its transcendent mode and to the essential in its immanent mode in a manner that validates the ultimate meaning and value of his existence on earth. For these studies it is axiomatic that there is no such thing as a secular culture. Deviation and impoverishment must ever fail to supply the terms of positive achievement, as the new barbarism makes plain.

This admission calls for a further note of clarification: for if the sacred is here ranged against the secular no less is it that qualitative understanding is ranged against quantitative knowledge; precisely the polemical component of these studies.

In these pages reference is made, whether directly or indirectly, to the 'modern mind'. The reader should understand by this term the pre-disposition of contemporary thought towards quantity and its external, manifold character as opposed to quality with its internalising, unitive function. The modern mind is above all characterised by its undeniable tendencies in this direction. So much so that it regards metaphysical and spiritual intuition as, at worst, inadmissible and at best an abstraction (not much more than a symptom of thought) and favours empirical demonstration as 'concrete' evidence in its attempt to discover the real. This tendency lends it what seems the natural bias of naive materialism; ascribing a higher ontological status to the perceptions of external phenomena, with its counter-tendency to devalue intuitive and imaginative modes of apprehension. In the field of the arts this has led to a far higher status being placed on aesthetic sensations than on cognitive value. These studies are in part meant to challenge this bias and its consequent direction.

In the final analysis there is only Truth and our deviation from it. It is a matter of seeking to recover something of the spiritual anthropology of the sacred traditions, of recognising the greater inclusiveness of their visions of the totality of the Real. One way of doing this is to determine what has been lost to us by a process of historical development that has brought man to countenance, on a global scale, social and economic agendas that now threaten his very survival. The question that overwhelmingly presents itself is whether and to what degree we are prepared to return to the full amplitude of our proper nature, rather than to the impoverishments of the reductive logic of the modern mentality. The schizomorphic tendency of the modern mind seeks to accommodate man to the dimension of a reality that must, in due course, lose him altogether in the flux of history—among the detritus of his own productions. Let it be recognised that man is more than he makes, more than a brief epiphenomenon on the surface of history, followed by an inglorious oblivion.

The chief debt owed by these studies is to that group of writers who have become known as the traditionalist school and which comprises, primarily, René Guénon, Ananda K. Coomaraswamy, Frithjof Schuon and Titus Burckhardt; but also Seyyed Hossein Nasr, Martin

Lings, Marco Pallis, Henry Corbin, Gilbert Durand and Elemiré Zolla amongst many others, not least to the many traditional sources I have made use of in these pages. But I am especially indebted to the books and articles of Coomaraswamy. Others before me have noted the peerless quality of his exposition of the traditional and 'normal doctrine of art and life'.[2] Since it would serve no useful purpose to duplicate his researches I hope the reader will accept that his findings frequently underwrite parts of my own exposition.

Both Kathleen Raine and the late Philip Sherrard have over many years come to my aid with wisdom, learning and friendship. Such immense debts can never be adequately repaid. Among other friends to whom this book owes its existence I acknowledge my deep gratitude to Alan Goodfellow. For the last decade, with his indulgent generosity and understanding he has aided and abetted Golgonooza's attempt to maintain a typographic standard. Without his collaboration and generosity such a standard could not have been achieved. For this, our last collaboration, we have used the digitized version of Eric Gill's Golden Cockerel typeface in tribute to Gill's craftsmanship. Not for the first time I am more than happy to acknowledge my indebtedness to Stephen Overy for his help in preparing the final text. All remaining insufficiencies are, of course, the author's.

Several of these studies began life as conference papers, others were delivered to a variety of audiences. Some have appeared in print. All have been revised, or in some cases completely rewritten for their present publication. 'Man, Nature and the Sacred' was delivered to the second Temenos Conference at Dartington, November 1986, 'Work and the Sacred' to the first Temenos Conference, again at Dartington, in November 1986. 'Eric Gill's Radical Critique of Industry' was delivered at Ruskin College Oxford to the Jupiter Trust in January 1996; 'David Jones's View of Art' to the David Jones Conference, 'At the Turn of a Civilisation' at the Art Workers' Guild, London, November 1995. 'Are the Crafts an Anachronism?' was a contribution to the First International Conference on Religious Art organised by IRIB Tehran in November 1995.

2. See the author's 'Ananda K. Coomaraswamy, Scholar of the Spirit', in *Sophia* (Oakton, VA, 1996) Vol 2, Number 1, pp.71-91.

Art: For Whom & For What?

The father that dwelleth in me, he doeth the works,
…believe me for the very work's sake.
John XIV: 10-11

One whose understanding is deluded by egotism thinks; 'I am the doer'.
Bhagavad Gita III: 27

NOTHING engages us with such seeming ease and naturalness than the feeling that we *are*, in some interior sense, and that we are called upon in life to take action in a world external to us. The reality of both the subjective 'I' we suppose and the objective world we act upon is something we seldom stop to question. The potter who makes a pot could hardly doubt that he is a 'someone' who manipulates a substance called clay that is 'other' than who he is. That the effect of his taking certain actions results in an object that has been caused by those actions. The potter's sense of the reality of this situation is fundamental to all acts of making and doing. After all, to make anything is to see an object take shape under our very eyes as the result of actions we have taken, whether by deliberate intention or intuitively as we say when we are unable to rationalise or recall the mental processes that guide us towards certain choices and not others in order to effect the outcome of those actions. That much is obvious.

Or is it? Will the truth of this situation bear scrutiny? Or might we conclude, on closer examination, that what has so far been assumed owes more to unthinking habits of thought and reaction than to the underlying reality of the process? And if we should be so persuaded, what implications follow from our unmasking a state of affairs that seems so incontrovertibly true from repeated experience? It is the purpose of this chapter to explore what underlies these habits of perception.

There are some things we do not see. Not because they are immersed in a darkness we cannot penetrate but because they are possessed of a blinding brightness that obscures their presence. Such things escape our perception because they are too close to us. If you look straight into a light, before long you see only darkness. Metaphysical truths blind us precisely because they form the preconscious condition of all our thinking. The superabundant illumination of the spirit makes possible every mode and manner by which we attempt to define and objectivise our identity and our destiny. Metaphysical truth orientates us in this way for the very reason that we are its *place* of manifestation. 'If the doors of perception were cleansed everything would appear to man as it is, infinite', said Blake.

In living a life, even in its most simple and unregarded actions, we respond to certain positive and negative possibilities. Sometimes with careful deliberation, sometimes with an instinctive impulse, we choose one path of action against another. While it is certainly true that some of what contributes to such actions will be responses acquired as a result of our experience of sensory data, none the less our responses can also include a sensitivity to and an appreciation of such things as love, justice and beauty that in themselves transcend our mundane life as such. Indeed, it is doubtful whether we could lead any sort of life worthy of the name without the intervention of these things.

All this would seem to indicate that, even in what might be our most unregarded actions, we have already presupposed a potential if not actual pattern that life might take, a path to be followed that we in part create rather than simply accept as inevitably laid down for us. And such a pattern, at some deep level, might hold the key to the implied principle life should conform to if it is to be more than just the continuum and accumulation of events and actions that, in flowing through it, make up our everyday experience. Might we not go so far as to say that we only truly *act* when we fully realise just such a pattern—when it is a life-informing reality for us—since anything less must be a *re*action to some circumstance imposed upon us; an imperative for which we are the passive agent?

Can we not go one step further and acknowledge that it is in the nature of this pattern that it should enable us to recognise that our lives are somehow inadequate, somehow fail to realise their full

potential, if we ignore the validity of this pattern to shape our experience in accordance with its ultimate significance—the cardinal end of life itself? For the ephemeral and fleeting strands of experience that are woven into the fabric and of our everyday life, as we all recognise, inescapably involve some sort of evaluation. And this in turn, if we are not to be condemned to invincible ignorance, implies that we already possess within ourselves some adequate principle from which to derive the ultimate meaning of life itself—some fundamental precept that is 'other than' our reactions to the shifting panoply of appearances and substances that confront us on a daily basis. And can we not say that, as a result of our possession of such a principle, one that is 'other than' the constant interplay of subjective reactions to objective events, that all things point to something beyond themselves? Proof enough of this possibility is the fact that we are able to pose the question 'From whence?', and its corollary, 'To what end?' In other words to pose such questions in itself indicates that there is something of our being capable of recognising the diminishment implied by the absence of any answers to such questions—a recognition of some principle not derived from but possessing, as it were, an adequacy not found in the life of external experience.

And, to take one further step in this line of argument, given our possession of the faculty of objectivity (for that is what it amounts to, and without which we would not even conceive of a subject) we must conclude that the totality of our experience is not confined exclusively to a self-contained prison of phenomenal appearances and chronological events. That man himself contains an organ of knowledge that possesses of its nature the unity of wholeness we recognise must underwrite the diversity and multiplicity of the world of empirical experience.

If this puts what seems like too heavy an emphasis on the internality of experience, at the expense of the world of external objects we find ourselves obliged to acknowledge and deal with, then perhaps we ought to recall how little effect, in recent centuries, so-called progress, civilisation, and the trappings of culture have had on ridding man of his imperfections and his inadequacies. These are the very things that are founded upon his false identification with that subject or ego that precludes him from attaining those qualities

of his being he might judge to be his proper nature rather than his attendant failings.

The ego, or empirical self, is that which, assuming the identity of an agent, ascribes to itself the reality that is the generality of psycho-physical activity. But the fact that the ego can never objectivise itself, can never purify itself of that to which it is a response, is sufficient indication that it cannot be the ultimate agent of action. What the ego knows is in truth a series of interactions or *re*-actions in the sphere of empirical existence from which it is never free, by reason of the fact that, as René Guénon reminds us, 'action cannot have the effect of liberating from actions'. And, as Ibn Arabi observes, 'outward existence can perform no act of itself' since it depends upon an agent or principle that is free and objective in relation to the aggregate of existential experience. It follows that, not only is the ultimate agent of action located beyond the sphere of psycho-physical experience, but that, as Ibn Arabi goes on to point out, this very 'outward existence is passive, and action cannot be attributed to it'.

The implication for the artist of this metaphysical view of things is, to say the least, far-reaching. Nothing less than to see that the truest action of the artist—the maker—is not so much the effort of a subject to shape an objective substance that is *other* than himself, but a response to circumstances which in the fullness of their denot-ative compass seek to locate and celebrate the ultimate nature of the 'doer'. In the light of a metaphysics that does full justice to the amplitude of our perception of what distinguishes the Real from the illusory, art ought not to be the demonstration of those feelings and responses we ascribe to the personal ego, but an effort to realise the intrinsic coherence of things as we participate in it and as it com-prises the essential order of being. Plato's banishment of the artist from his ideal Republic was precisely on the grounds that the ex-pression of ego—the art of false ascription—disrupts the harmony that is the universal order that coheres in all things. This makes perfect sense of those traditional texts that speak of the artist (artisan) as one who upholds the order of the universe, as well as those texts that speak of the disequilibrium that follows from the production of things for personal aggrandisement: 'Destruction of the natural integrity of things, in order to produce articles of various kinds, this is the fault of the artisan'. (Chuang Tze, 10)

It is now widely admitted that the crisis which confronts the westernised world stems directly from the reluctance of the modern mentality to admit that a world-view, conceived after the model of phenomenal reality and articulated in a rationalist science of materiality, is unable to reveal the source of those meanings and values by which life is ultimately lived. That is to say, the modern scientific world-view quite simply excludes an adequate principle for the *raison d'étre* of human existence. This is nothing more than to acknowledge that modern man, for some four centuries, has been heir to a culture that has attempted to function in denial of the metaphysical dimension of things. To all intents and purposes, and in every quarter, the unmanifest, supra-empirical perspective of unity, oneness, coherence and ultimate permanence—always the implied context of meaning—that underwrites all possible reality is glossed over. Instead of seeing this hidden—better say veiled—context as the timeless source and final term of all human endeavour, this eternal perspective is simply set aside and considered as an irrelevance when it is not denied outright. In thrall to the materialist model, so far as westernised consciousness is concerned, the natural world has to be understood on its own terms and without reference to any principle or criteria that is beyond or outside it, an experience of life circumscribed on the one hand by ego-bound consciousness and on the other by sensory data or its mathematical surrogate.

Given the all-pervasive sense of relativity and impermanence that characterises the consciousness of those incapable of surmounting this state of affairs, to insist on an immutable, eternal core at the heart of human experience must seem at best a case of special pleading, at worst an act of perversity. However, it is not a matter of supposing that such an immutable core, were it real and effectively present in things, would be immediately apparent and discernible without the least effort or preparation on the part of anyone who wishes to know something of it, any more than it is a question that, because of our existential condition, we are of necessity forced to accept the world's insufficiencies as the sole claimants to our attention. In any case, against *what* are such insufficiencies to be demonstrated? No. It is more a question of real needs and what it means to satisfy a real need.

In this respect the secular man of westernised consciousness is like one who comes to a feast at which every conceivable luxury is laid out before him. But he arrives without even a conception of what it means to have a real taste, a real appetite. (Eric Gill once remarked, 'a real taste is a mortified taste'.) The situation in which modern man finds himself, the feast to which he is bidden, is one in which he supposes that he has access to the whole history of man's cultural heritage. In books, films, recordings, libraries, exhibitions, archives, museums, computer files and the like, from the most profound masterworks of spiritual enlightenment down to the humblest tribal artifact, the entire sum of man's cultural endeavour seems to be his for the asking. Yet there is a price to pay.

The configuration of historical events that permits such a feast to be arranged is the very same one that grants man the illusion that he does actually have access to the inner riches of this heritage. This illusion, nothing less than the fact of his secularised consciousness, is the very same illusion that obscures that amplitude of his being that he must actualise within himself if he is to join with the *meaning* and *purpose* of all but a fraction of man's past spiritual attainment. For this dimension of his being, were it fully effective, would take him out of historical time—that 'funeral cortège' of chronological events, as Henry Corbin called it—and situate his consciousness within the eternal perspective of the sacred that is integral to a real attachment to the Divine: the same attachment, let it be admitted, which was the very occasion of that past cultural effort modern man is at such pains to amass, record, catalogue, celebrate, explain and promote. Except for the period of the classical decadence and the secular centuries of the post-renaissance—from the elaborate geometry of the Gothic cathedrals to the most delicate tracings of the North American Indian sand painting, from the simplest steps of a peasant dance to the over-arching vision of the *Divina Commedia*—it has always been the purpose of art to situate man within a cosmo-logical frame of reference that takes account of his ultimate destiny; to form the connecting link between his earthly experience and the light of the Divine Reality.

Like it or not, the eclipse in his being of that which actualises his affinity with the Divine is the very same eclipse that allows secular modern man to become what he has become, a cultural polymath

who consumes the spiritual culture of others because he cannot create his own, one who is dispossessed of the archetypal vision that alone gives access to the meaning of his spiritual heritage—the vision that alone validates a true culture. The real and urgent need of westernised consciousness is to be able to see beyond the ephemerality that now mesmerizes it to the point of obscuring its accordance with the Divine, in order to plunge the roots of its transient existence into that eternal principle which does not yield to the flux of a world that is ever-changing into something else, created and annihilated at every moment.

The advent of a purely empirico-historical view of the world has been largely responsible not only for the impoverishment of art itself (an art for the most part content merely to record the passing show mirrored in the most fugitive of emotions), but also for a way of looking at works of art that tends to exclude the atemporal, suprasensual origins of creative motivation. This way of looking at art also tends to obscure the fact that art is only partially explained by being studied in the historical context of its time. To study art as being *of* its time is to approach it from the point of view of an abstract time that is lived by no one.

No man is wholly *of* his time, for man is joined to 'his times', as Goethe noted, by his weaknesses. At the heart of his being he *is* his own time in a spiritual way analogous to that of the experience we each have of being at the centre of physical space. Such is this 'blinding' evidence that it is all too easily overlooked that only on the premiss of a timeless dimension to subjective experience—the transcendant and supra-conscious witness to the fugitive reality of sensory data—can the cognitive polarity of consciousness function. Only on the basis of this inscrutable intuition can consciousness form that polarity without which there could be no conception of a subject facing or acting upon an object: the primary datum of all making and doing.

The difference in orientation is vital to an understanding of the studies in this book. For they all imply that the ultimate value of a work of art is not fully explained in any appreciation of how it is *of* its historical time, or even in the internal consistency of its making, but that the value of a work of imaginative vision (and all works of making must in some degree proceed qualitatively from imaginative vision) is integrally *of* the presence of its creator as he is located

and identified with the timeless source of his inspiration.

Furthermore, these studies are meant to imply that we are able to grasp the value of works of art only to the extent that we have developed the capacity to be effectively present as a witness at the same source of inspiration. (Dante said the purpose of his master-work was 'to remove those who are living in this life from the state of wretchedness to the state of blessedness'.) A work of art can only have a real and intelligible meaning, can only *signify* something above and beyond the complex of operative and aesthetic procedures that have permitted it to find its manifest form, in the effective presence of just such a witnessing subject. Now what is entailed by this?

Facts are *known* by, events *happen* to, circumstances are *part* of a subject without which these same terms would be meaningless. No man lives in future time, which is not yet, as no man lives in past time, which is no more. Yet, however closely we narrow the gap between them there still remains a dimensionless gulf that will not let future time be joined to past time. The very terms future and past imply a moment that is *now*. And all things live *now*, or they are not yet, or have been. Without a *now* past and future could have no reality since it is *from* this transtemporal moment we project a future, and *to* this same moment we recall a past. And it is *in* this moment that all human knowledge, in so far as it is present in consciousness, is present as living, coherent experience. Even the memory of past things and the forecast of future things takes place in the present moment. And what threads the warp and the woof of things and events to produce this coherence is the cognitive polarity of sub-jective and objective consciousness that is the *modus operandi* of the intuitive intellect. This intuitive intellect is the ultimate agent of the present moment in which all life is lived, the term to which all experience is brought. This is the true subject, the timeless witness to the fact that future time ceaselessly flows into past time yet, as witness, is never part of that past or that future.

Here we have to invert the all-too-prevalent habit of secular consciousness of seeing what a work of art implies by what can be deduced from it. We have to see what the undisclosed intuitive intellect itself implies—all those meanings that have their reality in virtue of the presence of this sapiential intuition and what it is its nature to mediate.

It has been the perennial purpose of works of imaginative vision, whether in symbolic forms, iconic images, mythical narratives, ritual enactment, as well as contemplative modes of experience, to highlight, to separate out from the attributes that comprise the jigsaw pattern of temporal causalty, to affirm this permanent, meta-historical level of reference. The thesis of most of human culture, as the works of Ananda K. Coomaraswamy and others have amply demonstrated, is to validate at the highest cognitive level of meta-physical intuition, the true subject of human experience, the one who acts in transcendence of all the *re*-actions that make up our psycho-physical existence. It is this self that true art addresses in its effort to wrest consciousness from the *nihil* of endlessly mirroring surface phenomena one upon another—whether these be natural appearances or the infra-subjective vagaries of personal psychology. Traditionally, art keeps faith with a perspective that situates and unites man with a cosmic and eschatological frame of reference— not with the objective of robbing the particularity of each thing of its unique qualities, of dissolving *things* into disembodied, abstract conceptions, but the better to allow consciousness to grasp the way in which the particular and transient thing possesses an immutable essence; is a sign, is significant of, a specific quality of the Divine Reality.

At the heart of all cognitive experience there is a link, a reci-procity, between the immutable essence of every object and the intuitive core of every subject, which obliges us to recognise that art cannot properly possess a meaning that is wholly of itself. Arising from just such a reciprocity of object with subject, art applies a prior knowledge and extends an operative skill to ends other than the practice of art itself. Even when we recognise the extent to which art embodies values that are incommunicable by any other means, still it is never the cause of its own significance. Art has to be significant *of* something; it addresses itself to something other than itself. The thesis 'art for art's sake'—even in the thousand disguises with which it bedevils our times—cannot escape its pretence that there are creative and imaginative values that are true in them-selves without reference to the ultimate nature of the subject to whom they are of value. Valuation itself is inseparable from under-standing, just as understanding is inseparable from intelligence.

And intelligence demands an adequacy from all things that are placed under its scrutiny.

The chief purpose of the present chapter is to provide something of the metaphysical premises on which the studies in this book are largely based. Each study treats its subject *sub specie aeternitatis*, that is, from the perspective of permanence, and as a series of 'places' or 'junctures' at which certain artists have responded to the profound mystery of what it means to be a part of the Creation. The genuine artistic impulse springs from and is finally directed towards the metaphysical realm, and it is to that realm that these studies aim to be faithful. That being so each study proceeds from the necessity to have in mind an implied metaphysical context of wholeness and unity without which, as the poet Vernon Watkins observed, the artist works in confusion.

To approach a work of art from this point of view is not, however, to impose unwarranted and irrelevant criteria upon it. To talk, for instance, of the 'real' and the 'illusory' in connection with a work of art does not oblige one to point to the actual appearance of the terms themselves. Terms like 'being', 'becoming', 'absolute', 'contingent', and the like may not to be found there. None the less, that to which such words are directed is present by virtue of the fact that, as we have already argued, any act of human doing and making rests of necessity upon the effective operation of metaphysical pre-conditions. Moreover, to create a work of art is itself to imply, whether by affirmation or denial, that metaphysical assumptions are part and parcel of what it means to be a man as well as an artist. As David Jones insists, 'only men are artists and only artists are men'. The relevance of the metaphysical for the study and practice of art is no different from what it is for any other branch of knowledge or activity. It is against the background of the Eternal and the Absolute that any temporal and any relative 'event' takes place. When the *Garuda Purana* voiced that profound paradox to the effect that it is no use a man reading a book until he has understood it, it underwrote the paradox of all knowledge. In order to understand any one thing we need to understand everything.

It is the eternal soul—that which makes the subject truly human—that mediates the imaginative pattern in accordance with

which a man *acts* in transcendence of all the reactions that make up his ephemeral worldly existence. For these reactions have no value when they are considered without reference to the hidden presence of the subject who is the 'place' of their existence. It is this fact alone which makes an attempt to arrive at an understanding of this world on its own terms one that is bound to condemn man to the sterility and impotence of endlessly regurgitating the ephemeral contents of a life alienated from the very source of its own reality. If there is to be a true renewal of meaning and value in our lives, and so in our art, it cannot come about simply from arbitrarily rearranging our reactions to life's external circumstances, where, inescapably and remorselessly, we would in any case be obliged to admit to an implied, pre-existing pattern according to which the new arrangement must be conceived. Such a pattern can only be located at its innermost source, where our true subject is rooted in the timeless matrix from which all orientation and renewal proceed.

Man and Nature as Polarities of the Sacred

For the invisible things of him from the creation of the world are clearly seen, being understood by the things that are made, even his eternal power and Godhead.
Romans 1 : 20

IN answering the question why it is we have the arts at all few would disagree that they are practised for the good of life. This is to imply that the good is in some sense more than what life would provide without art. And a life without art would surely be little more than the exercise of our animal faculties for the sake of pragmatic utility. But on the evidence of the past we can recognise that the arts normally function as the means to draw man towards the summit of his full potential. Finding ourselves among the contents of many of our modern art galleries, with their idolatrous displays of psycho-effluent, we might well ask if this function is any longer being served. Here we might well conclude that the arts, or rather the artist, has lost his way and has become the victim of his own cultural decline. How has this situation come about?

It should be self-evident that art is being steadily depleted of human relevance, meaning and value, so that it is no longer thought to occupy a central position in relation to our need to engage with the presiding truths. It has to a large extent been marginalised by the sciences. None the less, we are not entirely comfortable with this state of affairs, and remain suspicious of where science might lead us. In other words, although we no longer use the phrase, the 'two cultures' debate is still with us. The effective substance of this debate, that of one mode of discourse in conflict with another, has as its tacit proposal that there are some people who possess what we might call a 'scientific consciousness' and others who possess what

we might call an 'artistic consciousness', and these two types of consciousness never share quite the same view of reality.

In this supposed division of the arts from the sciences what has been left out of account is man himself, more precisely the nature of man in relation to the totality of the Real that at one and the same time surrounds him and permeates his being. So, to express the same problem more conventionally, we are here dealing with the division of mind from matter in the modern consciousness, a division that has forced apart the subjective and objective poles of consciousness. It is this final and radical division that has allowed the sciences and the arts to become two irreconcilable ways of viewing reality that in their combined effect tend on the one hand to abstract man from the outer world of his creaturehood, and on the other to foreclose on the inner world that is the domain of his imaginative and spiritual being.

What has happened to shape these two irreconcilable views? In relation to the 'scientific consciousness' what has happened is that, with the all-pervasive influence of materialist thought-processes the modern mind equates those dimensions of reality that are perceived by the discursive faculties as actually corresponding to reality as such. By this means rational thought is permitted to impose its own patterns of logic upon the nature of reality, a process in which all supra-mundane qualities are, when they are not denied outright, pushed to the very periphery of consciousness. In effect any enquiry along these lines into the nature of reality becomes little more than a sort of eavesdropping onto the activity of observable phenomena while maintaining the pretence that the presence of the observer has little bearing on what is observed. Thus, for the scientific consciousness, mind becomes a sort of epiphenomenon of cognition faced with a fugitive 'reality' that it attempts to shape and chart by a series of statistical and quantitative formulae. Outside the circle of those who are professionally concerned to promote this quantitative view of reality, the vision of life it presents is remote, intimidating and of incomprehensible complexity. Such a view seems to suggest that man has been born into the world lacking the means to evaluate an experience of life necessarily defined in some measure by love, beauty, goodness, justice and the like. That is to say, by truths inaccessible to the empirical proof the practice of science demands. In

other words, the world-view of materialist science simply fails to satisfy what seems to be the integral need of our intelligence: to discern the ultimate nature of the identity and destiny of our common humanity.

Now, what has happened in relation to the 'artistic consciousness'? Following in the wake of nominalism and the collapse of the scholastic synthesis in the fourteenth century, gradually, European culture instituted a mode of perceiving reality as if it were no more than the rational and sensory perception of phenomenal appearances. Henceforth, immediate, sensory perception of outward appearances, and the rationalisation of the knowledge this gave rise to, was to be the arbiter of truth. Reflecting this transformation of consciousness the task of artistic expression came to be that of re-presenting outward appearances and (as if in summons to some principle of complementarity), the evocation of inner emotional states. In either case, the stimulation of aesthetic experience for its own sake was seen to be the justification for artistic expression. This development had two effects. Outwardly, it lead to a sentimental attitude towards nature, while inwardly art came to be thought of as designating a category of aesthetic objects set apart and in contrast to merely utilitarian things. This aesthetic category of 'art objects' was isolated from the total context of human life and the means to livelihood, and by degrees took upon itself a *raison d'être* that appealed exclusively to the refinement of sensibility. The abnormality of this exclusively aesthetic view of art is evident from its tendency to regard human creativity as an autonomous need in man. It makes art a self-referring activity which is supposed to serve the 'good of life' in a context in which there can be no other criteria of the good beyond that of aesthetic pleasure.

This development, over four centuries, had the effect of foreclosing on man's inner potential in such a way that the spiritual orientation of the soul has no integral part to play, either in the practical activities that comprise his livelihood, or in the aesthetic experience of the sensory data of his daily life. From the perspective of this 'artistic consciousness' man is, as it were, compressed wholly into the passional dimension of his being, while nature itself becomes, finally, more or less redundant except as a repository of sensory stimuli. As a result, both the full reality of man's being and

the full reality of nature are impoverished by a division in which man's spiritual development is curtailed in being set apart from the sacred unity implicit in the natural order of things. This curtailment, formed on the division of art from science, mind from matter, necessarily precludes the integral alignment and harmony of sensory perception, rational thought and spiritual vision. We shall see in more detail the response of several artists to this state of affairs in later chapters of this book, each of them, in their different ways, concerned with the healing of these divisions, a healing that can only come about by way of recovering the human self-image as comprising a threefold hierarchic structure of spirit, soul and body.

According to the traditional wisdom man is created as a theomorphic being who at the level of his ever-changing bodily existence is more strictly described as a 'becoming', and for whom Being itself is located in the supra-mundane origin and unity of all things. This means that from the primordial, metaphysical perspective the Real is located at the highest ontological level of being and not, as is the case with the modern mind, in the most minutely articulated particles of substance it is possible to quantify. Each of the three hierarchic levels or degrees of man's becoming has its *reason* (that by which it is accounted) in the level above it. The very life and essence of each of these levels is therefore under the rule of, and is fitted for, the perfection of the level above it. That this hieratic disposition of our being should have an upward orientation is consistent with its intrinsic order.[1] We can see this by considering the relationship between ignorance and knowledge. The state of ignorance is, so to say, a state of unknowingness. Not to know is to suffer the deprivation and absence of what is greater than, what is beyond, any state of

1. The spiritual necessity and the function of this hierarchic structure is explained by Augustine in this passage from his *De Musica*: 'It is necessary that the soul be ruled by a Superior and rule the inferior. That Superior is God alone; that inferior is the body alone ... as the entire soul cannot be without its Lord, so it cannot excel without its slave. But, as the Lord is greater than the soul, so the slave is less. And so, intent upon its Lord, the soul understands His eternal things, and then more fully *is*. The more also its slave *is*, in its kind, through the soul. However, on the other hand, neglecting the Lord, the soul, intent upon its carnal slave by which it is led into concupiscence, feels its movements which the slave offers to it and it *is* less'. Quoted from *The Essential Augustine*, selected by Vernon J. Bourke, (1974), p.47.

unknowingness. But in any subsequent state of knowledge ignorance is shown to be the insubstantial thing it is, rather as a shadow is removed by the introduction of light. In like manner each stage of our progress towards Truth itself is subsumed and included in the level above it until a state is reached where the knower and the known become completely identified and unified. We are here in a realm where, as Toshihiko Izutsu has pointed out, 'differentiation or distinction means distance, and distance in cognitive relationships means ignorance'.

The three principal levels of the human state receive the *reason* of their being from the level above. That is to say the *reason* ('cause', 'motive', or 'validation' are all cognate senses here) of a thing is the universal principle and root of that thing. It is of the nature of intelligence to want to know the reason of a thing. To ask of anything 'what is it?' is to enquire about the first cause of a thing: it is the act of knowing in drawing the knower towards what is to be known. In the *what* of a thing, in its cognitive essence, is to be found the *why* of a thing. That is, the motive of its characteristic qualities.

In our original threefold nature the highest level, Spirit, receives the reason of its being from that which is uncreated and beyond our being as such. In this uncreated essence the profound mystery of our human identity is finally located in that which is beyond the human. That is the meaning of Christ's words: 'No man can be my disciple who hateth not his own soul'; and 'he that would save his soul, let him lose it'. Eckhart says, the highest point of the soul touches upon God. Thus, to the degree we are capable of the spiritual vision that is integral to this level of our theomorphic nature we are able to glimpse the *reason* in which all subsequent spiritual possibilities must be subsumed, the summit to which all religion and all art ultimately seek to draw us. This is the source of all things in that from it directly stems the first principle of the one sacred unity that in its transcendent aspect governs the order of all things, and in its immanent aspect is like a super-essential light at the core of all things.

The soul has its life from Spirit. In this middle realm the light of Spirit is reflected as in a mirror: the Divine reflected in the soul. Here, in the intuitive vision that is appropriate to its state, the gods and the angels come face to face with the human. But in addition, in the soul, rational (that is discriminative) knowledge has its seat,

and by this knowledge we are not only aware of our own 'person-hood' but we are also able to re-cognise it as possessing the possibility of being greater than what constitutes merely our personal individuality.

The primary faculty of the soul is that of imagination, the soul's organ of cognition and vision, with its ability to form distinct images in imitation of sensible appearances in order to embody supramundane values and meanings. But the soul acts both as a mirror and as a window. The imagination is not limited solely to reflecting images from the natural world, for it is situated between the levels of sensory data beneath it and perfect cognition above it. Seeing that the vital operation of the soul is to draw us ever upwards to this perfection it is its proper nature to reflect, this operation is the equivalent of polishing the surface of the imagination to the point where, rather than reflecting the images of the sensorium as in a mirror, it becomes transparent, like a window, so that we see *through* the images that are present there, and see them anew as illuminated by the light of the Spirit that now penetrates them. In this way imagination assumes its role of being an organ of active, spiritual perception that draws us beyond the transient appearance of things so as to enable us to contemplate their permanent, life-giving energies.

At the lowest level of our three-part nature the substance of the body is illuminated by the soul. Though it is renewed and sustained by physical matter as the organic sheath of the individual life none the less, the body gathers the life and reason of its purposes from the soul. Itself unilluminated the body is only properly at one with the world it inhabits when it reflects its actions and its appetites back in the direction of that which gives them meaning and value. The soul, in other words, is the repository of the reason or significance of whatever the body seeks to attain. Which is not to say that the body is of no importance or in any way to diminish its value. It is simply an acknowledgement that the direct and immediate experiences of the body, through the beauty and ugliness of its perceptions, the joy and pain of its transient passions and appetitive experiences, are only recognised as having these properties in the soul itself.

What possible use could we have for the 'good' of art and nature were this not so? In the delight and immediacy of sensory experience —because it is a mode of knowledge—is nurtured a consolation for

the lost paradise, that momentary freedom from restriction, a lifting of the burden of that corporeality which is inescapably the condition of our bodily existence in the world. 'The road of excess leads to the Palace of Wisdom', wrote Blake. There is no joy in art or nature that is not in some sense a pre-figuration of the final triumph of the spiritual over the bodily.

In his Commentary on the Book of Genesis, Eckhart reminds us of the earlier tradition of interpreting the story of Adam and Eve symbolically. He quotes Augustine to the effect that according to this interpretation the serpent signifies the sensitive faculty we share with the animals; Eve is understood as the rational faculty, or inferior reason, that is directed towards external things, and Adam the rational faculty, or superior reason, which adheres to God. Eckhart goes on to explain that 'in the words "serpent, woman and man" are expressed the substantial being and nature of the human creature and how it is constituted in relation to its principles and their natural properties'.

This symbolic interpretation establishes at once the hierarchy of the faculties of our three-fold state as well as implying the three ontological levels of reality to which they correspond: the Divine (sapiential wisdom), the intellectual (discriminative understanding), and the animal (sensory perception). These three levels can also be thought of as the divine, the intellectual and, the animal activities of the soul. As we shall see, this interpretation not only has profound implications for our understanding of the relationship of art and nature to our human vocation, it also offers a similar insight into the nature of the much debated 'dominion' that man is given over nature in Genesis, as well as the relationship between man and woman.

From a Christian perspective the Creation can be seen as a sacred utterance. According to the Gospel of St John, 'In the beginning' [*in principio*, in the first principle] 'was the Word and the Word was God ... All things were made by Him ... in Him was life; and the life was the light of men'. Also, in Genesis, it is said that God created the heaven and the earth. Moreover, at its completion, it is said that 'God saw everything that he had made, and, behold, it was very good'. But in order to bring the Creation to its fullest completion—that it

should reflect and realise the fullest potentiality inherent in it—God created Man 'in our own image' from the same 'dust of the ground' of which the earth and the other creatures were created. God 'breathed into his nostrils the breath of life; and man became a living soul'.

We see immediately that there can be no division of man from nature. Both are of the same 'dust' as both are of the same 'breath' that is the Logos, the primordially uttered Word which already was when all things began (which is to say, as all things begin nowever), and which therefore underlies all things, and which is the same breath as that of the life of man. The Word or Logos can also be thought of as a supra-luminary energy that, by degrees of emanation from its un-created source in the Divine, is at last manifested in the corporeal light that illuminates the natural world, as well as irradiating each level of the threefold hierarchy. By this light each level is given its life. The light of Truth is reflected at the level of intellect, the light of understanding at the level of knowledge, and the light of beauty at the level of the created order of the world, finally becoming palpable as the light that permits us to witness the objects of nature.

Before the temptation (which is to say in the first principle of our constitution) Adam witnesses the Creation as a paradise, a living theophany in which the spiritual vision of pure intellect—the knowl-edge of the fully-awakened soul—and the sensual experience of the life-given body are illuminated from a single, divine source enabling him to see and understand all things through the contemplation of the highest glory that is God. Thomas Traherne speaks from this perspective in his poem 'Wonder',

> How like an Angel came I down!
> How Bright are all things here!
> When first among his Works I did appear
> O how their Glory did me crown!
> The World resembled his ETERNITY,
> In which my Soul did walk;
> And evry thing that I did see
> Did with me talk.

William Law also speaks of the 'superior reason' of this act of visionary cognition in which the Creator and the Creation are seen in the light of their divine reciprocity:

Man, though fallen, has this strong *Sensibility* and reaching *Desire* after all the *Beauties* that can be picked up in fallen Nature. Had not this been the case, had not *Beauty* and Light, and the *Glory* of Brightness been his *first state* by *Creation* he would now no more want the Beauty of Objects, than the *Ox* wants his Pasture enclosed with beautiful Walls, and painted Gates.

After the Fall it was necessary for Adam to contemplate God through the things of created nature, the 'inferior reason' of the perspective of earthbound cognition—the polarity implying division of subjective and objective experience—the necessity of which, Eckhart, elsewhere, explains: 'If (the soul) could know God without the world the world would not have been made for her sake'.

All this is to say that in the essential threefold structure of our being (we must remember it is a continuous and never-ending creation, its origin and end as near to us now as ever it was or is), aesthetic experience, discursive thought and spiritual vision are ultimately strung together on a single golden thread; are ever the properties of the outflowing universal principle whose reason, or root, is the radiance, the breath of the Divine substance. In the order created by this emanating principle we note that Adam and Eve, spiritual vision and rational thought, at this pre-temptation stage (we might say at this degree of being), are still 'as one flesh', both 'naked and not ashamed', as stated in Genesis.

Surely this has profound significance for how we interpret that much disputed passage (Genesis, 1:28) wherein Adam and Eve are granted 'dominion' over 'every living thing'. This dominion was granted before the expulsion from Paradise, so we must acknowledge that their dominion has only an efficacy in virtue of the dynamic unity of spiritual vision and rational thought—in other words, the understanding of all things through the contemplation of God. Which is also to say that the governance of man over nature is granted in virtue of man's deiformity. Because man *was* once 'naked and unashamed' he *is* (nowever and essentially) a unity with the cosmic, subtle and phenomenal levels of the Creation. It is this centrality of his place in the order of created things that enables him, as it were, to transparentise the existential world and to transform its seeming solidness, to have the measure of its contingency in relation to the

absolute its transience implies. In his dominion over nature man is not called upon to act *as if* he were God, but to act *in God's image*—to be witness to the sacred theophany that God saw was 'very good'.

The primordial human pair were created *after* God had made the world and all it contained. The sequence here is crucial. In creating the world God of necessity has to create a witness to the Divine Act of his creativity (which amounts metaphysically to saying that in the infinity of the principle there must be included the very possibility of an external witness to the principle itself, its own self-reflexive limit, created nature). Why else would there be a Creation? Man alone knows that created nature is dependent upon powers beyond nature itself. Which means that his 'dominion' over nature must be responsible to those powers in virtue of the complementarity of his and its hierarchic constitution. It is this complementarity that proves the centrality of his position in the created order of things and bestows the right of his 'dominion'.

Man must act *in* nature. He cannot act neutrally as if outside of it. He has no liberty to absent himself either from the outcome of his actions or from the commonality of created things. Actions have outcomes, which in turn entails the possibility of success or failure. But by what criteria can he possibly deduce that he has failed or succeeded if the only standard he has is taken from nature itself; is already *in* nature? It is man's cognizance of powers beyond the Creation that lends the burden of his responsibility to, and must ever temper his dominion over, nature. Man, then, has no freedom without consequence to dispose of nature according to an arbitrary wilfulness. He is such a creature that his freedom is to conform his creaturehood according to the order and luminescence of the sacred substance he recapitulates.

But we should not see a type of determinism in this orientation of man's freedom. Rather, it is man's deiform constitution that necessitates a share in the Divine freedom. To Adam, as to Eve, and in distinction from all other creatures, is given the freedom of will to choose whether or not to eat of the fruit of the Tree of Good and Evil. In this freedom of choice is located the source of original sin. Adam is warned that eating the fruit will cause his death. That is, the faculty of spiritual vision not only proceeds from, but is nourished by, the Divine so that it sees all things as they subsist in the eternity

of their original glory. But this vision of the ineffable is occluded whenever the soul's cognition is deflected so as to attend exclusively to the external, transient forms of created nature—phenomenal appearances. Eckhart points out that the highest part of the soul, intellect, the light of spiritual vision, exchanges a 'mutual glance' with God. This is the natural origin of truth, founded in the root and source of all good. The pre-fallen pleasure of Adam in the Garden of Paradise is just such a 'mutual glance', just as the 'sorrow' and 'desire' (mentioned in the Biblical account) of the fallen state of Adam's expulsion is Adam's apprehending the consequences of his dust-formed creaturehood.

We must remember that the precipitation of the Fall begins at the lowest level of man's threefold state, the serpent's temptation to Eve. This is the appeal of the faculties of 'inferior reason'—sensory perception—to consider the fruits of this world as sufficient unto themselves. There would have been no substance, as it were, to the temptation were it not for this promise to the rational faculty that it would become Divine in its vision—an inversion, be it noted, of the threefold hierarchy. That was the temptation; the promise that 'ye shall be as Gods', and the creature of earthbound cognition should possess all things and be granted the vision of eternal simultaneity. Discriminative knowledge, then, fore-closing on its dependence upon the rule of the higher faculties of the spirit, is promised a vision of things as if it possessed God's eye-view of the Creation, that of the very weaver of the fabric of opposites; of good and evil, light and dark, heaven and earth, night and day, man and woman, life and death. That the warp and woof of this fabric is unknown to Adam and Eve before the Fall is signified by their being 'naked and unashamed'. Which is to say they know nothing of the cognitive division that is the polarity of past and present, male and female, subjective and objective worlds. In their pre-fallen state they possess a direct vision of the Divine Unity as it subsists within the division and refraction that is the multiplicity and concatenation of opposites. Adam is said not to have any sight until his eyes were opened after eating the fruit. His 'closed eyes' thus indicate the interior gaze of the highest intellect upon the Divine Principle itself—the very source of the duality of things. It should not escape our notice that it is only after the expulsion that Adam and Eve *knew* the division of their sex.

Adam's act of free will, as it were willing his own death, and at the initial instigation of the serpent, begins the inversion of the proper order of the faculties. Now each level is in thrall to the ontological state of the level beneath it. The Divine Order is overturned; the primordial sin in instituted (*sin*, from the word for dis-ease, thus a dis-order or dis-ruption in the qualities of a thing that prevents the perfection of the nature of that thing). Eckhart glosses the word 'evil': 'It is order that makes something good, so that it is impossible for there to be good outside order and conversely for there to be evil where order exists.' Having no longer the vision of the Divine Unity contemplated only in the perfect alignment of the threefold hier-archy of states of being, Adam's and Eve's eyes are opened outwards to a recognition of their carnal nakedness, the imperfect state of their humanity and their dependence in common upon the prop-erties that constitute the lowest level of the triad of faculties. Adam, after eating the fruit, is said by God to have 'become as one of us'. Thus it is the expulsion that sets the seal upon Adam's loss of contemplative vision. Thereafter the Divine is not directly manifest to the eyes of flesh which must now attempt to trace the sacred luminosity from the shadows of the things of this world. All this comes about because, as God says (3 : 17) 'thou hast harkened unto the voice of thy wife'—the inferior reason of the rational faculty direc-ted to outward things. This occlusion of vision is nothing less than discriminative knowledge and aesthetic sensation given rein to func-tion seemingly of their own accord, an illegitimate autonomy that isolates them from the superior reason that ultimately lends intelligibility to their actions. (The significance of this usurped func-tion might be glossed with these words from the first chapter of Romans, 'they ... became vain in their imaginations, and their foolish heart was darkened'.) The consequence of this occlusion of cognitive vision is that in the state of our creaturehood the con-forming of our nature (the pattern or exemplar *after* which it is shaped), is never achieved without a sacrifice that is perfected by Grace. And that is the paradox of the human state, that in order to become fully human we must transcend our 'humanity', a path that takes us beyond the level of our psycho-physical selfhood and all that accrues to it. Only by relating everything to the deepest interior principle of our subjective being can we become 'objectively' what

we truly are. Only thus can we avoid the anomaly of seeking to be wholly our 'self' by means of habits of thought and action we know that 'self' to be the author of.

The serpent is not evil in its acknowledgement of the sensual world, but in its resolute attachment to it. In Adam the Divine Substance becomes man that man may become Divine. Which is to say, in his integral deiformity man returns all things to their just measure. But to the extent of his attachment to the things of this world, so the path by which the way of return is traced becomes effectively obscured—phenomenal appearances lose their transparency so that, cognitively speaking, the knowing subject is faced with a *res* it cannot unite with.

The first act of the primal One, the Creation *in principio*, must by definition be created out of a state of nothingness since its advent precludes any existent thing out of which it could be formed. This cosmic principle is at the root of all manifestation. Nothing is explained by reference to the same ontological level of reality of that which is to be explained. Nothing material is explained materially. The origin of the world is not explained by reference to any of its manifest aspects. The world is nothing if not an appearance and logic demands that every appearance is *of* something—a prior reality.

From a biblical perspective the creation of the world is also the articulation of a thought—a word uttered in the void of the Divine potentiality. This prior potentiality is no 'thing' as such but is the 'nothingness' on which all things are formed. It is the Cosmic Dream that dreams us, as Shakespeare's Prospero saw—

> the great globe itself,
> Yea, all which it inherit, shall dissolve,
> And, like this insubstantial pageant faded,
> Leave not a rack behind: we are such stuff
> As dreams are made on.

The articulation of the one Divine Substance at the level of sensible manifestation is the 'hidden' reason or root—the intelligible principle—of every part of its multiple reflections in the world. Each and every minute particular, in other words, is a reverberation, a replica that harks back to the One that is the prior Divine Unity.

Why else would Blake ask us to see 'a world in a grain of sand', and 'heaven in a flower'? This principle of replication is mirrored in the fact that everything we *re*-cognise in this world is one in so far as it is itself in its abiding sameness. Thus every one thing, rightly perceived, is a window onto the 'veiled' reality of the primordial Oneness from which it emerges. This cosmic veil that is the multiplicity of things is the screen or surface onto which each thing, as a cognizable image, is projected. Without the single, anterior veil of crea*tive* nature onto which they are projected the multiple things of crea*ted* nature would not exist, would have no reality, just as the images of a film projected into darkness would disappear for want of a reflective surface to receive them, to permit them to appear.

The intelligible principle of a thing, that which makes our cognition of it possible, is the *form* of a thing—that *on* which and *after* which a thing is formed. The word *form* and its derivatives, formulate, conform, deform, reform, inform, transform, uniform, all imply a pre-existent type or model of which the thing in question is a re-presentation. The form of a thing is what it *is*. This is no less true of works of art in that they are the outward articulation of an image or idea first held in the artist's mind. Every work of art, everything made, is a representation of its form. And it is this form that we seek when we ask, for instance, of a thing we have not previously seen, and so do not understand, 'What is it?' Or of a person we have not previously met and so ask, 'Who are you?' We are asking to *know* the form or identity of an appearance we see but cannot *re*-cognise. The phenomenal appearance of a thing is, then, a resemblance of something that is more than simply what is outwardly manifest. The resemblance tells us *that* a thing is but not *what* or *who* it is. This is how, for instance, he or she appears to be. Indeed, the word person, from the Latin *persona*, a mask, itself suggests something concealed by an external appearance; an appearance that personifies and thus makes evident a veiled or hidden reality. Only with reference to the ontological root of their being, their form, can we find the who or what of an individual's existence. Without this form there would be no person to put in an appearance.

It is the same with the appearance of the world. We cannot discover the *why* of the world's appearance because we are able to examine—whether minutely through the microscope, or compre-

hensively through the telescope—every characteristic of *how* it behaves. This takes us no nearer the *form* which is 'hidden', and is undiscernible by those faculties that allow us to comprehend the fact of its phenomenal appearance. For this we must develop the faculties of the soul appropriate to the level of reality to be discerned. For this we need what Traherne called 'virgin apprehension': an innocence, a purity of internal vision that is such a stillness at the root of our being—without disturbance or taint of any created thing—that it can be likened to the soul's becoming a polished surface on which is clearly reflected the ineffable life of a thing as it subsists in the original glory of its being in the unity of all things beyond generation or decay. This is what Blake referred to when he wrote: 'There exist in that Eternal World the Permanent Realities of Every Thing which we see reflected in this Vegetable Glass of Nature. All things are comprehended in their Eternal Forms in the divine body of the Saviour... The Human Imagination'.

The deformity of man's threefold constitution makes of him just such a creature as has to enquire after the hidden *forms* of things. Seeing that this necessarily implies that what is known can only be known in the mode of the knower—that like is known by like—this amounts to our asking the question 'Who am I?' (*Who*, rather than *what*, as Richard of St Victor reminds us, since it is a person who answers to the question.) Man is haunted by the knowledge that the things of this world are not sufficient in themselves; that things are not entirely what they appear to be. It is man's vocation to trace their origin, to uncover their true reality. Man has to ask of all that surrounds him, *what* is incontrovertibly true of that which appears to be so? It is of the very essence of his being that he asks why is there anything at all rather than nothing.

In so far as man looks outward onto the world with his sensory faculties he sees objects, colours, shapes, movement. But he does not *see*, with his eyes of flesh, that which permits the appearance of each thing; he does not *see* the light of which colours are a refraction; he does not *see* the space that shapes articulate; he does not *see* the time in which movement takes place. So far as the senses are concerned light, space and time are non-existent, even though they are the hidden veil that make sense-data possible, the 'illusion' that permits man's discovery of the Real. To find the hidden dimension, the im-

plicit context of his apprehensions, he must turn inwards and begin the ascent of his faculties, referring the beguiling and manifold attractions of outward appearances back to the One that is implied by their manifoldness.

It is precisely at this sensory level that the perception of beauty is located in its immediacy. And it is our love of beauty that motivates our search for the perfection of its source where it no longer bears the shadow of transience. In other words, and because extremes meet, in the perfect, sensory beauty of a flower, for instance, we have an intimation of the sacred order of things: at the level of sensory appearances we have a prefiguration of that 'very good' that God 'saw' (sees) in his Creation. It is here that the enkindled soul begins its ascent, through the rational levels of cognition, beyond thought to the heart's intuition of its transcendent origin. Eckhart comments: 'Man's sensitive faculty is more excellent than those of all the other animals by reason of its participation in the rational faculty'. For man alone sees the *ratio* of all things, thus in him alone among the creatures is there the possibility of an unerring cognition and this, finally, is the only justification for his 'dominion . . . over every living thing that moveth upon the earth.' (2 : 28)

But at the rational, discriminative level of our apprehensions, however clearly we may see the things of corporeal vision, none the less we possess at this level only a partial grasp of their complete nature. Here we can only in limited measure grasp the being that objects re-present; the time which allows movement to be witnessed; the light that colours participate. Here the full measure of what being and time harbour is not yet laid bare. We see things coming into existence, their growth, decay and death. We recognise their fleeting passage as the future ceaselessly flowing into the past. So we come to understand even time as an 'appearance', a fleeting 'seeming to be' from which something of us escapes. If there were not a part of us untouched by time it would not be possible for us to witness the passage of time. Movement is only measured by something static, something that is not totally identified with the properties of movement. As William Law observed, 'What could begin to deny self, if there were not something in man different from self?' The world of appearances is everywhere impermanent. But yet we have the idea of permanence. And so we recall Augustine's obser-

vation that 'the world was not made *in* time, but *with* time'. Thus, man's deiformity, the fact that he is created in God's image, lends him, so to say, the possibility of adopting God's eye-view of the world. That is, his ultimate being shares in the reality, the *in principio*, that *is* before the flow of time begins.

To pierce to the root of Oneness, the all-comprehending stasis that makes this dance and play of multiple seeming possible ('mirror on mirror, mirrored is all the show', is how Yeats described it), requires a stillness of being that is beyond the rational, discriminative faculties. We must have Divine assistance; we must see with what Traherne calls 'Celestial Eyes'. Here the Adam of our nature is called upon to recover its original innocence. Here is our utmost assent to the fullest radiance of our being, here we exchange that 'mutual glance' with God; Serpent, Eve and Adam, spiritual, rational and aesthetic faculties finally in mutual harmony.

What comes first must take priority. What comes first must be most eminent. What comes first all subsequent things are ordered to and all faculties are governed by. It is finally light—the 'light that lighteth every man that cometh into the world'—in whose illumination we are trans-figured ('trans'—to go across, over, beyond) by the Divine Substance that is the 'object' of our redemption and the 'subject' of our 'dominion'. The true perception of nature's beauty, and the joy of making what conforms to our true being, draw us to this summit. The making of the Creation is the divine play, necessary in that there should be an outer witness to the inner beauty and goodness of its Creator. And art, in imitation of His 'sport', is man's making of the things that are needed to bring him to the state of inner witness. Thus the creature works in the mode of the Creator that the Creator can work in the mode of His creature—He knowing Himself in us and we knowing ourselves in Him.

Samuel Palmer's Vision
of Nature

I have beheld as in the spirit, such nooks, caught such glimpses of the
perfumed and enchanted twilight—of natural mid-summer, as well as, at
some other times of day, other scenes, as passed thro' the intense purifying
separating transmuting heat of the soul's infabulous alchymy.
Samuel Palmer, 14. 11. 1827

AT some time during 1824 and 1825 Samuel Palmer painted an unusual picture now known as *The Rest on the Flight into Egypt*, or *The Repose of the Holy Family*. It was begun in the painter's nineteenth year. The picture, painted in oil and tempera, is curious for two reasons. First, there had not been anything quite like it in the history of English painting. It is stylistically almost without precedent. Secondly, the picture is an odd mixture of not quite resolved pictorial features. It shows the Holy Family in what appears to be an English landscape. But, incongruously, to the right, is a large palm-like tree. In the middle distance is a richly autumnal wooded landscape typical of the Kentish hills around Shoreham with which Palmer was already familiar and with which, in the following decade, he was to become intimately associated. In the picture, this wooded landscape gives way, towards the skyline, to another sort of landscape more reminiscent of the Alps than anything one might see in England. To the left of the picture is a steeply banked field which reveals, rather too precipitously, a cottage with a smoking chimney. In the right foreground the Holy Family are at rest. It is not quite clear on what they are resting owing to the ambiguity of the ground plane beneath them. For this reason it looks the most unlikely place to rest with, presumably, the hill falling away just behind them. There is considerable distortion in the figure of Mary; and Joseph makes a somewhat token appearance just behind her.

All this would not matter were it not for the fact that the picture

is painted in a style that is, in its detail, representative of natural appearances. Any prolonged contemplation of the picture is likely to leave the viewer with the impression that the representation is not sufficiently removed from naturalism for its incongruities to be resolved. It is a beautiful picture, richly worked, and yet it has something of the appearance of a transitional work, as important for what it heralds as for what it accomplishes. And what it heralds is a style of painting that immediately after was to result in the six masterpieces of the year 1825. These are the six sepia wash drawings that are among Palmer's greatest works.

These six pictures are painted in a style that manages a fruitful and balanced tension of naturalistic and abstract elements. They present a convincing and homogeneous pictorial reality that in varying degrees only partially corresponds to the reality of physical appearances yet none the less in such a way that any visual incongruities we might find in the pictorial reality seem to be acceptable and do not disturb the mind's eye. In *Early Morning*, for instance, it does not strike us as incongruous that it is not clear where the source of the light is. Does it come, as perhaps it should, from the large mushroom-shaped tree, or does it come from a source beyond the left side of the picture? The three slender tree trunks to the right seem to indicate this, but then their shadows are not angled consistently.

In *A Rustic Scene*, the spatial depth from the head of the front ox to the thatch of the cottage is foreshortened to the point of having no extent at all. Again, the ground plane is ambiguous so that it is not certain on quite what the back ox is standing. The ears of corn in the middle distance are of a size that would, in natural fact, make them the size of small trees. (Such corn is also a feature of *The Valley thick with Corn* and *Late Twilight*.) In front of the cottage to the left of the picture there are four wooden palings of a fence that seems stout beyond its function as such. And what is the fringed triangle of leaves that cuts across the bottom left-hand corner of the picture?

In *The Valley thick with Corn* multiple perspectives seem to operate so that one part of the scene is inconsistent with another from the unifying point of view of the observer's eye. It is as if the painter wants us to look closely and to absorb areas of the picture to the exclusion from our field of vision of other areas, so that a series of minutely articulated scenes 'join up' at their edges to cohere

pictorially as we draw away and take in the whole picture at a glance. By means of this sectioning of the picture plane we are made to inhabit imaginative space which itself replaces physical space. This lack of physical depth is registered in several instances: by the two birds to the right of the trunk of the mushroom-shaped tree in *Early Morning*, for instance, and those to the left of the central tree; as well as the shepherd and his sheep on the escarpment in the top right-hand corner of *The Skirts of a Wood*. The birds in flight in the centre of *The Valley thick with Corn*, and the three fruits in the top left-hand corner of *A Rustic Scene* are all devices that in conventional pictorial language would be used to measure distance. But here they do not quite succeed in that function.

More generally, but with the possible exception of *The Valley with a Bright Cloud*, which is redolent of an after-storm calm, we note that in all these pictures there is no climatic atmosphere. No mist has ever formed, no wind blown through, no rain fallen upon these land-scapes. In their ecstatic ripeness they are aloof from the transitory vicissitudes of weather and of the seasons. These, and any other ambi-guities and incongruities we might find, seem rather to be beside the point in the context of the stylistic means that Palmer deploys, and which is entirely consistent with its own imaginative intention. The stylistic balance of naturalism and abstraction, depicting as it does a rapt stillness that honours the theophanic miracle of the observable creation, he seldom again brought to such a pitch of concentration as here in these six works.

We cannot say how our overall view of Palmer's Shoreham period would be altered were the works destroyed by his son restored to us. But in only a few other pictures does this stylistic synthesis of naturalism and abstraction form such an integral part of the pictorial reality. These are *A Hilly Scene* of 1826 (which is a masterly summation of the 1825 sepia works), *A Shepherd and his Flock under the Moon and Stars* of 1827, *Ruth Returning from the Gleaning* of 1828/29, *Coming from Evening Church*, and perhaps *The Magic Apple Tree*, both of 1830. All of Palmer's other paintings, including the typically 'Shoreham' works show scenes that are plausible in terms of naturalistic representation. In the six sepia works of 1825 such representation does not seem to be in question. They stand apart, so much so that we must conclude that here something different was intended.

The maturity of the conception and the mastery of the execution of these works are, to say the least, surprising in a painter of only twenty years of age. The possible iconographic sources of their pictorial and stylistic richness have been well-researched and identified. But useful as such studies are they reveal almost nothing of the motivation, the creative impulse, behind the making of these pictures. Apart from the literary sources (no less important in this case than the pictorial), the only visual precedents for them that we have from Palmer's own hand are to be found in his sketchbook of 1824. Here, in embryo, along with intensely detailed studies of natural forms, are those radiant scenes of magical intimacy; here is the landscape forming itself into unlikely extra-geological configurations; here trees and plants no longer quite answer to strict botanical categorisation. In these pages the elements of a pictorial style are being tried and tested for their imaginative significance no less than for their pictorial value.

Something of Palmer's mental state can be inferred from an entry in another notebook described by his son A. H. Palmer as covering the period November 1823 to July 1824: 'I ... shall try to work with a child's simple feeling and with the industry of humility'. Nothing could be further removed from simplicity than the painter's work of this period, unless we understand him to mean innocence of vision—the direct imaginative apprehension of the child. Indeed, in another entry in the same notebook Palmer refers to his 'very early years, in which I distinctly remember that I felt the finest scenery and the country in general with a very strong and pure feeling'. Yet another entry for 2nd January 1825 gives us an insight into his then somewhat febrile mental condition with its highly strung spiritual pre-disposition:

> Now is begun a new year. Here I pause to look back on the time between this and about the 15th of last July. Then I laid by the [Holy] Family in much distress, anxiety and fear; which had plunged me into despair but for God's mercy I then sought Christ's help, the giver of all good talents whether acknowledged or not I improved more since I resolved to depend on Him till now ... and have felt much more assistance and consolation. For very soon after my deep humblement and

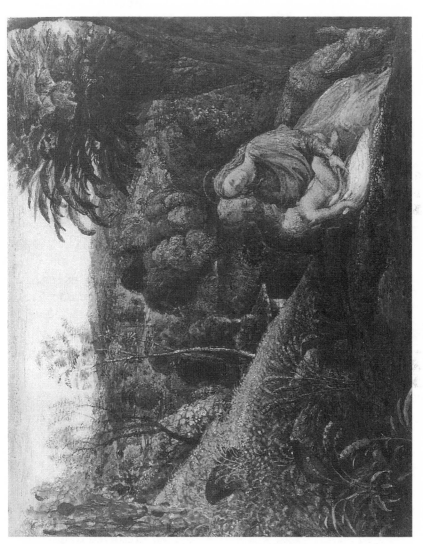

Samuel Palmer, *The Rest on the Flight into Egypt*, c.1824–25, 323 x 294mm, mixed media.

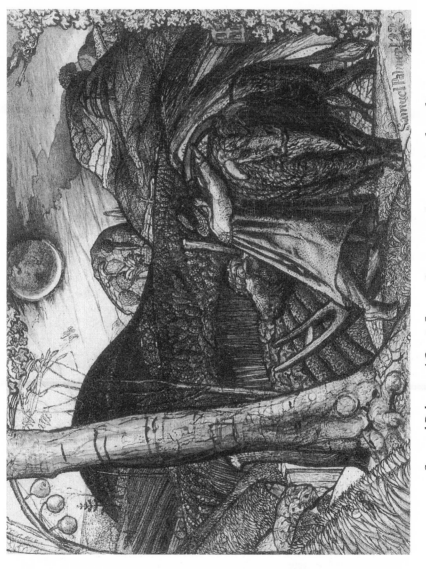

Samuel Palmer, *A Rustic Scene*, 1825, 197 x 236mm, mixed media.

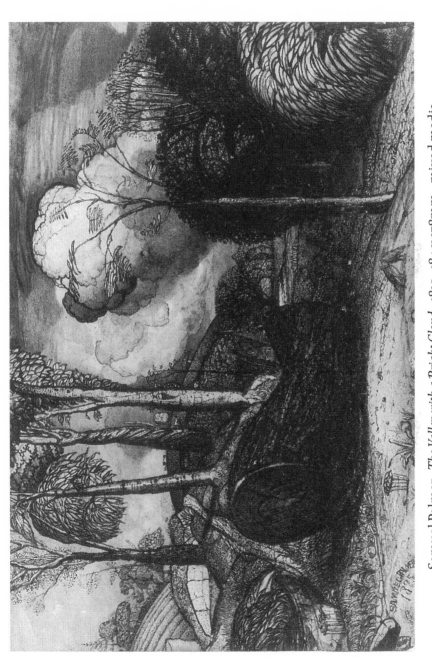

Samuel Palmer, *The Valley with a Bright Cloud*, 1825, 184 x 278mm, mixed media.

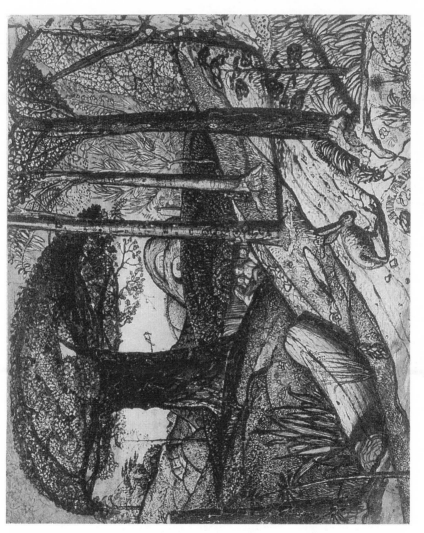

Samuel Palmer, *Early Morning*, 1825, 188 x 232mm, mixed media.

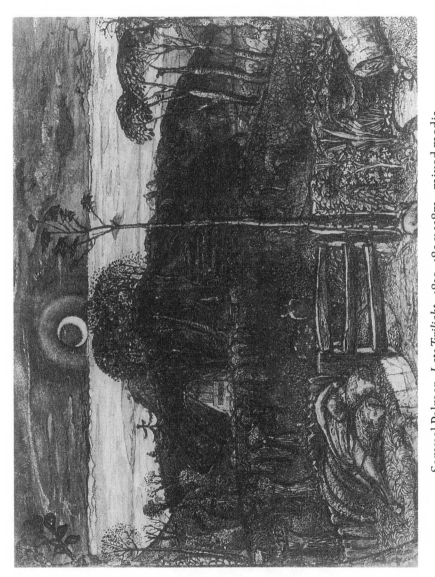

Samuel Palmer, *Late Twilight*, 1825, 180 x 238m, mixed media.

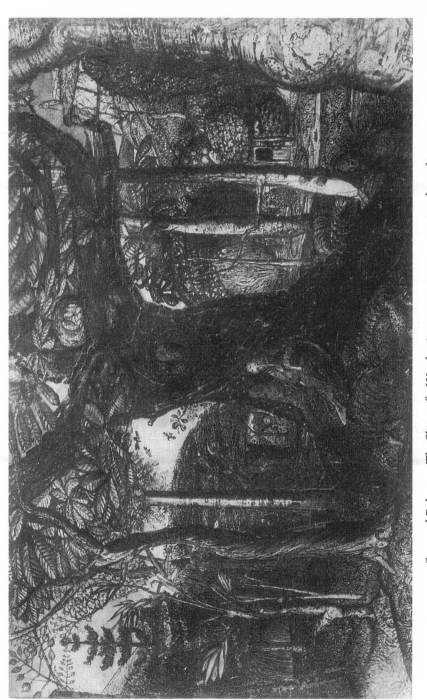

Samuel Palmer, *The Skirts of a Wood*, 1825, 174 x 277mm, mixed media.

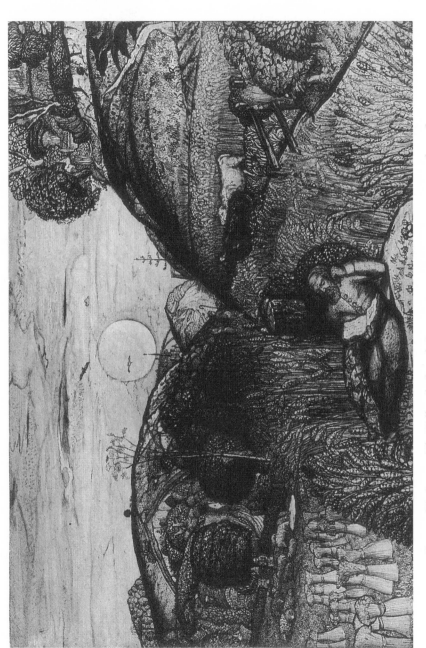

Samuel Palmer, *The Valley thick with Corn*, 1825, 184 x 275mm, mixed media.

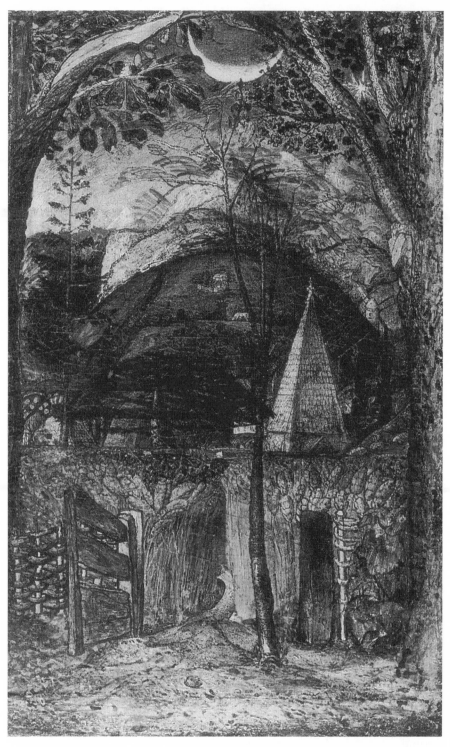

Samuel Palmer, *A Hilly Scene*, c.1826, 209 x 136mm, mixed media.

distress, I resumed and finished my *Twilight*, and quickly took
up my *Joseph's Dream*, and sketched in my new sketchbook ...
knowing my own stupidness I gave back the praise to God
who kindly sent it, and had granted to me desponding, that at
eventide it should be light.

At the time of writing this passage Palmer had known the painter
John Linnell (later to become his father-in-law) some fifteen months.
The older man had encouraged Palmer a good deal and of this fateful
friendship he was to write 'it pleased God to send Mr Linnell as a
good angel from Heaven to pluck me from the pit of modern art; and
after struggling to get out for the space of a year and a half, I have just
enough cleared my eyes from the slime of the pit to see what a
miserable state I am now in'. During 1824 Linnell also introduced
Palmer—in 'fear and trembling'—to William Blake.

It is difficult to ascribe the greater degree of importance either to
Blake's personality or to his work in so far as they were to influence
Palmer. But of one thing we can be certain, the incalculable in-
fluence on him of Blake's half-visionary, half-pastoral woodcuts exe-
cuted for Dr Thornton's Virgil in 1821. The impact of these small
pictures on Palmer was immeasurable: his own testimony being well
known. He described them as

visions of little dells, and nooks, and corners of Paradise; models
of the exquisitest pitch of intense poetry There is in all such
a mystic and dreamy glimmer as penetrates and kindles the
inmost soul, and gives complete and unreserved delight, unlike
the gaudy daylight of this world. They are, like all that wonderful
artist's works, the drawing aside of the fleshly curtain, and the
glimpse which all the most holy, studious saints and sages have
enjoyed, of that rest which remaineth to the people of God.

What emerges from this confluence of training, of influences and
inspirations is that Palmer, whose first recorded drawing had been
executed at the age of seven, and who had sold a picture at the Royal
Academy at the age of fourteen, had reached what he considered an
artistic impasse at the age of seventeen. This impasse—the 'pit of
modern art'—was clearly the more or less unquestioned assumption
of the age that the art of painting was the art of naturalistic represen-

tation. Yet within three years, at the age of twenty, with the help of Linnell and Blake, Palmer had painted six masterpieces in a style that had little in common with either of his mentors' work. Blake was understood by very few of his contemporaries because there was no widespread convention at the time to grasp the meaning of his images. The same fate befell Palmer's works of the Shoreham years, for they remained mostly unsold. A baffled critic, commenting in the *European Magazine* of August 1825, wrote of two of them that they are 'so amazing that we feel the most intense curiosity to see what manner of man it was who produced such performances'. We forget how recent appreciation of these pictures is, and for reasons that are not always helpful for an understanding of them, as we shall see.

In order to grasp more fully Palmer's achievement in these six pictures we must recall that neither Blake nor Linnell painted in a style such as we now associate with Palmer's Shoreham years. It seems likely that Linnell had re-focussed Palmer's sense of pictorial value by directing him to certain 'very ancient Italian and German masters'. His recent friendship with Blake no doubt re-inforced his incipient awareness of the significance of imaginative vision—of the supremacy of the soul's cognition over the sensory apprehension of the world of appearances. With his newly clarified vision Palmer felt sufficiently confident to dismiss his contemporaries' attempts at naturalistic representation, saying he 'wondered what the moderns could mean by what they called their "effects"'. That is, seeing nature as a series of retinal impressions. And a memorandum of the period, 'guard against bleakness and Grandeur', demonstrates his early resolve to resist the eighteenth century artistic ideal of the sublime.

It must be assumed that it was Blake's friendship that gave Palmer's naturally platonic bent just the support and encouragement it needed seeing that, with the exception of the Virgil woodcuts, the human dynamic of Blake's figurative compositions has little in common with Palmer's empathic pastoralism. Whereas Blake transcribed what he saw inwardly, Palmer alchemized what he saw outwardly. But what is meant by speaking of Palmer's 'platonic bent'? Here we must examine more closely Palmer's own record of his intentions. In this we are fortunate since the painter was hardly less able to describe in words his intentions than he was able to execute them by pictorial means.

When Palmer wrote, in a letter to George and Juliet Richmond dated June 1836, and quoting from Milton's *Comus*, 'every little self denial and agonizing brings after it "a sacred and home-felt delight", so, on the large scale, our whole earthly existence ought to be a short agony to secure eternal blessedness', we might be forgiven for thinking that he was prey to a degree of morbidity. But we cannot gainsay the other-worldly direction of the sentiment, one which remained with him throughout his life. Moreover, it is obvious from much that he wrote that the painter had at times a pressing acquaintance with the powers of evil. An entry for 31st August, 1826 in his notebook reads:

> After dinner I was helped against the enemy so that I thought one good thought. I immediately drew on my cartoon much quicker and better Satan tries violently to make me leave reading the Bible and praying O artful enemy, to keep me, who devote myself entirely to poetic things I will endeavour, God helping, to begin the day by dwelling on some short piece of scripture, and praying for the Holy Ghost thro' the day to inspire my art.

A few years later he wrote again to the painter Richmond (21st September, 1832): 'If only people knew how deeply the whole world lieth in wickedness, and how totally it is estranged and set in opposition to God'. Obviously Palmer shared with Blake a keen sense of the fulcrum of good and evil at the point of inspiration for human motivation and action.

Yet Palmer was far from seeing man's position in this world as being one of sin and hopelessness. In the same letter he refers to man's pre-fallen image as 'the similitude of a divine parentage'. And in a letter to John Giles' family dated October 1838 he advised his brother Albert to

> go on drawing, continue to study from the divine, eternal, naked form of man The devout and holy study of the naked form purifies the imagination and affections, and makes us less pervious to evil temptation in eternity that human form is, as it were, the body and symbol of goodness and truth . . . it existed from eternity in the Divine Idea.

This 'archetypal perspective', as one might call it, remained with Palmer throughout his life. Writing from Italy in 1838 to the Giles family he ranged the 'old Platonic philosophy' against the materialistic, pragmatic 'Useful Knowledge Society' of his day, remarking 'money and beef are not, as people imagine, the solid things of the *mind*; but as unreal and unsatisfying to the immortal part, as a lecture on metaphysics could be to a hungry belly'.

Palmer must have read Plato in the translation by Thomas Taylor, whose *Works of Plato* was published in 1804, which would have familiarised the painter with the idea that the human soul, while in its earthly body, is in exile from its true state in the Divine realm. If we add to this what Palmer would, as a Christian, have understood of the Creation as the artifice of God, a manifestation of His goodness and beauty, then we have the essential sources for nearly every one of Palmer's reflections on the human condition in relation to his vocation as a painter of appearances. But the reality beyond created appearances is consistently the focal point of Palmer's art and thought. On the evidence of his writings the platonic myth of the Cave was a *leitmotif* of his thinking from first to last. From the time of his adolescence to his old age it was natural for him to think of the world of nature in terms of its insubstantiality, its ephemerality. In his 'Observations on the Country and on Rural Poetry', written in his more philosophical old age (in fact the last year of his life) and published in 1883 as a Preface to his *Eclogues of Virgil*, he rejected the 'Facts and Mutton' vision of the universe habitual to the modern intelligence, but doubted whether he could warn such as were possessed by it of the unreality of what they saw: 'We must not tell him that perhaps his back is to the light, like those men in Plato's Cavern; and that though his eyes are wide open, he may be watching shadows'.

Palmer never makes the assumption of the naive materialist that reality is what we observe. For him appearances are the shadows, the language, even, of the world we should strive to see. To this extent art, for Palmer, has a moral obligation, as well as a spiritual import. There is on the one hand the perfect form of man, the immortal Soul, Divine in its essence, and on the other hand there is the insufficiency of the natural world acknowledged by our senses. The resolution of this duality that is the very condition of man's earthly existence, is for

Palmer the task of art. Nature, as he wrote to Linnell in December 1828, 'does yet leave a space for the soul to climb above her steepest summits: as, in her own dominion she swells from the herring to leviathan; from the hodmandod to the Elephant, so divine Art piles mountains on her hills, and continents upon those mountains'. The nature we see is not another reality 'opposed', as it were, to the Divine: it is rather as if what we see is the 'wrong side of the tapestry'. (The six sepia works do indeed have something of the texture of a tapestry in the way they are closely worked with interwoven shapes over their entire surface.) It is not for the eyes of flesh to penetrate to the right side, for only the cognitive vision of the soul, imagination proper—'intellectual eyes' as he called it—can fathom the true reality. Palmer used this phrase in a letter to George Richmond in September of the same year, where he complained of the danger to students of having their 'intellectual eyes jaundiced' by merely copying natural appearances.

This duality suggests if not an opposition between art and nature at least a distinction in their purpose. And so there is. Writing to his patron Leonard Rowe Valpy in May 1815 Palmer notes: 'Nature knowledge and art knowledge ought to be in harmony, but they are two distinct things'. That this harmony is not brought about in the attempt to represent natural appearances becomes obvious from much that Palmer wrote in an effort to explain his intentions. For instance, in a letter to Philip Gilbert Hamerton in February 1874, long after his Shoreham years, he concluded,

> as for the last thirty years we have been working backwards, not towards nature but naturalism.
>
> The Philosophers, who are by no means too imaginative, can set us right. Lord Bacon says it is the office of poetry to suit the show of things to the desires of the mind. We seem to aim at suiting the desires of the mind to the show of things. Does not the former imply a much more profound and inclusive study of the 'show of things'—'nature', as we call it, itself?

Unlike Blake, Palmer had little to say on the subject of imagination. But clearly it was for him the faculty or transmuting agent that joins sensible perceptions of beauty to their paradigms in the Divine.

Writing in his *In Memoriam* for Oliver Finch in 1863 he observed: 'He had imagination, that inner sense which receives impressions of beauty as simply and surely as we smell the sweetness of the rose and the woodbine'. And later, in his 'Observations' of 1883, he elaborated:

> A bird deprived of her wings is not more incomplete than the human mind without imagination, a faculty distinct from the spiritual and rational, yet having a common language; for the language of imagination is poetry, and it is in poetry that both sacred aspiration and secular wisdom have found their noblest utterance.

From such passages we may deduce that for Palmer the function of imagination is to resolve the opposing tensions that exist between the demands the outward world makes upon the senses and the inward aspiration that beauty inspires in the soul. The symbol of the bird is aptly chosen for does not the bird's wing presuppose the possibility of upward flight? Such imaginative resolution must surely be what Palmer was referring to when he wrote, in a letter to Linnell on 21st December 1828, 'creation sometimes pours into the spiritual eye the radiance of Heaven', so that the effects of natural beauty 'not only thrill the optic nerve, but shed a mild, a grateful, an unearthly lustre into the inmost Spirits and seem the unchanging twilight of that peaceful country, where there is no sorrow and no night'. In other words, the resolution of opposites that is the '*rest* which remaineth to the people of God', is an act of imaginative perception: the greatest art, as he wrote to Valpy in May 1875, addresses 'not the perception chiefly, but the IMAGINATION, and here is the hinge and essence of this whole matter'.

But how is this resolution between the generated creation and the Divine Reality, and between nature and art, effected? For the depiction of what is beyond the 'fleshly curtain' by means of some semblance of created appearances must surely have inherent in it the danger either of idolatry to those appearances, thus increasing the possibility of our being attached to sensible beauties rather than to the truth of their unmanifest source, or of some form of pantheism that obscures the distinction between the Creator and the Creation? The dilemma Palmer, in effect, posed in the letter to Linnell in December, 1828:

I have ... no doubt but the drawing of choice positions and aspects of external objects is one of the varieties of study requisite to build up an artist, who should be a magnet to all kinds of knowledge; though, at the same time I can't help seeing that the general characteristics of Nature's beauty not only differ from, but are, in some respects, opposed to those of Imaginative Art.

But does not the very existence of the incarnation imply the sacramental nature of material things? In which case the Creation is best seen as a vehicle of grace where the minute study of its manifest forms—'Temporal Creation, whose beauties are, in their kind, perfect' (as he called it in the same letter)—leads to contemplation of its hidden prototypes, 'those abstracted, essential, fiery, and eternal conceptions known by few in any age' (letter to George Richmond, September, 1828). It is precisely this intimate correspondence between the revealed manifestation and the veiled essence that permits the 'material tablet' to 'receive the perfect tracings of celestial beauty' (notebook 1824).

The 'material tablet' is not, after all, some vague, amorphous entity but a theophanic array of living minute particulars. For the artist the study of nature is not so much the imitation of how those particulars appear to the ocular sense so much as the use of them to dismask appearances, to reveal the 'right side of the tapestry'; nature used as the language of forms to convey the very sacredness of the Creation. Martin Butlin, in his edition of the 1824 notebook, has pointed out how the power of Palmer's drawing is related to a heightened vision of direct perception of natural forms and how this power diminishes in so far as it draws upon the imagination; meaning, in this case, personal phantasy.

This being so, it is noticeable how during the Shoreham years Palmer had an almost obsessive concern to balance an intense study of natural detail with his spiritual preoccupations. Both the written and drawn entries to the 1824 sketchbook show his absorption in physical details, but on page 81 we find;

It is not enough on coming home to make recollections in which shall be united the scattered parts about those sweet fields into a

sentimental and Dulwich looking whole. No. But considering Dulwich as the gate into the world of vision one must try behind the hills to bring up a mystic glimmer like that which lights our dreams. And those same hills, (hard task) should give us promise that the country beyond them is Paradise.

To suppose that the 'abstract' element of Palmer's style during the Shoreham years reveals a desire to experiment with the shapes of natural forms obscures the point: it suggests that the painter's intentions were more or less exclusively aesthetic and artistic whereas he was obviously and equally concerned to make a faithful rendering of his spiritual discoveries.

It seems likely that Palmer's spiritual ardour was at its most intense during the time of his early acquaintance with Linnell and his introduction to Blake; the years 1823 and 1825. And if Linnell's influence led him to the minute study of natural forms then the influence of Blake was no doubt instrumental in showing Palmer how the observational and inspirational impulses could be creatively joined. Blake's advice to the young painter was to 'draw anything you want to master a hundred times from nature till you have learned it from heart.' Such advice could only mean to receive the image of a thing into one's very soul so that it can be freed from the incidental qualities of its material existence and re-cognized from an interior, visionary state of concentration. This assimilation of the knower into the known throws light on another entry in Palmer's 1824 sketchbook: 'Nature is not at all the standard of art, but art is the standard of nature. The visions of the soul, being perfect, are the only true standard by which nature must be tried'. Some years later, in 1845, Palmer was still referring to this process of inner purification as one of the essentials of artistic practice: 'It is almost impossible to do rightly or wisely. That conceit, self-complacency, and indolence, should be incessantly hunted out of the inner man'.

Blake further advised Palmer: 'You have only to work up imagination to the state of vision and the thing is done'. A. H. Palmer spoke of his father's 'vivid intensity of mental "vision" that preceeded the actual working of a design'. This faculty Palmer evidently shared with Blake. Indeed, the 'ripeness' of the things of nature's garment that is such a telling characteristic of the 1825 sepia works seems in itself to

be mysteriously consistent with the intensity of the painter's absorption in the imagery of nature. It is as if the sheer abundance of the latent spiritual possibilities that might exist between observer and observed, between man and nature, is suddenly unlocked and realised in a unity that is greater than their simple addition. This would explain the profound 'interior' stillness of these works, their lack of that climatic atmosphere which is the life-blood of a Constable or a Turner landscape.

A. H. Palmer wrote in his *Life* of his father,

> Judging by the hundreds of other examples I have of my father's work, executed before and since he became acquainted with Mr Linnell—judging by the most characteristic works of any period, it is possible to maintain that what made him 'singular among his fellows' ... was not borrowed from anybody but was essentially his own. Further, that his art is particularly remarkable for belonging to no school; and that his 'pictorial genealogy' cannot easily be traced through any other artist.

This judgement remains largely true. The efforts of commentators have only marginally traced his stylistic antecedents. Artistic sources alone could never adequately account for the sudden flowering of the six sepia works. There is nothing transitional about them; their style is as fully accomplished as their appearance is dramatic. The fact is that in his journals, notebooks and letters Palmer is nearly always speaking, in effect, of his attempt to visualise nature internally. Here was an artist, barely out of adolescence, yet already his own master, who had been granted a direct inspiration to record an hermetic vision of nature.

Palmer's stylistic achievement seems all the more audacious when we realise that it was also a challenge to the whole ethos of the modern intelligence with its bias in favour of granting a higher ontological status to the material than to the spiritual. The young Palmer was, by implication, striving to repair the rupture between man himself and the agnostic, nominalist view of nature as simply a mechanistic, external process devoid of any spiritual significance. Palmer has been described as a mediaevalist, and this is so to the degree it is understood that his contemplative approach to nature harks back to that of

the gnostic for whom nature is an intermediary between the human soul and the Divine Presence. To label him an 'idealist' is also true but only to the extent that his aspirations are seen to be meaningful in the latter context.

At least in these Shoreham works Palmer was a gnostic in that he looked to nature as the channel of grace which mitigates man's fallen condition and so narrows the gap between God and his creature. If art differs from nature it is precisely because of the need to bridge this gap, for the very multiplicity of nature, by turns ensnaring and dissipating the senses, divides us from the Divine Unity in which multiplicity itself participates. But in those arts in which the imaginative act is allowed its proper function, as Palmer understood it, unity is sought and recovered not by abandoning the immanent beauties of nature, but through the convivial stimulation they afford as energising the aspiration to reach their transcendent source: as he wrote to Linnell, 21st December, 1828;

> Terrestrial Spring showers blossoms and odours in profusion, which at some moments 'Breathe on earth the air of Paradise'; indeed sometimes, when the spirits are in Heav'n, earth itself, as in emulation, blooms again into Eden Still the perfection of nature is not the perfection of severest art: they are two things: the former we may liken to an easy charming colloquy of intellectual friends; the latter is 'Imperial Tragedy'. *That*, is graceful humanity: *This*, is Plato's Vision; who, somewhere in untracked regions, primigeneous Unity, above all things, holds his head, and bears his forehead among the stars, tremendous to the Gods!

Palmer's endeavour, especially during the Shoreham years, was analogous to that of the mystic who seeks truth *through* the world of appearances. The fact that mastery of the ego-bound self is not lastingly attained by artistic means should not disguise from us the significance of that spiritual nostalgia that floods both his writings and his pictures during this period. It leaves us with no option but to see Palmer's work in this analogous light. For Palmer art is a form of the pursuit of wisdom, and the attainment of Truth comes via the soul whose own pre-fallen essence is of the same substance as the energies that spread the 'fleshly curtain' of the world before our eyes.

Palmer's pre-occupation with light, for instance—'to bring up a mystic glimmer like that which lights our dreams'—is as much a concern with those consonances between the soul's faculties and their proper object, the self-illuminating interiority of things, the sacredness of their being, as it is with the 'material light' which must in some mode engage the painter. In an entry to his 1824 sketchbook written at 9 (o'clock) pm on 15th July he spoke of just such an 'inherent light' as seemed to make a thing 'luminous in itself' in his description of a tower observed in the summer twilight. Whereas natural objects merely reflect 'the gaudy day light of this world'. To penetrate beyond 'brute matter' to this interior illumination of things is to perceive 'a subdued solemn light which seems their own and not reflected, send out a lustre into the heart of him who looks—a mystical and spiritual more than a material light'.

To this painter's eye mass, line and extension are the harbingers of a qualitative mode of discourse. The 'abstraction' of Palmer's style in the sepia works is an attempt to deploy empathic symbols, imbued with the sentiment of personal emotion and the mystical overtones of a visionary intuition. Such symbols as would allow him to reveal the eternal face of things: 'After all, I doubt not but there must be the study of this creation, as well as art and vision; tho' I cannot think it other than the veil of heaven, through which her divine features are dimly smiling' (letter to Linnell, 21st December, 1828).

No truly symbolic language was available to Palmer, who was thereby obliged to adopt something of the naturalistic conventions of the art of his time. In practice this meant using, so to say, *natura naturata* to give a countenance to *natura naturans*—the ever-becoming forms of generated nature to show forth the eternally fecund source that gives birth to them, original nature. But little by little, and with the loss of the contemplative leisure the Shoreham years afforded him, the painter's eye was drawn more and more exclusively into an intensive study of natural detail to become, eventually, the observation of appearances. That is to say, visionary contemplation became absorbed imitation as the painter's eye became ensnared, woven into the living texture of the phenomena under observation. As we have seen, during the period of the 1824 sketchbook and the sepia works of 1825, in aspiring to render the spiritual essence of nature Palmer was confronting his own spiritual self. For as men envisage themselves so

they envisage nature. There is no such thing as a spiritually en-lightened soul that looks upon nature as part of a profane, mechan-istic universe.

All this is borne out by Palmer's writings as well as the pictures themselves. In the years that succeeded his Kentish sojourn he gradu-ally became solely pre-occupied with the rendering of observed effects as the spiritual ardour of his imaginative vision declined. And here indeed we do find 'transitional' works. In the Shoreham pictures that share something of the stylistic features of the six sepia works we notice a growing dependence upon naturalistic representation. By 1828 we have the Lullingstone Park tree studies that are almost wholly based upon observation, as well as such works as *Sepham Barn* and *Barn with a Mossy Roof*. By the time he painted *Pastoral with a Horse-Chestnut* in 1831-2 the abstract element of the sepia works is all but absent, and is totally so by 1833 in a work such as *The Gleaning Field*. In *The White Cloud* of 1833-4 and *The Bright Cloud* of the following year climatic atmosphere becomes a constituent of the landscape; and in *A Pastoral Scene* of 1835 something of the 'sublime' manner of Turner makes an entry.

By 1835, and away from Shoreham, in a work such as *Pistyll Mawddach, North Wales*, we see not only a total pre-occupation with depicting observed detail (even if recollected in tranquillity) but Palmer's mastery of it as well. His correspondence at this time shows him searching for 'views' to paint as he travels through Devon and Wales. Such mastery of 'realism' was to earn the painter Ruskin's approbation; he wrote (in the 3rd edition of *Modern Painters*), 'A less known artist, S. Palmer... is deserving of the very highest place among faithful followers of nature. His studies of foreign foliage especially are beyond all praise for care and fullness. I have never seen a stone pine or a cypress drawn except by him'. And this of a man who had written to Linnell in 1828, 'I will, God help me, never be a naturalist by profession'. Palmer's memoranda and journals of 1839-45 are full of notes of physical effects he had observed and prescriptive of how they might be rendered.

In the light of this development it is revealing to compare the vocabulary of his notebook entries. For instance, writing at Princes Risborough in 1845, after noting the inherent limitation of art to imitate natural effects, he concludes of his efforts that they 'should

perhaps only be considered as the *corpse* which is to be ANIMATED'. By contrast, an entry in his 1824 sketchbook, after speaking of possible subjects for pictures he might with the help of Christ's inspiration undertake, he writes, 'But smaller studies of separate *glories of Heaven* might be tried'.

In his *Catalogue Raisonné* of Palmer's work Raymond Lister draws attention to the fact that among the painter's favourite books was John Flavell's *Husbandry Spiritualized* (1669). The preface to this book contains the alchemical formula, 'That the world below, is a Glass to discover the World above'. The spiritual import of the formula Palmer would certainly have understood. But for the western artist the pursuit of nature in and through the imitation of her outward effects has always been problematic. Another Hermetic formula is 'Nature loves to hide'.

In other words, what constitutes the essential reality of a thing is not obvious to sensory perception. For nature is a kind of generative 'play', a form of cosmic magic so sustained in attunement to the senses that it produces the illusion of being permanent—of being a fixed reality. But the history of the idea that art should *imitare la natura* has over and over again demonstrated the illusiveness of nature's identity. The Renaissance re-discovery and application of perspective and the representation of physical space did not make the imitation of the reality we perceive any the less illusive. The development of pictorial styles from the sixteenth to the twentieth century illustrates nothing if not that sensible perception is never free from presumptive conventions in the rendering of physical appearances. Even with the advent of the humanist ideal of verisimilitude it took a long time for artists to really look at natural appearances.

Turner thought he saw nature at its closest in her moods of grandeur and sublimity. Constable sought to capture nature in the mutability of her habitat as providing the background to man's life on earth. Artists were still searching for nature at the time of the Impressionists. Monet thought he could capture her very impermanence and took the logical step, in his paintings of the façade of Rouen Cathedral, of trying to record her movement through the passage of time. For Seurat the true imitation of sensory perception required the atomisation of the spectrum, and hence of the artist's palette. With the Cubists nature was absorbed into the psychology of the cognitive

act: form is what you *know* is there and not what you see. It is obviously one thing to decide that art should imitate nature but quite another to determine quite what nature is. The history of post-Renaissance European painting can be seen as a series of attempts to answer this question.

It ended in the breakdown of the idea altogether; in abstraction. Finally, shape, colour and line are released from the necessity to represent anything but themselves and so become the arbitrary tokens of emotional volition. Had not nature, in keeping with its immemorial designation as illusive 'play' (*maya*), proved to be a chimera after all? And is not *natura naturata* precisely the 'phantasy' of *natura naturans*? Nature, true to its nature, proved as illusive as ever and in abstraction disappeared! It was then but a short step to concluding that abstraction is the appropriate manner of expression for the ineffable content of spiritual perception because it seems to accord so intimately with subjectivity. Here nature is redundant after all and our senses hopelessly deceptive in being unable to provide any sort of language appropriate to spiritual discourse. But if there is no possible analogy between the natural world we perceive and the veiled, spiritual reality we seek—between, that is, creature and Creator—then why at least in our creaturehood are we so evidently fitted through our senses for a world that turns out to be unnecessary? Why seek to be transformed by a supra-human reality if all that is needed is an act of psychological volition? In natureless abstraction the mind acts as if reality is given out from the human subject. But intelligence is nothing if it is not meant to *take in* reality. All this Palmer, at the height of his visionary powers, implicitly challenged and rejected. In so far as he has left a visual and written record of his struggle against the materialist bias of his time, so we understand that for him the Real is 'hidden' in the very forms that pre-determine the mode and manner of its actualisation. That is to say, nature, the theophany of the Creation, is nothing more and nothing less than a series of epiphanic moments prepared for the senses, like divine gifts to be transmitted in the interiority of the soul.

It has been necessary to rehearse something of the logic of the development of the imitation of nature in western art if only to clarify an area of misunderstanding with regard to Palmer's visionary

style. This concerns the view that Palmer's Shoreham works, and especially the six sepia works of 1825, look forward to the twentieth century. One must suppose that this is because several modern painters who have confessed to an admiration and an indebtedness to Palmer's work, have deployed a semi-representative, semi-abstract style. However, the stylistic 'abstraction' in the works of such painters as Sutherland, Nash, Minton, Vaughan, Reynolds and others can hardly be said to spring from the same source as the spiritual imperative of Palmer's attempt to express the hidden essence of natural forms. In the case of these painters the element of abstraction is the legacy of the breakdown of the notion of representation in western art so as to become merely a feature of their personal style. As such it is never anything more than of aesthetic significance and does not refer to anything beyond the intrinsic considerations of twentieth century pictorial innovation. Palmer's visionary style is inexplicable in terms of such a self-referring limitation that would in any case make nonsense of all he ever wrote concerning his intentions. Palmer's style was, so to say, forced upon him and in defiance of any contemporary convention and precedent of picture-making.

Moreover, it should be obvious that to speak (as has been done) of Palmer's landscapes as having an 'idealised content', or of their being in any way 'escapist' is to misconstrue both his intention and his achievement. In this case Palmer's 'abstraction' is taken to imply that his visionary style must be interpreted as accepting natural forms as a starting point for a development that becomes more expressive of personal emotion as it moves away from sensory perception. Such a misreading of his work could only arise from a one-dimensional view of perception not shared by Palmer himself. Palmer's abstraction does not seek to impose a surrogate 'reality' onto perception but to locate the Real *in and through* the particularity of the cognitive act itself. The 'escapist' is one who will not face the fact that the manifest world—'this outward perishable creation', as Blake called it—is the fleeting image, the shadow of an unmanifest and permanent Reality, what Palmer himself referred to in a letter to Leonard Rowe Valpy dated September 1864:

that mystery which cannot be commanded, that immaterial and *therefore* real image, that seed of all true beauty in picture or

poem falls into earthly soil and becomes subject in a great measure to the conditions of matter, and fails or fares as the soil permits—the desert sand; the ploughed field; the rich garden mould. To say that the seed does everything is fanaticism.

In the final analysis the imagery of Palmer's Shoreham works, and especially the six sepia works, is iconographic rather than abstract, their latent import hieratic rather than ideal. His inability to sustain the implications of this were as much due to the age and its artistic conventions as to any personal failure. His vision demanded an art impossible on the terms of his age. But he never lost sight of the vision he wished to attain even though he had not, in the end, been able to throw off the yoke of the 'naturalism' he so abhorred. He caught a glimpse of that far-off goal to which his visionary propensities had earlier driven him when he wrote to Leonard Valpy in 1875,

> earth hath not many things to show more fair than the west front of Wells Cathedral. It shows what Christian art might have become in this country, had not abuses brought it down with a crash, and left us, after three centuries, with a national preference of domesticated beasts and their portraits, before all other kinds of art whatsoever.

Of Punishments and Ruins

We are living even now among punishments and ruins.
Wendell Berry

IN a later chapter reference is made to a long and continuing school of radical thought that has questioned the very basis of industrial society. Any list of the protagonists of this 'school' might include Blake, Cobbett, Carlyle, Ruskin, Morris, Gill, Guénon, Coomaraswamy, David Jones, H. J. Massingham and Wendell Berry among many others. It has been the fate of these thinkers to have fought the lost cause that none the less prevails. Something of what constitutes the social and economic outcome of the type of mentality these writers felt themselves called to challenge is gathered together in the pages of Humphrey Jennings' *Pandaemonium*. By means of some 372 extracts from novels, diaries, reports, poems, essays, etc, from Milton to Richard Jefferies, Jennings has sought to illustrate, as the subtitle of his book has it, 'the Coming of the Machine Age as seen by contemporary observers'.

In a conversation shortly before his untimely death in 1950 Jennings is reported as having said that his choice of texts was entirely objective but that he found a theme emerging spontaneously—'that the coming of the Machine Age was destroying something of our life'. The collection as a whole presents us with a moving series of, so to say, 'snapshot' images of our contemporary predicament in the making. All the ingredients for the beleaguered and apathetic consumer society, the sense of alienation and defeat at the hands of uncontrollable events, are here in these extracts.

Their theme is nothing less than the gradual manifestation of the

post-Renaissance materialistic philosophy of man and nature as it unfolds and becomes tangible in its application to nearly every detail of life in Britain over the last three and a half centuries. If the machine is the antagonist in this drama certainly the victim is the soul of man, for here it is pitted against the remorseless onslaught of a reductionist and impoverishing ethos that is set on destroying the soul as an organ of truth, reality and being.

Given that this is the essential drama being played out in the historic events we name the Industrial Revolution, then a proper understanding of the implications of the action, a grasp of its real import, can only be had from 'above' the actual events themselves. For this drama is a spiritual drama with the impetus for the action coming from a source beyond the flux of time, the sequence of events, and the circumstantial conditions of their unfolding.

To recognise some insufficiency in Jennings' presentation is to do no more than to acknowledge that it takes a mind of the qualities and strength of a Blake, or a Coleridge, or a Ruskin to disentangle the dramatic narrative and discern the nature of its outcome. And that is why these authors stand out here with something of a prophetic eminence. They knew the depth and the extent to which this Revolution was the outward manifestation of an interior struggle of the soul to prevent its total occlusion. Indeed, it was the heroic struggle conducted by these and a few others, going against the grain of history, that makes it possible for us to envisage how it is in the nature of machine culture—left to develop freely and according to the logic inherent in its own possibilities—to require ultimately the abolition of man. This fact alone must be the sufficient explanation for the opposition the machine has so repeatedly encountered. As so many of these passages make plain, over and above the obvious crudity, exploitation and repression of the machine age, there was a feeling of irrevocable loss, an underlying sense that the organic thread as between the quality of the workman and the nature of his work had snapped. For the Industrial Revolution witnessed a change of the most fundamental order in the sphere of human action in which the primacy of being over doing was inverted. The subtle correspondence and interaction on several planes of being by which, hitherto, a man might show in his work what he is *essentially*—not accidentally or circumstantially—was eroded and replaced by a

mechanical technique of production that took no account of man's need to work in an environment related to his final end as a spiritual being. The 'luddite mentality' is not simply a primitive and blind opposition to progress. It is the instinctive and perhaps brutally inarticulate response to the encroachment of an inner impoverishment. That is why, periodically, there is a crafts revival. That is why the question posed and the challenge answered by hand facture remain with us.

So we have to ask *where* is this sense of loss felt, and against *what* is it measured? Why is it that the juggernaut of industrial production which promises so much on the material plane fails to satisfy us on a spiritual plane? Why are we not entirely grateful for the abundance it has produced? One thing is certain: if man were merely a creature without a soul—a higher primate without any spiritual dimension to his being—then he could have no possible grounds of objection to a system that more than ably satisfies his appetites. But he would thereby be a creature pre-determined and without free will. And if he had no power of choice then his every innovation and action in the production of material things would be for the best in the best of all possible worlds. But we know it to be otherwise. The simple fact that we are able to recognise the notion of fallen man presupposes an image of pre-fallen man and gives us pause for thought. In every thought, in every action there is a portion of our being that is witness to the thought and the act; is uninvolved in them. It is in this, the innermost part of the soul, where we must come face-to-face with the final term of what we purpose and all we achieve. Anything less is already conditioned by the external occasion for the action and cannot fully satisfy our need to know the ultimate good of the action in question.

The soul is, then, the stage where the meaning of our earthly existence is played out. The correspondence and harmony, or lack of it, between man and his outward environment may be reflected in the outcome of this internal drama but is not the substance of the drama itself. As so many of the extracts that make up Jennings' anthology show, this harmony was continually under threat during the period of the Industrial Revolution and it finally succumbed to the relentless pressure of that single vision which sees the passive operation of the rational mind upon the external world as the final term

and exclusive function of intelligence. Coleridge challenged the assumption:

> My opinion is thus... that all Truth is a Species of Revelation... Newton was a mere materialist. Mind, in his system, is always *passive*—a lazy looker-on on an external world. If the mind be not *passive*, if it be indeed made in God's image, and that, too, in the sublimest sense, the image of the *Creator*, there is ground for suspicion that any system built on the passiveness of the mind must be false, as a system.

The same secularising, passive mind of the Newtonian view that saw mere 'particles' of light, were for Blake grains of sand thrown against the wind by such as Voltaire and Rousseau to become every one, 'a Gem/Reflected in the beams divine'.

It is the myopic crudeness of the implicit assumptions of the materialists, that the created world can be understood on its own terms, that is so much in evidence in many of these passages. But the poets knew otherwise. The spirit of Romanticism, whatever else it did, carried the soul forward as in an ark on the flood of the materialist nightmare. Jennings, in a note for an introduction, wrote: 'The poets are the guardians of the Animistic system, the scientists of the materialist system'. The primacy of *res* over *cogitans*, of the outward thing over the inner apprehension, was the very signature of the new science. Wordsworth looked in vain for the place of the soul in the burgeoning industrial culture. He recorded his verdict in his Preface to the second edition of *Lyrical Ballads* of 1800:

> If the time should ever come when what is now called science, thus familiarised to men, shall be ready to put on, as it were, a form of flesh and blood, the Poet will lend his divine spirit to aid the transfiguration, and will welcome the Being thus produced, as a dear and genuine inmate of the household of man.

The implication being that it would not!

Commenting elsewhere on a passage of factual description from Robert Hooke's *A Method for Making a History of the Weather*, Jennings writes:

> Hooke is secularising the sky, or heaven, long thought of as a

divinity or the home of a divinity, its aspects exerting magical influence on the lives of man. He is making out of it the subject matter for a new science of meteorology: but in doing so he continues to use animistic language. The sky has 'faces' that are sometimes 'bearded or hairy'.

The 'single vision' of this process of secularisation, against which Blake later railed, is the beginning of that restless and endless elaboration of scientific formulae that soon becomes an unscalable edifice of quantitative knowledge; the separate sciences that study some aspect of the world of natural effects without reference to anything outside the limits of thought required for its own specialist study. It represents the increasing pluralisation of a nature in flight from the knowing subject. On a practical level it manifests itself in the multiplication of the means of living at the expense of making life itself banal. For the idolisation of quantity is nothing more than a sort of secularised parody of the mythic quest for the origin and source of eternal renewal. But in this case the unmanifest unity of being that is implied and presupposed by the multiplicity of things, and by which the things of this world have a certain transparency in respect of its metaphysical order, is lost to view. The rational mind, no longer able to penetrate a phenomenal world become opaque, is dazzled and mesmerised by the outward surfaces of things. In this mode of idolatry the mind is passive, enthralled before the wonders of experiments in optics, mechanics, chemistry, electricity, the worship of large structures, the fascination of fleeting images (as from the window of a speeding train, for instance); even the sensation of speed itself becomes a new wonder. Never mind the purpose of the journey, the sensation of fast travel is sufficient in itself. In a famous passage of withering condemnation from Ruskin the Victorian sage likens the rocky valley between Buxton and Bakewell to the Vale of Tempe where

> you might have the Gods ... morning and evening—Apollo and all the sweet Muses of the light—walking in fair procession on the lawns of it, and to and fro among the pinnacles of its crags. You cared neither for Gods nor grass, but for cashYou Enterprised a Railroad through the valley—you blasted its rocks away, heaped thousands of tons of shale into its lonely stream.

The valley is gone, and the Gods with it, and now every fool in Buxton can be at Bakewell in half-an-hour, and every fool in Bakewell at Buxton; which you think a lucrative process of exchange—you Fools Everywhere.

Ruskin had noted just one instance of how the single vision of the materialists had issued in a world seen to be merely a vast repository of matter that, given the opportunity (and to how few it came!), one could exploit for personal gain. The bond between natural 'resources' and economic speculation had gained an invincible hold upon men's minds. Now it is the motorways that convey us from town to town, city to city, each offering the same consumer goods (as often as not manufactured abroad), in the same shops, in places that daily come to seem interchangeable.

On one page we have a 'snapshot' of Sir Humphrey Davy bounding about the room in ecstatic delight at seeing minute globules of potassium burst through a crust of potash and take fire as they entered the atmosphere. On another page we have Benjamin Haydon in awe of the great dome of St Paul's announcing at once, as he thought, civilisation and power. But this idolatry, far from leading to a greater sense of realism, promoted insidious forms of abstraction in men's thinking. It is noticeable throughout Jennings' choice of texts how the philosophy of materialism ends in the worship of some abstraction. Most often it is a variant on the notion of the extremities of space or magnitude; the seemingly *infinite* reaches of space, the *aeons* of time, the *might* of the new productive power, the *wonders* of microscopic vision, and so on. A passage from Jeremy Bentham's *Constitutional Code* is alert to the development of this tendency to abstraction:

> Among the instruments of delusion employed for reconciling the people at the dominion of the one and the few, is the device of employing for the designation of persons, and classes of persons, instead of the ordinary and appropriate denominations, the names of so many abstract fictitious entities, contrived for the purpose. Take the following examples:
> Instead of Kings, or the King—the Crown and the Throne.
> Instead of a Churchman—the Church, and sometimes the Altar.
> Instead of Lawyers—the Law.

Instead of Judges, or a Judge—the Court.

Instead of Rich men or the Rich—Property.

Of this device, the object and effect is, that any unpleasant idea that in the mind of the hearer or reader might happen to stand associated with the idea of the person or the class, is disengaged from it: and in the stead of the more or less obnoxious individual or individuals, the object presented as a creature of fancy, by the idea of which, as in poetry, the imagination is tickled—a phantom which, by means of the power with which the individual or class is clothed, is constituted an object of respect and veneration.

It would be an easy matter for the reader to add to this passage his own variants within the framework of today's economic totalitarianism.

The 'phantom' upholding the whole productive enterprise of the machine age is of course the 'worker'. He is the fodder by which the mechanical operation is maintained, and least considered for his human qualities. Did not *The Times*, on 29th November 1814, boast that it was now printed, thanks to improvements in the mechanical design of the printing press, at a rate which 'far exceeds all human powers'—1100 sheets an hour! The result has all the remorseless inevitability of an inhuman logic and is announced with a considerable degree of pride at the achievement: henceforth, the worker was to be nothing more than a sentient part of the machine, an 'unconscious agent in its operation'. Soon he was not wanted even for that! In the age of the microchip, we are familiar with the robot, mass-unemployment, the 'leisure industry'. It was inevitable, and part of the system, that the worker would soon be 'surplus to requirements' whenever he was not actually engaged in the business of consuming what the very same system produces in mechanical abundance. Thus work is gradually but inexorably emptied of all hope of spiritual reward. No more is it the case that 'to labour is to pray'. No more is work to have its meditative core, whether in the silence of the activity itself or in the 'play' of the many dances and songs, for instance, with which the worker was once accustomed to intertwine his or her daily labour.

We are given a glimpse of this in an extract from Thomas Pennant's *Tour in Scotland, and Voyage to the Hebrides* of 1772. Here, that

subtle bond between the outward work and the inward being of the worker is still vital; but only just. After describing a group of twelve or fourteen women waulking cloth with their feet and hands, how their rhythmic working and singing rises to an almost demoniacal pitch, he comments:

> They sing in the same manner when they are cutting down the corn, when thirty or forty join in chorus. The subject of the songs at the Luaghadh, the Quern, and on this occasion, are sometimes love, sometimes panegyric, and often a rehearsal of the deeds of the antient heroes, but all the tunes slow and melancholy. Singing at the Quern is now almost out of date since the introduction of water-mills.

Who is now to say what this near demoniac possession held for its participants? What states of being were possessed in this manner in which the worker rises to a pitch that places him above and beyond the material occasion of his labour to catch some glimpse of the interconnectedness of worlds so that the worker inhabits a realm where the heroes and Gods of myth and folklore are his natural companions? In all tradition the skill and calling of the craftsman, as primordial worker, is divinely appointed. His task, having its signature from the highest source, is nothing less than to fashion his needs in this world after the model of the Gods fashioning the cosmos itself. We, on the other hand, released for 'higher things', have the transistor radio to distract us from the boredom of work in a world we find it hard to face.

Paradoxically, it is inherent in the nature of the machine that it so often leaves us with just those tasks still to do which it were better it had not created in the first place. All those soul-destroying jobs of mind-numbing repetition that the machine leaves in its wake actually constitute the drudgery it was popularly supposed it would eradicate. It may well be that much of the more onerous drudgery created by machines has now gone—and gone for good. Now every step forward of technological advance is introduced into our lives under the guise of *convenience*. But that convenience is only measurable in terms of an economic efficiency and has no regard for the self-fulfilment of the worker. When we speak today of 'creating jobs' we know we mean 'occupying posts'. Even those tasks most readily

at hand which contribute so much to the quality of our daily life—cooking, cleaning, gardening and the like—have been mechanised and so take on a certain element of mental drudgery, to be avoided whenever possible.

From the very beginning the industrial method seems to have had tyranny as co-partner. The harrowing memoirs of George Oldfield concerning his childhood (c.1842) in a Yorkshire factory, are a vivid reminder that only with the ready availability of a mass of dispossessed peasantry, hounded from the land by the enclosures, and herded into towns and cities, could such a system of tyranny function at all. The mass of workers were the basic raw material of the whole process. While such as Edward Fitzgerald and Michael Faraday could worship the Deity of Abstraction of Infinite Space and Time, there was no such abstraction to comfort those for whom daily life was increasingly one of real misery and squalor. These appalling external conditions notwithstanding, the resistance of the 'Luddite mentality' saw that a far deeper issue was at stake. There is almost no task whose demands cannot be made bearable if it is not offensive to the worker's reason, if the task is undertaken freely and has some meaning and offers the challenge of an ultimate accomplishment.

Having destroyed the organic link between the worker and his accomplishments the factory system needed the worker merely to expend his energies on tasks the outcome of which had little or no bearing on life except to postpone starvation. His was not the responsibility to decide *what* shall be made, or *how*. His was simply to slave irresponsibly at the behest of those who held the monopoly on profits. And slave he was by virtue of his dispossession however his lot was made more bearable by such as Robert Owen in his New Lanark 'Utopia'. Enslavement is not removed by benevolence any more than freedom necessarily abolishes discomfort.

Not to be deceived, Robert Southey, in his *Journal of a Tour of Scotland* of 1819, gives his verdict on the New Lanark Cotton Mill.

> Owen in reality deceives himself. He is part-owner and sole Director of a large establishment, differing more in accidents than in essence from a plantation: the persons under him happen to be white, and are at liberty by law to quit his service, but while they remain in it they are as much under his absolute

management as so many negro slaves.... But I have never regarded Man as a machine; I never believed him to be merely a material being ... why the end of his institution would be ... the destruction of all character ... the power of human society, and the grace, would both be annihilated.

Naturally enough the victims were by no means articulate as to the inherent meaning of their loss, but a passage from the 'Petition of the village of Raunds in Northamptonshire' of 19th June, 1797 touches upon the root of the matter, the 'rule of return' of organic husbandry, the sense of an organic interrelatedness and interpenetration between the conditions that govern human life on Earth and obedience to the laws of God as they are in the nature of those conditions:

A more ruinous Effect of the Inclosures will be the almost total Depopulation of their Town ... driving them from Necessity and want of Employ in Vast Crowds, in to manufacturing Towns, where the very nature of their Employment, over Loom or the Forge, soon may waste their strength, and consequently debilitate their Posterity, and by imperceptible Degrees obliterate that great Principle of Obedience to the Laws of God and their Country, which forms the Character of the simple and artless Villagers ... and on which so much depends the good Order and Government of the State.

The erosion of that same organic unity of life rooted in the transcendent was noticed by Wordsworth. In a letter to Charles James Fox, written 14th January, 1801, he drew attention to the

most calamitous effect ... the rapid decay of the domestic affections among the lower orders of society ... the evil would be the less to be regretted, if these institutions were regarded only as palliatives to a disease; but the vanity and pride of their promoters are so subtly interwoven with them, that they are deemed great discoveries and blessings to humanity These people have an almost sublime conviction of the blessings of independent domestic life.

By the time Ruskin reiterates something of the same truth seventy years later, in *The Future of England*, he spoke to a society that had but

the slenderest hold on the ancient Wisdom: 'Hand-labour on the earth, the work of the husbandman and of the shepherds;—to dress the earth and keep the flock on it—the first task of men, and the final one—the education always of noblest lawgivers, kings, and teachers'. Now that we have more tractors than labourers on our farms, now that we have the eroded soils of monoculture and our food and soil are contaminated with toxic chemicals, we could do worse than learn from the ancient organic wisdom to see the harmony and sufficiency of cyclical renewal replace the progressive surpluses of expansionist productivity.

The whole weight and impetus of the industrial juggernaut rested, and continues to rest, on two things: a view of nature and a view of man. They are inextricably interwoven. T. H. Huxley, in a letter to Charles Kingsley dated 30th April 1863, points to the conclusion of science as to the nature of the Creation. Extrapolating, as it were, on the notion of a 'dead nature' (the phrase is actually Charles Lamb's, taken from a letter to Wordsworth), Huxley writes:

> Whether astronomy and geology can or cannot be made to agree with the statements as to the matters of fact laid down in Genesis—whether the Gospels are historically true or not—are matters of comparatively small moment in the face of the impassable gulf between the anthropomorphism (however refined) of theology and the passionless impersonality of the unknown and unknowable which science shows everywhere underlying the thin veil of phenomena.

Here indeed was the paradox of the new quantitative science: that a nature self-evidently the giver and sustainer of all life according to the terms of its method must be to all intents and purposes studied as though it were without life. In the face of the diversity and richness of nature where at least we might conclude that appearances ought logically to be *of* a prior and unmanifest unity, the materialist mentality projects its own state of mind (across an *impassable gulf*?) upon the object of its study. Where Huxley's scientific eye fancied it saw *passionless impersonality* the poet's mind (that of William Blake in *A Vision of the Last Judgement,* c.1810) grasped a greater thing with imaginative comprehension:

'What', it will be question'd, 'When the Sun rises, do you not see a round disk of fire somewhat like a Guinea?' O no, no. I see an Innumerable company of the Heavenly host crying, 'Holy, Holy, Holy is the Lord God Almighty'. I question not my Corporeal or Vegetative Eye any more than I would Question a Window concerning a Sight. I look thro' it & not with it.

By what higher laws of truth has materialism, by the painstaking accumulation of scientific facts, replaced the vision of nature as one continued theophany?

Charles Darwin puts the case for the scientific view of man:

Man is an eating animal, a drinking animal, and a sleeping animal, and one placed in a material world, which alone furnishes all the human animal can desire. He is gifted besides with knowing faculties, practically to explore and to apply the resources of this world to his use. These are realities. All else is nothing: conscience and sentiment are mere figments of the imagination. Man has but five gates of knowledge, the five senses; he can know nothing but through them, all else is a vain fancy, and as for the being of a God, the existence of a soul, or a world to come, who can know anything about them? Depend upon it, my dear Madam, those are only the bugbears by which men of sense govern fools; nothing is real that is not an object of sense.

Darwin is here reported by Mary Anne Schimmel-Penninck in her autobiography. So we have this curious creature man, evolved biologically to have no other means of knowledge but through his five senses, a creature therefore wholly relative to and contingent upon his environment who yet has the power of absolute judgement in matters of reality and falsehood. And what is more (and for what purpose?) the trajectory of his 'evolution' has cursed him with the gifts of conscience, sentiment and imagination that lead him constantly into fields of deception and may yet prove to be the instruments of his undoing.

The consequences of the impoverished terms of this scientific view of the human self-image are even now being played out in our society—indeed, in the soul of westernised man. There is hardly a sphere of knowledge or field of action in the sciences and in the

humanities, which is not witness to the fact that modern man is faced with an unprecedented crisis. The internal drama takes place against the backdrop of world-wide insecurity and mass alienation. It is nurtured in a materialist culture such as ours in the displacement of that spiritual wisdom which saints, mystics and poets have perennially held to be the highest point of human endeavour. It is in the idolisation of progress whose chief instrument of persuasion, the machine, puts man at the mercy of a blind fate of seemingly irreversible catastrophe. It is in the barren gifts of the peddlers of information who have conquered education by the betrayal of knowledge. It is tasted in the idleness turned sour of the leisure state. It is in the apathy of a consumer society whose very consumption has the note of tedium. It is distributed in global pollution and the demoralisation of the working community. It could finally be unleashed in the triumph of naked power that is the nuclear holocaust. It is in all those things that continue to disfigure our present world and blight our hopes for a future one.

There are many protagonists, sub-plots and subsidiary themes played out in the extracts Jennings has collected. The erosion of human values by the encroachment of the cash nexus in all social transactions; the destruction of man's organic relationship to the environment by the imposition of the synthetic 'life-styles' of the city; the decline of work as a vocation and the rise of 'art' as a palliative; these and many others are the sometimes explicit, sometimes implicit themes in these pages. But one last 'snapshot'. These lines were written around 1808 by Coleridge in his 'Rationalism is not Reason':

> O! place before your eyes the island of Britain in the reign of Alfred, its unpierced woods, its wide morasses of dreary heaths, its blood-stained and desolated shores, its untaught and scanty population; behold the monarch listening now to Bede, and now to John Erigena; and then see the same realm, a mighty empire, full of motion, full of books, where the cottar's son, twelve years old, has read more than archbishops of yore, and possesses the opportunity of reading more than our Alfred himself; and then finally behold this mighty nation, its rulers and its wise men listening to—Paley and to—Malthus! It is mournful, mournful.

Work and the Sacred

Man is a slave in so far as alien *wills* intervene between his action and its result, between his effort and the task to which it is applied.

This is the case in our day both for the slave *and* for the master. Man never directly confronts the conditions of his own activity. Society makes a screen between nature and man. Simone Weil

WORK, whether as a topic of discussion, a fact of daily experience, or merely as a mental preoccupation, touches the lives of all of us. We argue endlessly over who should do what and how much; about what are the appropriate conditions for the performance of work; and above all what is the just reward for its accomplishments. We live in a society that has for some time now devoted a considerable effort to the eradication of work—at least as physical toil—only suddenly and paradoxically to discover, at a time of unemployment, that we need the dignity of work. Certainly we are heirs to the problems that work poses, even to the point of wondering whether it has a future at all. But in the midst of all the activity and preoccupation it engenders we seldom pause to reflect upon the essential nature of work.

Towards the end of her book *The Need For Roots* Simone Weil observes of modern civilisation that 'it is sick. It is sick because it doesn't know exactly what place to give to physical labour and to those engaged in physical labour'. This may seem at first hearing a somewhat unusual diagnosis of the malaise and alienation common to our age. But remember the phrase 'physical labour'. It is physical labour—merely quantified human effort, unrelieved by any qualitative satisfaction to transform it—that to Simone Weil is the essence of our sickness. She goes on:

Physical labour is a daily death.

To labour is to place one's own being, body and soul, in the

circuit of inert matter, turn it into an intermediary between one state and another of a fragment of matter, make of it an instrument. The labourer turns his body and soul into an appendix of the tool which he handles. The movements of the body and the concentration of the mind are a function of the requirements of the tool, which itself is adapted to the matter being worked upon.

She ends her book with the following two sentences: 'It is not difficult to define the place that physical labour should occupy in a well-ordered social life. It should be its spiritual core'.

This seems an audacious claim until we recall that meaningless work and soulless work are one and the same thing. Work imposed upon our lives so as to be meaningless we feel to be a burden that is contrary to our inmost nature—in some sense a denial of our very being. Yet work is man's very signature. It is said that by his fruits we might know a man. So the question we have to ask is not 'What does a man get *for* his work?' so much as 'What does he get *by* working?'

To speak of there being a 'spiritual core' to work is not only to invoke a certain image of man, it is also to hint at the existence of a subtle thread that joins the sacred to whatever demands are made upon man in order that he sustain his physical existence. It is to presuppose, in some way or other, that the spiritual forms the implicit context of our lives and that our being is not fully real without this hidden context. If this is not so then we would have to face an awkward question: how it ever came about that, in order to sustain his earthly existence, man should be obliged to follow a course of physical action that seems a direct denial of his deepest nature, as if by some ghastly mistake of his Creator it is man's destiny to follow a direction that leads him away from the very thing it is his nature to be? If we are to avoid such a dilemma, we must conclude that in some way work is, or should be, profoundly natural and not something that must be avoided or banished as being beneath our dignity. So, we are here concerned to enquire whether, in what ways and under what conditions, work possesses a contemplative dimension.

If we are to fully understand this dimension of work, we must lay bare its essence; what it is *before* it is conditioned by any social, moral or economic prescription. We must apprehend it as an inner

experience prior to any productive outcome it may have. We must isolate it from all the modes it assumes as a consequence of our presence in the world and which result in the obligations society imposes on us; obligations we discharge by working. These obligations can make such totalitarian claims upon us that we tend to lose sight of the immaterial significance that lies at the very heart of work.

The modern habit of equating work with time-consuming toil makes us prone to forget that it is *man* who is the instrument and the agent of work. Only man works. A horse may toil, as may a beaver. But only man can be liberated or 'uplifted' by working. Only man can be demoralised by work. And herein lies the danger of the work ethic of mechanised industry; that it makes an ethical absolute of our social and economic necessity to make and do things. In having no real and effective use for the intangible and pre-productive impulse that is at the core of work, modern industry loses the spiritual function of work. And in its tendency to push man to the periphery of the productive process it effectively loses man as well. In an environment in which man is subordinated to mechanical techniques it is all but impossible to experience the physical effort of work as the natural and inevitable medium through which body and soul effect the transformation of matter.

The problems and paradoxes of work that are all too evident in our society will only be resolved if and when we are willing to return to a spiritual anthropology, when we are willing to acknowledge our theomorphic self-image and restore our traditional constitution as beings that possess an integral threefold structure of spirit, soul and body.

In our threefold constitution all three states of the human microcosm are thought of as receiving their life and illumination ultimately from that which is uncreated and therefore 'above' that process of continual change and development that is manifest life. At the highest level the spiritual faculties of the soul act as a mirror reflecting the archetypal realities of the Divine Intellect. It is in the light of this level of reality that we contemplate the mystery of our subjectivity and discover it to be finally irreducible as an identity within the Divine itself. In the middle realm the faculties of the soul are bipolar; they act like a window that in one direction looks 'above', or inwardly, onto what is beyond our subjectivity as such. In the

opposite direction they look 'below', or outwardly, onto our sensory experience in order to localise or 'clothe' and give continuity to our psychological life. By means of these two directional impulses of the soul we map out the intelligible value of all our experience.

Finally, even though the substance of the body, as the living, organic sheath of our individual life, is renewed by physical matter, it none the less gathers the reasons of its purposes from the soul. Itself unilluminated, the body is the sustaining instrument of material transformation. But its bodily nature is only in harmony with the material world it inhabits when it is empowered to relate its actions and its appetites directly to the higher levels of being which give them meaning.

Work is the chief means by which the focal point of consciousness is concentrated 'outside' the individual's subjectivity. The effort of work is an act of transformation in which the worker has the possibility of rising to the level of those values and meanings that transcend the operations of physical life. It is this potentiality for transmutation that we should at all times keep in view in any consideration of what constitutes the essence of work. Whenever this potentiality is not present in the effort of work then our physical engagement with the world of matter becomes no more than a burden, and we become merely brute instruments in the manipulation of material substances. If this were not the case we could not even conceive of, much less experience, joyless, soul-destroying work. And such an experience is no less possible in the most mechanised and hygienic industrial workplace as it is in the most unremitting physical drudgery. However much we increase the effort, and however much we elaborate the mechanical means of shaping matter in the pursuit of production, we cannot escape the paradox that at its most meaningful and its most accomplished, work can provide us with an *inner* harmony and balance when those means are kept relatively simple and direct.

This paradox poses an important question in relation to the fact that the manipulation of matter exacts its price in the expenditure of both material and bodily energy. (The Latin *homo*, for man, incidentally, is closely linked with *humus*—of the earth—from which we derive our words *humble* and *humility*.) Should we not see, then, in this expenditure of energy, an in-built correlation between the finite

material resources of the world and the physical limitations of the human body? Should not this consumption of bodily energy awaken in us a recognition of and a humility towards our physical limitations, thereby setting a limit to our exploitation of the living body of the earth? In other words, ought we to consider whether there is a natural, integral correlation between the limitations of our bodily energy and the degree to which we should consume material resources in order to sustain ourselves, a correlation that should not be betrayed by any means of production that does not take account of the *inner* meaningfulness of work?

One of the most pernicious ideas that prevents us from realising the intimate relationship that should exist between work and our spiritual nature is an idea that has seemed almost impregnable to attack in western thought over the last three centuries, and even now shows little sign of exhausting the springs of absurdity it constantly draws on. It is the idea that art and work are and must be separate categories of activity. We have got into the habit of thinking of art as a separate category of aesthetic *feeling*, and so have also got into the habit of acting as if art were a separate category of *making* that is not directly related to the immediate demands of our physical life. We have forced an artificial division between the 'outer' and the 'inner' man which amounts to sustaining a pretence that human kind constitutes two races: that of man as artist and that of man as workman—as non-artist.

This is to fly in the face of common sense. Neither can it be said that the work of the workman—that is the work of utility—that it is necessarily non-beautiful in contrast to the work of the artist. Nor can it be said of art—that is works of refined sensibility—that it serves no human need. If we admit that man is a spiritual being then it is clear that he has needs and requirements beyond and in addition to his bodily needs. It is also clear that the integral wholeness of his being demands that he should not be divided within himself so as to serve his spiritual needs with one sort of activity and his physical needs with another. For the work of utility rightly done may result in a type of beauty that is informed by a refinement of sensibility, just as art inevitably involves some form of making and utility such as is characteristic of practical work. Just as there is no art without work,

so there should be no work without art, so that all who are actively involved in work should be in some sense artists. All artists are workmen. At least to the extent that each seeks to achieve some mastery over his material, to effect its transformation, and to the extent that such transformation, properly accomplished, will involve mastery over oneself. If we are to save ourselves from any division between our making and our thinking, in which our houses, the fixtures and fittings in them, our everyday utensils, our clothes and all the things we use daily are one part of life (produced industrially with the minimum of human agency), while we have a few 'art' objects (that are the expression of nothing more than the sensibility of the person who made them) to 'transform' another part, we must see such a state of affairs as profoundly unnatural and demoralising. Can we really believe that a visit to an art gallery, in our 'spare' time, is sufficient to compensate us for the meaninglessness of a humdrum experience of work unrelieved by any personal satisfaction?

If we are to recover the 'spiritual core' of work we should not only remember that to accept a division between art and work is to falsify our true nature, we should also remember that it is with man himself that any reform must begin, for man is greater than what he creates. In Philo's words, 'Even a witless infant knows that the craftsman is superior to the product of his craft both in time, since he is older than what he makes and in a sense its father, and in value, since the efficient element is held in higher esteem than the passive effect'. In reminding ourselves in this way of the anteriority of man's being to his work we also catch a pre-echo, as it were, of the relationship between the human context of work and the archetypal nature it mirrors. As Plotinus wrote: 'All that comes to be, work of nature or of craft, some wisdom has made: everywhere a wisdom presides at a making'.

Once we have recovered the idea that there is no unbridgeable gulf between art and work we can go on to consider the ways in which man is linked by his spiritual nature to the work of his livelihood. For if the sacred is not present in things at hand it is unlikely to be present at all. It does not function only in exclusive categories of thought and spirituality. The numinous, sacred essence of things is nearer to us than is our jugular vein—to borrow a phrase from the Koran. How can this be? Let us examine some of the words we habitually use when we discuss the relation of work to life. Wisdom

so often works in words like a preconscious, directive energy.

It is still just possible to speak of the workman as having a trade, or as following a vocation. The etymology of the word trade is uncertain but its root is possibly *tread*. What we tread is a path—a walk towards some goal. A trade, then, is a form of work or craft, an occupation conceived as a walk in life. From this we can see that the idea of a manual trade contains the sense of a vocation, and as such possesses the possibility of some form of realisation, by way of conforming a set of external circumstances to an inner imperative, an inner voice.

A vocation is, of course, a calling, and functions by virtue of an inner summons (and, incidentally, raises the question of *who* is summoned by whom?). The etymology of the word work implies the expenditure of energy on something well or finely made—made with skill. As such it points towards a kind of perfection of attainment in the human artificer. So, hidden in the word work we come again upon the idea of realising or attaining something above or beyond the mere expenditure of physical energy. Moreover, this attainment implies not only the rejection of certain possibilities and the adoption of others, it also implies (as Plotinus suggests) an inherent wisdom to make the choice that will permit the effective realisation of whatever is to be attained. Now, since strictly speaking there is no perfection in the created order of things, this perfection towards which skill inclines must belong to another order, a supra-natural order of things; precisely that towards which man is called.

The abstract Greek noun *techne* gives us, in its Latin equivalent, *ars*, meaning, in one of its general senses, a way of being. From the Latin *ars* we derive our word *art*. The Indo-European root of *art* means to fit together. *Techne* has the same root as the word carpenter (in old English a skilled worker is especially one who works in wood). The carpenter is one who fits things together. *Techne* means a visible skill in craftsmanship. But in Homer it is used in the sense of something in the mind of the artist—what later comes to be called imagination. And this sense of art as being a mental predisposition that stays in the artist was deeply embedded in our language until the seventeenth century, when it began to be applied to a select category of things made. So, permeating all the meanings that accrue to the language of work and art we have the sense of one who fits things

together: one who fits the domain of manual necessity to the order of a higher imperative. Certainly the symbolism and the mythology of the various sacred traditions, as they are connected with the arts and crafts, indicate that such is the case.

To stress the idea of art as an effective reasoning of the person who makes things, rather than applying it to an exclusive category of aesthetic objects, is not to suggest that there is no difference between say, the art of cathedral building and the art of the potter. (The difference is one of degree rather than one of kind.) That is not the point: which is that in all cases (and who would care to decide which was the most important art between say cathedral building, motherhood and agriculture), human making is a wisdom. In each an art is involved, and in so far as this involves the expenditure of effort, both mental and physical, it is a sacrifice—and one of the meanings of sacrifice is 'making holy', to perform a sacred ceremony.

The primordial meaning of human work, then, is to be found in the fact that it is not only a skill about doing, but that it also embraces a supra-human wisdom about being. Or, to put it another way, the act of making has a contemplative foundation at the heart of our being. And when we turn to the sacred traditions, whose expression in human artifacts is a constant source of wonder for their beauty and skill, we find that the workman or craftsman or artist does not receive his vocation from the material circumstances of his life but that his calling is from the highest source.

In the Indian tradition the source and origin of the craftsman's calling is derived ultimately from the Divine skill of Visvakarma as being revealed by him. The name for any art is *silpa,* a word that is not adequately translated by our words 'artist', or 'artisan', or 'craftsman' since it refers to an act of making and doing that has magical powers. In the context of the Indian tradition works of art imitate Divine forms and the craftsman recapitulates the cosmogonic act of creation as the artifact itself recapitulates the rhythms of its Divine source. By his action of making, and in conjunction with his practice of yoga, the craftsman as it were reconstitutes himself, and thereby goes beyond the level of his ego-bound personality.

In the craft tradition of Islam certain pre-Islamic prototypes were preserved and came to be connected with parables in the Koran and with certain sayings of the Prophet. Speaking of his ascent to heaven

the Prophet describes an immense dome resting on four pillars on which were written the four parts of the Koranic formula—In the name—of God—the Compassionate—the Merciful. As Titus Burckhardt has pointed out, this parable represents the spiritual model of every building with a dome. The mosque in Islam is the symbol *par excellence* of the Divine Unity, the presiding principle of Islam itself. The mosque thus acts as the centre towards which the arts and crafts of Islam are orientated in virtue of its involving so many of them. From the construction of the mosque the crafts, as it were, flow, since architecture, along with calligraphy, is the supreme art of the Islamic revelation.

In Islam the crafts were organised around guilds which were themselves closely connected with Sufism, the esoteric dimension of the Islamic faith. Similarly, the guilds of mediaeval Christendom employed a symbolism and a knowledge of a cosmological and hermetic nature. The symbolism of the crafts in the Christian tradition take as their starting point the person of the Christ who was himself a carpenter. (The Christ of the trades appears as a carving in many English Parish Churches.) It may be argued that the highest sacred art of Christianity is the icon—the re-presentation of the Divine image. But alongside this is the craft tradition, pre-Christian in origin, which is above all cosmological in its symbolism, beginning with physical space as the symbol of spiritual space, and the figure of Christ as Alpha and Omega, the beginning and the end, the timeless centre whose cross rules the entire cosmos.

Such symbolism is innate to the arts and crafts—which is to say, the livelihood—of past civilisations, and has a ubiquitous presence in the physical artifacts of people's lives. All crafts and trades, from ploughing to weaving, carpentry to masonry, metal work to poetry and music, are traditionally interwoven with their transcendent principle. Here is one such witness to the fact, from K. R. T. Hadjonagoro's *Batik, Fabled Cloth of Java*:

> [Batik] was a vehicle for meditation, a process which gives birth to an uncommonly elevated sublimity in man. Truly realised beings in the social fabric of Javanese community all made batik—from Queens to commoners.... It is almost inconceivable that in those days batik had any commercial objective.

People batiked for family and ceremonial purposes, in devotion to God Almighty, each man's endeavour to know God and draw near his spirit.

According to Genesis, work is the result of original sin. None the less, for the Christian there is always the exemplar of God 'who made the world and saw that it was good'. Against this there is the counterpoint of a recognition that His Kingdom is not of this world, so that man, who has some remembrance of the Divine Paradise of his origin, retains the possibility in his work of travelling the path back to God, for 'there is no faith without works'. (James 2:26)

Between these two perspectives the earthly destiny of man takes place. What proceeds from the Divine Principle is good; the archetype of perfection is the unmanifest reality of the Divine Principle: 'Every perfect gift is from above, and cometh down from the father of lights'. (James 1:17) The following passage from H. J. Massingham's *The Wisdom of the Fields*, (1945), indicates something of the remarkable longevity of this idea:

> The most eloquent example I know of this inborn and indwelling principle comes from Droitwich where lives a cabinet maker named Fowkes. For in him it has become conscious and part of his philosophy of life. He made a small oval hand-mirror in mahogany scrap-wood for the wife of a friend of mine. When my friend called for it, he disclosed his belief that the crafts were originally divinely bestowed and the gifts had ever since been passed on from father to son. In support of this hereditary theory he told my friend that his grandfather on the mother's side was renowned in his day as being one of the finest workers in veneer and inlay in England. He himself had known nothing about veneer work. One day he 'felt the itch' to do it and immediately and with ease, so he said, accomplished it. Having discovered that no trial and error nor self-teaching were necessary he derived his proficiency from his grandfather.

In all human work the archetype is a prior knowledge or wisdom in which resides the Divine prototype or perfect model of any particular act of making.

The vision of the Divine prototype as a wisdom inherent in the

actual tools of trade is beautifully evoked in Exodus (Book 25), where, after describing in some detail the making of a sanctuary, Moses is urged that it be done, 'According to all I shew thee, after the pattern of the Tabernacle, and the pattern of the instruments thereof, even so shall ye make it'. But on the indefinite number of possibilities capable of being realised it is the burden of work to place a limitation, since all work involves a pre-conception or image that is subsequently shaped to a determined end. Without this pre-conception and its subsequent determination there would be no distinction of means from ends. Work would be sufficient unto itself. But as Aquinas points out, 'As God who made all things did not rest in those things ... but rested *in* himself *from* the created works ... so we too should learn not to regard the work as the goal, but to rest from the works of God himself, in whom our felicity lies'. Work is the imposition of order on matter, matter transformed by human intention and will. The true workman does not work merely to perfect the operations of work itself, but according to an inner order that is his perfect nature. That is why the worker must be free to become the very thing he makes. As Eckhart says,

> The work that is 'with', 'outside', and 'above', the artist must become the work that is 'in' him, taking form within him, in other words, to the end that he may produce a work of art in accordance with the verse 'The Holy Spirit shall come upon thee' (Luke 1:35), that is, so that the 'above' may become 'in'.[1]

It follows that if the artist or the workman is to achieve perfection in his making he must let nothing come between his conception of what is to be done and its execution. And this conformity of his being to the final realisation of the work is the primordial model of human workmanship. It implies that work is, in essence, for the sake of contemplation, just as much as it implies that the perfection of work is achieved only at the expense of self-consciousness. As the Japanese potter Hamada puts it: 'You have to work when you are not aware of self'. In work perfectly realised there is no thought of reward, no love of procedure, no seeking after good, no clinging to goals, whether of attainment or of God himself.

1. *Treatises and Sermons of Meister Eckhart*, trans. by James M. Clark and John V. Skinner, (1958), p.251.

Eckhart, in a sermon on justice, gives a further clue as to how our work and our being are interwoven; how, essentially, our work is to *be* and our being *is* our work:

> The just man does not seek for anything with his works, for those who seek something with their works are servants and hirelings, or those who work for a Why or a Wherefore. Therefore, if you would be conformed and transformed into justice do not aim at anything with your works and intend nothing in your mind in time or in eternity, neither reward nor blessedness, neither this nor that; for such works are all really dead. Indeed I say that if you make God your aim, whatever works you do for this reason are all dead and you will spoil good works Therefore, if you want ... your works to live, you must be dead to all things and you must have become nothing. It is characteristic of the creatures that they make something out of something, but it is characteristic of God that He makes something out of nothing. Therefore, if God is to make anything in you or with you, you must beforehand have become nothing. Therefore go into your own ground and work there, and the works that you work there will all be living.[2]

As if to expand and annotate this passage from Eckhart we find at the end of Plotinus's Fourth Ennead the following:

> All that has self-consciousness and self-intellection is derivative; it observes itself in order, by that activity, to become master of its Being: and if it studies itself this can mean only that ignorance inheres in it and that it is of its own nature lacking and to be made perfect by intellection.
>
> All thinking and knowing must, here, be eliminated: the addition introduces deprivation and deficiency.

None of this is in any way meant to deny that our acting upon a material substance is conditioned by that substance proceeding through our senses. But at the very core of the act the senses are not consciously involved and there is an immediate and unconditioned intuition in the soul of the timeless source of action: something that

2. Clark and Skinner, op. cit., pp.53-4

is not part of the act of making as the dead centre of a hub does not take part in the rotation of the wheel. And no degree of perfection in work is attained that does not touch upon this stasis of Perfection itself. That is the spiritual function of skill. No perfection is embodied in that which is unprepared or insufficient, for like is known by like, and skill in the execution of work is first of all a skill residing in the workman. The skilled maker intuitively knows that the perfection of his work rests upon his own being and is not determined by external circumstances. It is the worker's own lack of self-discipline that prevents the perfect realisation of his task. It is just this interior perfection of being that the crafts, with their tools as an extension of the physical body, serve and which the machine destroys. The tool nurtures the integral relationship that lies at the heart of all work; the total freedom of potentiality in physical effort corresponding with the necessary determination inherent in perfectly realised workmanship. Such is the 'spiritual core' of work. H. J. Massingham recorded the living process in his *Shepherd's Country*, (1938); watching a craftsman who was making a traditional Cotswold, five-barred gate or 'hurdle', he wrote:

> The intrinsic contact with his material must and does humanize him and unseal the flow of the spirits. He seemed to be talking to his wood as well as to me, and sometimes he forgot I was there It would be meaningless to say that such a man as Howells loved his work: he lived in it.

We mentioned earlier that the word *homo* (man) is connected with *humus*, and has important ecological implications. Man is quite literally 'of the soil', his life is sustained hourly and daily by what the soil provides. All traditional cultures have been sustained by the crafts, especially agriculture. By virtue of their being intimately rooted in a specific geographic place, and so to the specific set of social, material and ecological circumstances that provide the formal occasion and substance of the means of livelihood, the crafts conserve the natural environment. This is so because the crafts are in turn tool-based. The tool is a conservative instrument of manufacture precisely because of its intimate relationship with the bond that unites hand, eye and the intuitive sources of skill.

Skill is to some extent cumulative. It is born of circumstances that are relatively stable and it flourishes in the context of tried and tested ways of doing things. We can only measure skill against a given set of conventional procedures and a pre-determined end. We cannot determine whether a totally new procedure is skilful since the novelty of the method required for its accomplishment will be outside any convention and will be unique to the occasion. The worker cannot test himself against a set of circumstances that are unknown to him. For which reason the constant search for novelty and innovation in work demoralises the worker (as indeed it has demoralised the 'artist' in our time). Constant innovation must eventually undermine the conventions and social occasions that unite the worker and his patron—not forgetting that all workman are also patrons.

There are profound reasons why the crafts tend not to elaborate the means of production away from the elementary procedures of hand-tool skills. To do so has the effect of diverting the operation of the worker's skill away from the perfecting of his inner resources, and diverting it towards the external, instrumental circumstances of the means of production. When this happens, as we see today in the almost total uniformity of the machine-made infrastructure that surrounds us, the natural world that sustains us is eventually reduced to no more than so much raw material, to be plundered regardless of any ultimate outcome. We should not be surprised that such an amoral and indiscriminate view of the material context of work has slowly lead us to poisoning the environment. The crafts, on the other hand, are far more likely to be materially sustainable. They tend not to work against the interests of man and nature but integrate the rhythms and substance of both while at the same time opening a door internally upon states of mind and of beauty that transcend the necessarily physical conditions by which life proceeds.

The fact that in the mechanised, industrial milieu men confuse *needs* with egotistical appetites and have great difficulty in imposing any restraint upon them is itself a demonstration of that same milieu's amoral irresponsibility in seeking infinite expansion of consumption in a world of finite resources. When we speak about our needs we have to remember that they are determined not by our appetites but by our nature as spiritual beings. It is in virtue of the intuition of our spiritual nature that we understand who we are. Which is to say we

understand that we are not, as creatures, sufficient unto ourselves but are beings who are called to perfect ourselves. That we are able to regard our appetites, our passions, our desires, objectively as *part* of our nature proves the possibility of our being raised to a level above them. And this obliges us to recognise that whatever is required to bring about our human perfectibility constitutes our needs. As Plotinus says: 'In the matter of the arts and crafts, all that can be traced to the needs of human nature are laid up in the perfect man'. To labour is to pray. When work is truly for the sake of contemplation it carries the same import as a passage of scripture. The work of Gothic cathedral builders speaks with the same voice as Gothic spirituality. There is as much a message of non-attachment to the ego in a Sung vase as there is in a Zen text.

To make something by hand is a relatively slow process, it requires commitment, patience, aptitude and skill such as is usually gained over a period of gradual mastery, during which the character of the worker is also formed. The tool draws upon the unwritten and accumulated wisdom of past usage. The hand, and its extension, the tool, challenge the inner resources of the workman in a direct way. His mastery of the working situation must operate so that there is a vital accord between mental concentration, physical exertion and the material properties of the substance worked to the degree, as we have seen, that the workman lives *in* his work. What he produces is vibrant with a life and a human signature that is missing from the uniform products of the machine. Why else should we feel nostalgia at the artifacts of the past but for the fact that they have been invested with a quality of human involvement that is so evidently absent from the mass-produced products that surround us? We feel in such artifacts something of the pulse that is common to the pulse of our own being.

By contrast, the mark of the machine product is its uniformity. To the rhythms of life and the rhythms of nature the machine is indifferent, if not disruptive. Although the development of the machine is based upon a cumulative, technical knowledge, for the machine operator there is no wisdom of past methods of production. The machine has no 'history' since it is continually updated by technical innovation, so that it cannot be an instrument of human continuity. The organic link that binds one generation to another in mutual inter-

dependency is thus severed by a quantitative mechanisation that responds only to the economic imperative. The continual technical development of the machine projects forward to an uncertain future and is disruptive of those natural rhythms of renewal and consumption that tend to be conserved by the tool. In a craft culture, which is in a sense a flowering of nature that addresses itself to heaven, production fosters the primary human qualities of resourcefulness, self-reliance and moral integrity in the context of man's obligation and responsibility to his natural environment. What in the tool is the possibility of a reciprocal rythmn of exertion and contemplation open to the spiritual dimension, becomes with the machine a sort of diabolic ingenuity and contrivance that stifles the soul through an inimical, mechanical pace. In other words, and by way of summary, the tool produces *according* to human needs, the machine *regardless* of human needs.

Nothing is easier than to point to the many ways in which life has been made easier by the machine. But are these benefits such that we may have full confidence in the direction and final goal towards which the machine blindly forces us? There is little point in arguing that life is now more comfortable and convenient for the mass of men and women (which is far from being incontrovertible in any case) than it has ever been before if we do not consider at the same time the ultimate price of this achievement. Our progress is towards a future that no one can accurately envisage, let alone claim to determine. Are we to accept unquestioningly this blind enterprise?

In looking back to the craft cultures; in recognising the essentially spiritual character of the arts and crafts of the sacred traditions; in studying tool-made artifacts as a repository of wisdom through the means of symbolism and initiative practices, there is no need to deceive ourselves that such things can be re-instituted by our simply wishing it to happen. We know that this cannot be the case. Our world has not yet finished with its self-mutilation. But in so far as we are human and able to recognise for that very reason that we are made for that which is greater than our own productions, so we must address ourselves to the truths above and beyond the fact of our historical circumstances. By that much we may avoid falling victim to historical fatalism.

If we are to seek some ultimate cure for the sickness Simone Weil

spoke of then surely we must first establish the nature of the disease. The very least we might achieve in taking stock of past cultures of people for whom work and the sacred were an organic unity is to have, in a positive sense, some measure of what we have fallen from. Rather this, surely, than to conclude negatively that we are merely the victims of events we have neither the power to control nor the will to understand. The dominant forces at work in our society would have us believe that the next step in our technological development will rid us of our work altogether. That such a utopian dream should go hand in hand with the possible destruction of man himself is no coincidence. It is certainly the projection of a false image of our nature. If we are to offer any effective resistance to this dream it can only be on the basis of our understanding of how the 'spiritual core' that is the heart of workmanship both fosters and safeguards the inter-relationship between man and the sacred.

Eric Gill's Radical Critique of Industry

It was not so much the working *class* that concerned
me as the working *man*—not so much what he got *from*
working as what he did *by* working.
Eric Gill

T HE idea that Eric Gill stood in resolute opposition to much of the modern world needs no rehearsal. What has hardly been attempted is a review of the principles that underlie the arguments he so vigorously espoused. It is not difficult to see why this has been so. To accept in any degree what would be the outcome of adopting these principles would entail the upheaval and rearranging of much mental furniture, as well as removing a good many cherished practical and social conventions, not to mention the vested interests of the status quo. On the whole his critics, in thrall to historical determinism in one form or another, have preferred the blandishments of 'progress'.

It was the social historian R. H. Tawney, in his *The Acquisitive Society*, who reminded us that, 'it is a commonplace that the characteristic virtue of Englishmen is their power of sustained practical activity, and their characteristic vice a reluctance to test the quality of that activity by reference to principles'. Both because of its progressively dehumanising effects and its internal contradictions it was inevitable that in due course the industrial, mechanised model of society would be tested against first principles. Indeed, from William Blake through Cobbett, Carlyle, Ruskin and others, and up to Morris, Lethaby, Edward Johnston and H. J. Massingham, a good deal of analysis and disquiet had been sounded.[1] But not until the polemical writings of

1. See also the author's introduction to *A Holy Tradition of Working, passages from the writings of Eric Gill*, (1983), pp.7–34 which traces in more detail Gill's indebtedness to the radical thinkers who were his masters.

Gill, building on the work of his predecessors, do we meet with a testing 'by reference to first principles' that is adequate in scope and sufficiently radical to penetrate to the roots of the problem.

In order to forestall any impression that Gill adopted a doctrinaire approach to matters of life and work a note of clarification is called for. Much of what Gill wrote will not now bear examination—for various reasons. However, what might be called his 'philosophy of art' can be found at the core of his writings. This is not a collection of opinions aimed at expressing a personal 'point of view'. Here, Gill is not (to quote his mentor Coomaraswamy) '"thinking for himself", but assenting to credible propositions'. His philosophy is formed of a body of doctrine whose internal consistency affirms (again, to borrow a phrase of Coomaraswamy) a 'self-authenticating intelligibility'. That is to say, the doctrines remain valid as they remain true of the doctrine of art and work accepted by the greater part of mankind throughout history. In this he was fundamentally out of step with the modern world. That he was unable, despite his protestations to the contrary, to throw off his critics' accusations of 'medievalism' resulted from their failure to understand that he was not calling for the re-instatement of an antiquarian mode of life and art, but a truer, and therefore real and effective, change in our perception of reality.

At the centre of Gill's vision is God; and all things are subordinate to that overarching and enduring Reality. This fact distinguishes him from, let us say, William Morris at the centre of whose scheme of things is an *imagined* earthly paradise never to be adequately realised in the affairs of men. There is nothing of the dreamer in Gill.

Gill escaped both the 'dream' of much of the Arts and Crafts Movement on the one hand and the aesthetic relativism of what he called 'art nonsense' on the other by turning to scholastic and traditional doctrine. The Scholastics were careful not to grant to the notion of art a too subjective autonomy, as if guarding against the danger of a false pride in its achievements, and of ascribing too high a status to aesthetic experience. Art must humbly take its place in the operations of nature as an analogy of God's creative power, since art has no ontological power to create the Real as such. Traditional doctrine resists the attempt to centre the supreme moment of human experience in anything made by man as usurping the supreme Reality that is God himself.

To begin at the beginning.

It is absolutely necessary to have principles, that is things that come first, the foundations of the house.

What we want to know is: what principles of commonsense are relevant to the matter of human work

What principles are in harmony with divine revelation and in harmony with the conscience of man and the light of human reason. (MM115)[2]

Such principles are not derived from the 'facts' that furnish statistical prediction any more than they are general rules derived from pragmatic action, but are the truths on which contingent actions rest. Being no part of that action they are not open to dispute on the basis of expediency. We 'see' or judge the merit, or otherwise, of actions in the light of first principles in order to conclude that action cannot be its own justification. The 'way' or purpose of life's journey is not the study of directional signposts.

Gill's first principles are clearly and unequivocally stated:

In the beginning God created Heaven and Earth, and in the fullness of time—man. God is a trinity of Persons: Father, Son and Spirit (these names indicate as nearly as words may, in the paucity of finite speech, the eternal relationships of the divine persons . . .), and corresponding with the Three Persons of the Blessed Trinity are the metaphysical categories, Truth, Goodness and Beauty, and all things are definable in terms of the Threefold Divinity who created them. Man therefore is to be defined in terms of the 'what', 'why' or 'how' of his existence. (AN65)

For Gill, as for all traditional thought, it is axiomatic that the norm of our humanity resides in the Divine Principle within us and which it is our vocation to realise.

2. Abbreviated titles of Gill's books, followed by the page number, are as follows: ACC, *Art in a Changing Civilisation* (1934); AN, *Art Nonsense and other Essays* (1929); AU, *Autobiography* (1940); BLH, *Beauty Looks After Herself* (1933); LE, *Last Essays* (1942); MM, *Money and Morals* (1937); NB, *The Necessity of Belief* (1936); UT, *Unholy Trinity* (1938); WL, *Work and Leisure* (1935); WP, *Work and Property* (1937); ISL, *In a Strange Land* (1944); SS, *Sacred and Secular* (1940).

The nature of man is likeness to God—for God created him in his image. He is a rational soul. The purpose of his existence is to know God, to serve God and to love God on Earth and be with him eternally in heaven. The manner of man's existence is incarnation. He is spirit and matter! (AN65-6)

Either this or we descend to such sub-human behaviour as is demanded by our egotistical appetites. Everything Gill wrote has behind it this affirmation of our Divine vocation—the purpose of his 'polemic' to promote this our birthright.

Time and again Gill makes it perfectly clear on what terms it must be understood that man 'is created in the image of God'. It is in virtue of the incarnation that it is so and that all men are artists. Gill is invoking the metaphysical and perennial analogy of man the maker, the artist, acting in imitation of God the Creator.

The Incarnation ... being the act of God It is the greatest of all rhetorical acts and therefore the greatest of all works of art ... from His creative power all art is named In the Incarnation ... we behold a work of art, a thing *made* It is as a work of art that It has saving power, power to persuade, power to heal, power to rescue, power to redeem. (LE9)

The doctrine is stated by Boethius in his *Consolation of Philosophy*:

For as a workman anticipates the form of anything in his mind then puts the work in hand, and executes by stages in the order of time that which he had simply and in a moment conceived, so God by his providence disposes.

And by Plotinus in the Fifth Ennead:

The crafts which give us matter in wrought forms, may be said, in that they draw on pattern, to take their principles from that realm and from the thinking there [in the Intellectual Cosmos]: but in that they bring these down into contact with the sense order.

The traditional doctrine fully allows for an obvious difference. It is said that God created the world *ex nihilo*—from no-'thing' so called. That is, God creates from the 'nothing' that is his own uncreated and

Divine interiority. Analogously, man creates with what already exists, directing the impulse of will through the practical intelligence, which *habit*, the very principle of all making, stays within him. Thus the thing he makes outwardly in the 'sense-order' is properly called a work *of* art, *of* skill.

Gill's constant re-assertion that 'art' is 'skill' and that 'art abides entirely on the side of the mind', is the single most conspicuous principle in which he differs from modern aesthetics. His reiteration of this root meaning of the word 'art' as an inner disposition to the right making of a thing rests firmly on a tradition that stretches beyond Aristotle, but which was eventually given its most extended formulation in the treatises of the schoolmen. Art is an unwavering quality of the mind that seeks to perfect the operative efficiency of an intellectual activity when it informs the deliberate act that is the good making of something. Gill's most obvious source for the doctrine was Jacques Maritain's *Art and Scholasticism* (1930).

If it is said that we must 'seek first the Kingdom of God and *His Justice*, [our emphasis] and all things shall be added to you', then does not this injunction deny that man is first and foremost a creator, an artist? Man is spirit as well as matter and any 'seeking' he does must necessarily take into account the formalities that are part and parcel of his bodily existence. But the injunction refers to 'His Justice', so that, if we bear in mind Plato's definition of justice (*Republic* 370c) as being the liberty of each man to follow the vocational skill that is his by nature, that *is* his nature (the *Bhagavad Gita* says the same thing), then we begin to see how this turns back to the analogy of man as created 'in the image of God'. To seek first God's Kingdom and His justice cannot be done other than by means of and according to the proportion of our gifts to realise what it is our vocation to *be*. Thomas Hennell, a younger contemporary of Gill's, in his *The Countryman at Work*, recorded the living process:

> One could not come away from the basket maker without feeling in a serious and unusual way, that what is meant by grit and ... character has ... to do with such men as this: who really never have admitted defeat, who still persist in the ... task of making something of common use rather better, and all the time with less profit to themselves out of it, than those who rule and those who patronise them.

Such 'grit' is a man's nature, what is native to him: *natura*—birth; his nativity or inborn character, what he (or she) is born to fully realise and which cannot be attained other than by occupation of the 'kingdom of heaven' that is within.

How does Gill relate this profound conception to its necessary corollaries, free will and responsibility? For there cannot be justice, finally, in any situation in which man is not free. And there cannot be a true freedom for man that does not entail responsibility.

So: man is made in the image of God.

> That is to say, we share in God's spiritual nature. We are rational beings and can deliberate and weigh the pros and cons of action; and having thus weighed, we can act freely. Whether or not we can do good of ourselves, we can certainly refrain from evil ... for we are, in this religious view of man, more than just animals without responsibility ... if we are children of God, then we are heirs also. We are called to some sort of sharing with God in his own life. We have what we call a *vocation*. (LE41-2)

The word *vocation* comes from the Latin *vocatio*—which is a calling, a summons. We speak of a person's craft or trade as a calling, not always realising that the word trade derives from tread; so in following a call or summons one treads a path. And paths are trod in the expectation that some end is anticipated, some goal is to be reached. Moreover, there cannot be a path except it serves as a way through that which is other than the path itself—the obstacles and vicissitudes encountered along the way. 'Work is the discipline (the yoga) by means of which "body holds it noise and leaves soul free a little".' (ISL92) The path of a vocation along which a technique is practised and perfected, is analogous to the spiritual path we must tread in order to master those accidents of our personality that distract and detract from our progress along the way of life. Whether in the form of inadequacy in meeting outer obstacles, or as inner failings, such accidents of our personality cannot be the goal we are to attain. They are that through which the way must pass. The goal of our striving cannot be our own idiosyncrasy. It is the purpose of our will to urge us along the path of vocation, not to obscure the path from what surrounds it. The final end to which our vocation summons us

is precisely that we should accept the responsibility of perfecting our will, a perfection that is coincident with the nature of God's will— the true nature and purpose of things.

> It is to be expected that all human beings and all races will look to the same
> Now the end of the human race, the end to which all activity is directed, is the discovery and grasping of the real. However variously this aim may be described or pursued; however erroneous may be the conclusions of reason; however distasteful may be the material achievements of one people to a people of another time and place; nevertheless Reality, what is real and not illusory, is what is sought by each and all. (BLH 208-9)

Man, *homo faber*, is then, a creature for whom freedom inheres in the exercise of the practical intellect directed towards some outward making, and for whom responsibility inheres in the choice of what is to be made in the light of man's proper nature and final end. That is why,

> What a thing *is*, what things *are*, and, inevitably, whether they are good or bad, worth making or not, these questions bring him without fail to the necessity of making philosophical and religious decisions. (BLH 226)

For, St Thomas says, 'art is a kind of knowledge by which we know *how* to do our work'. It is not a knowledge of *what* we need, and therefore cannot tell us what we *ought* to make. Without a firm hold upon the philosophic and religious archetypes the decay of man, and therefore human art, will follow. This in turn weakens men's grasp of the motives for action and the manner and mode by which necessary things are made and done.

Gill is not saying that the things men make are necessary and good *because* of this or that philosophy or religion. The proper goodness of whatever is made is not determined by religious sentiment or philosophic stance. The issue is far more fundamental than that. Because man is a bridge connecting the material and the spiritual, because he is able to comprehend the spiritual significance of the material, because he is able to present in material form that which is spiritual, it is to all of these things that are the very condition of

man's being, that good and necessary works owe their existence, their very being. The 'essential perfection' of any man-made thing is 'the love of God to which it bears witness'. (AN11) If it were not so all possible actions would be a doing for the sake of doing; all possible making of things would be for the sake of making regardless of the final human good and the 'essential perfection' of the thing made.

Gill's hold upon first principles plunges the workman into the Real, for the practical and the contemplative are conjoined. To labour is to pray,[3] action is for the sake of contemplation. The proper discipline of work is a sort of yoga that binds us back to our essential nature by holding our carnal appetites in a state of equipoise so that the soul is momentarily freed to contemplate its source. To contemplation

> all other human operations seem to be ordered, as to an end; for soundness of body is required to make contemplation perfect and to soundness of body are ordered all the artificial necessities of life. Tranquillity also is required from the perturbations of the passions; and this is attained through the moral virtues and prudence. Peace, too, from the exterior passions; and to this the whole régime of civil life is ordered. So that all human functions, rightly considered, seem to be for the service of such as contemplate the truth. (St Thomas quoted by Maritain, p.221)

This is far from advocating that the workman, or artist, must be fired with a religious enthusiasm in the accomplishment of his tasks: 'Just as the good religious prays without noticing that he is praying, so the good workman works without noticing he is an artist'. (AN198). Gill's point finds corroboration in the experience of the potter Bernard Leach, who records in his *A Potter in Japan*:

3. *Laborare est orare*: this dictum of the schoolmen is exemplified in Gill's philosophy in contrast to its moral distortion in that 'work ethic' that sees in work a punishment for the sins of Adam. In this distortion the ascetic element that is a necessary part of the discipline of work becomes an unrelenting duty pursued even in the face of material satiety. It is a case of vocation being not so much *of* man's nature as one imposed *on* his existence. It could not but result in that excessive doing and making that becomes trading where, in due course, the productive capacity of mechanised industry leads to there being more consumers than makers of things, more goods than wealth or needs require.

In making handles something other than myself is at work and that, no doubt, is why these remote Japanese mountain potters were attracted, even as I have been attracted, by the impersonal rightness of their traditions. In fact, I knew more clearly on this day the underlying motive which has drawn me back to the East once again. It is to rediscover the unknown craftsman in his lair, and to try to learn from living and working with him what we have lost since the Industrial Revolution of wholeness and humility.

The fact that action is for the sake of contemplation determines that 'leisure is secular' (to restore the body) and 'work is sacred' (to restore the soul) and why 'the object of work is holiness' (to restore the wholeness that is the polar balance of body and soul). 'It is man's special gift to know holiness'. (MM101) Holiness means wholeness, and the holy man is the complete man, he is the 'poor in spirit' who is blessed (Matt. 5:3), having divested himself of all that is unnecessary for him to realise his vocation. Stripped of all such worldly accretions, he is in a state of holy poverty. In the impassive act of single-minded attention in which the distinction of subject from object is dissolved he participates in the essential unity underlying all things. He is thus said to possess all things since he 'nothing lacks'. Being in 'one mind',[4] he inhabits the kingdom of heaven within according to the Biblical injunction. In the contemplative stasis that perfect mastery of work can momentarily induce is a foreshadowing of man's beatitude.

Gill found it necessary to ask, and to keep on asking, the radical questions he did ask, not because current ideas were in need of clarification and fine-tuning, but because he could not find at all, among his contemporaries, a proper doctrine of man and work that stood up to scrutiny. This alone explains the resoluteness of his challenge to the world of industry, the world of art, and the world of 'art and crafts' straddled uncomfortably between then. Some useful guidance as to what the issues were had been provided by his predecessors. But a more basic effort was needed to fill the vacuum left by three centuries of industrial *laissez-faire*. The modern world, after all, operates by default. It does not come about as a result of some

4. Philippians 2:2. 'Let this mind be in you, which was also in Jesus Christ', Phil. 2.5—Christ, the incarnate Logos, it might be added.

superior conception, to replace the spiritual vision of man, art and nature implicit in the scholastic learning of the European Christendom of the Middle Ages. The idealism of the Renaissance and the pragmatism of the Industrial Revolution had left the artist and the workman in opposing camps, to the detriment of both and with the gulf dividing them still to be bridged.

Gill saw in scholastic doctrine the possibility of a resolution of the dilemmas that faced him according to principles 'in harmony with divine revelation and in harmony with the conscience of man and the light of human reason'. No such principles seemed likely to be forthcoming from a society in which

> the control of politics [is] by people whose one aim in working is the making of money ... [where there is] the division of human beings into two classes, the responsible and the irresponsible, the people who control and the people who are controlled, a minority who do what they choose and a majority who have no power of choice. (WP76)

Such aberrations are rooted in a mentality that is exclusively preoccupied with cause and effect in the material order of reality only. The fact that we are now faced with an environmental and ecological crisis on a global scale is proof enough that the same preoccupation continues to underlie our society—a failure to take into account the ultimate effects of human action embarked upon in ignorance of orders of reality that transcend the material.

By his adoption of the Aristotelian doctrine of the four causes, and his restatement of it in relation to his philosophy of art and work, Gill was able to challenge head on this deficiency of the modern mentality. It allowed him to situate the inner motives for human action in relation to levels of reality that take into account the ultimate end and nature of all things, not just the immediate factors that concern the human capacity to produce material things by whatever process. In more particular terms it helped him understand the materiality of things themselves, as necessities of human life, in relation to an order of values and meanings consistent with man's final end as a spiritual being.

Gill's restatement of the doctrine of the four causes is, in summary, as follows: Man makes *things*, and there are four causes for the

existence of a thing. The first is the formal cause. If a man makes a chair he makes a particular chair. It is one sort of chair and not another. It is uniquely *this* chair as differentiated from all other chairs, however similar. And what determines that it is just such a chair and no other is its formal cause.

But there is no such thing as a formal cause on its own. There must be some material, some substance for that formality to be, as it were, incarnated. In this sense the stuff or matter of which the chair is formed can be said to be another cause of the chair: without this matter there could be no chair. That is the chair's material cause.

But the formality and the matter do not come together of their own accord. They must be joined one to another. There must be an effective cause whereby that formality that is a particular chair is married to the particular substance it is made from, otherwise the chair would remain unmade. So the effective cause of the chair's existence resides in the will to act on the part of the chair-maker.

There is yet another element missing in this account of the chair's existence. The will is but a faculty. It does not operate of itself and purely for its own sake. The nature of man's making of things is such that he cannot will to make other than a specific, particular thing. There is no such thing as the making of a general idea of a chair—a chair in the abstract. The chair-maker's will must be motivated by something. He must have some vision or conception of *why* and *for what* chairs are made. He must have some adequate reason for making chairs. So the *what* and the *why* are what move the chair-maker's will. That is the chair's final cause. And this final cause is the first cause also.

The four causes are only classified in this way for the sake of logical convenience;[5] to, as Gill put it, 'help us see the acts of man in proportion and perspective'. They 'help us restore and maintain ourselves in our integrity' as *man*, that is one who knows himself as a

5. 'The four Aristotelian causes, the formal, material, efficient, and final, are systemized approximations of all the causes involved in bringing about an effect, for these causes include not only what is outwardly understood by the formal, efficient, and final causes, but all that such causes mean metaphysically. The formal cause includes the origin of a particular form in the archetypal world, the efficient cause the grades of being which finally result in the existentiation of a particular existent, and the final cause a hierarchy of beings belonging to higher orders of reality that terminates with the Ultimate Cause which is the Real as such.' S. H. Nasr, *Knowledge and the Sacred*, (1981), p.196.

being beyond doing, one who must honour his ultimate responsibility to his Creator: his beginning and his end.

It can be clearly seen that the doctrine situates the uncreated at the beginning and at the end of all created reality. This is nothing more than to recognise the true nature of things on a cosmic scale, a scale in which the origin of phenomena cannot have the material order as its cause. The same material order, being created and therefore subject to change and decay, must begin and end in that which it is not. Gill's challenge to the philosophy of materialism was on the grounds that it envisages no beginning or end beyond the material order of reality, and so cannot have a vision of, and so cannot 'name', a formality that is consistent with all orders of reality, a world of values beyond the business of getting and spending.

> And that is the special nature of the philosophy of materialism. It denies the formal and final causes. Because there is no being beyond doing, there is no form. There is no idea in the mind because there is no mind. And because there is no beginning there is no end. There is no formality and therefore no finality. If you cannot say definitely and certainly *what* a thing is, you cannot either definitely or indefinitely say *why* it is. (NB323-24)

In other words the 'end' or final cause of the things that are made cannot be distinguished from the productive process itself: the one is for the sake of the other. Such circularity traps man in the existential circuit of matter, leaving him with no means of escape. Life is for the sake of living as living is for the sake of life. 'And just where there is no beginning there can be no end, so where there is no end there can be no beginning. The end *is* the beginning. (NB324)

The doctrine of causality accounts for how the workman, the artist, may know his being beyond the productive process itself so as to discharge the implicit intellectual responsibilities that inform the act of making according to the wholeness of his being. As *homo faber*, made of both spirit and matter and by virtue of his faculties of judgement, he is capable of a knowing, willing and loving response to the full circumstances that determine what he should make.

> He is a responsible creature, an instrument of creation, an instrument by means of which that is made which cannot be made

otherwise. Responsibility does not only imply a burden imposed; it also implies a power to bring gifts. It is his power of willing response that gives to man his unique responsibility. And that response is primarily of the mind. Therefore it is that our industrialism, as such, is to be condemned; for it reduces the workman to a 'subhuman condition of intellectual irresponsibility'. (NB 323)

This last point is all-important. Gill certainly spent much time and effort castigating the iniquities of the industrial system and its socially deleterious effects. But his condemnation of it does not rest on the effects themselves—terms and conditions of employment, remuneration and the like. It rests firmly and squarely on the fact that the processes of machine manufacture inescapably curtail man's intellectual responsibility for what he makes. The precise point at which the diminishment starts is in the real and effective difference between the tool and the machine. A tool is not simply a primitive precursor of the machine. A tool is in itself a neutral instrument in respect of *how* a thing is made in so far as it allows its user to determine the way in which what he has conceived inwardly is imitated outwardly in manifest form. The tool allows the intellectual responsibility for this imitative process to remain *with* or *in* the workman. On the other hand this imitative process is usurped by the machine since it is constructed to produce, or rather re-produce, in a predetermined way. The intellectual responsibility of the machine's design pre-empts that of its operator who thereby becomes the sentient part of a mechanised function. A tool-user may know what he is *making*, a 'factory hand only what he is *doing*'. (ACC 223)

The fact that there is an indeterminate border line between where complex tool facture ends and simple machine facture begins does not invalidate the principle. No more does it deny the possibility that a man using tools may be a bored, loveless, mediocre worker or that a machinist may be a conscientious, loving operative. Nevertheless, the tool-user or craftsman works according to occasion and convention to re-create after a *type*, whereas the machinist attends a process that re-produces a duplicate. The distinction is one of kind and not of degree.

Yet Gill's final castigation of the industrial system (one made also

by Morris), follows on logically from his distinction between the tool and the machine. 'Machinery does not exist to make things better; it does not, in fact, exist to make things at all ... [but] to make the thing called profits'. (MM57) This ought to be self-evident in a society in which technology exists to displace human labour.

Gill's continuous equation of 'art' with 'skill' by no means leads him along the path of a narrow utilitarianism of the handicrafts. No such route could develop which had as its guiding principle the analogy that exists between the work of God and the work of man.

> God's work of creation was gratuitous. Man also is able to make gratuitously. He is able to make things simply because it pleases him so to do, and things such that they are simply pleasing to him. Such things are works of art pure and simple. They leave the world better than they found it, but that is not their *raison d'être*; their reason of being is the pleasure pure and undiluted of the rational being who made them. They do not set out to serve him; they add to his physical well-being only by accident! (AN293)

We should note, in this key passage, the context of the word 'pleasure'. It is the pleasure of the rational being that is in question, not sensory or aesthetic pleasure for its own sake. The pleasure of the rational being is of the kind that concerns the maker who is able to recognise that the things he makes 'are also objects to be contemplated as beings and not merely as instruments'. In other words, pleasure, like beauty, has only an incidental status in the actual process of making a thing.

Pleasure in beauty is not a sufficient reason for a thing to be made by that perfection of the operative intelligence that is the *habit of art*. To make a thing just for the pleasure to be derived from it is to debase the mind to serve the appetites of the body. It is true that man needs pleasure and needs beauty, just as he needs the practical and the impractical—chairs and icons. (This last being impractical in a functional sense while being supremely functional in a spiritual sense.) But there is no rational or intelligible need for things that merely indulge our sensibility in isolation from that wholeness of experience which belongs to man as a creature of both matter and spirit. The pursuit of what one 'likes', as an end in itself, should be beneath our natural dignity if we are not to be governed by our appetites:

'A good life is a mortified life'.
Good taste is mortified taste.
Mortified—that is taste in which the stupid, the sentimental,
the irrelevant has been *killed*. (BLH193)

Gill did not explore in any detail the real and effective analogy between the gratuitousness of God's work of creation and that of man's (by which analogy 'the human act of begetting is a type of divine creative power'). But it remained, none the less, a central tenet of his philosophy and was the foundation upon which he built his understanding of the redemptive power of the creative act. It was left to his pupil David Jones to explore more fully this subtle and complex doctrine, as we shall see in the following chapter.

Gill once remarked, in defence of his own repetitiveness, that there are those 'who can only remember the point if it is repeated often enough'. 'Those' would have been perhaps the majority of his readers among the 'artistic' fraternity, who would have found little comfort in his censure of 'art nonsense'. This repetition is as much as anything a relentless drive towards clarification of terms, itself symptomatic of a desire for clarification of thought. One ramification of the analogy of human with divine creativity that he did return to time and again was the distinction and interrelation of art to prudence.

Art is an act of deliberation. Art is deliberate skill applied to the making of a thing. It is not a deed done, for the exercise of art is concerned only with the good of the work to be done. It is not the immediate function of art to concern itself with the quality of deeds. Such deeds, have in view an end other than that which is the deed itself. Deeds look to the ends of actions, whether they are good, bad, appropriate, ill-considered, in relation to the final good of man. Deeds involve ethics and morals. As an artist the gunsmith is concerned only with the good of the thing he makes *as a gun*. If he has to consider whether or not the gun is to be used as a murder weapon he does so in his capacity as a moral person. The fact that the gunsmith is at one and the same time both an artist and a person of morals should not persuade us that the *exercise of art* specifically involves moral and ethical considerations, even though he may exercise skill in moral judgment. Thus it is that, as Gill says,

Skill in doing good to oneself is called *prudence*.

Skill in doing good to things is called *art*.

Prudence is the means to happiness in oneself.

Art is the means to pleasure in what is not oneself.

Prudence is the application of ethics to practice.
Art is the application of aesthetics to practice. (BLH13-14)

The value of the distinction, as Gill saw, is in aiding our focus upon the question of man's final end—the coincidence of human will with Divine will.

Man acts with a free will, and his ultimate goal is to perfect himself as a willing agent in the knowledge of God. Though man cannot be 'perfectly active', he can be 'perfectly passive'. For while his free will 'does not grant him creative power', it does give him 'perfect power to will what God wills'. For this reason it can be said that prudence is superior to art in so far as its purpose is the perfecting of human will. Prudence may also be thought of as superior to art in so far as 'art is concerned with things, while 'man is more important than things.' (BLH26) 'Prudence may be considered superior to art with regard to the perfecting of will, but 'art . . . metaphysically is superior to prudence'. (BLH19) Gill argues this last point from the fact of the created universe being primarily 'a work of art and not primarily a work of kindness . . . so works of art are more essentially human than works of usefulness or even than works of kindness'. (BLH76)

A thing made *by* art is good when its material formation lacks nothing that is integral to its nature as a thing first conceived in the mind and then realised outwardly by an act of willing deliberation. (Gill is in agreement here with Coomaraswamy, as well as being consistent with traditional doctrine, that critical judgment of art must be based on the ratio of intention to result.) A thing made, a work *of* art, is good when its essential perfection (an 'intellectual splendour', as the schoolmen would have said), is recognised in the mind as a property of its existence. Thus, on the basis of the analogy that likens human with Divine creativity, the good of a thing is in imitation of the 'good' that God saw the creation to be when he had completed the making of it ('as being now all together', as Augustine puts it). So it

is that things made are works of praise, and, as Gill says, 'praise comes before thanksgiving'; an implied corollary being that it is not possible to offer proper thanksgiving to God with ill-made things whereby man, made in the image of God, is abased. In the act of praise that is the making of true and good art is the happiness that is a state of being pleased with things. And 'man's end is happiness', the happiness that is the human pleasure we have

> in good things, in using good things, knowing good things, seeing good things (and the word seeing includes all the other senses...) the pleasure we have in good things is only explainable and only endurable if and when and because it is a foretaste of beatitude—it is a mark and a sign and promise of our divine destiny—our heavenly home. (WL73-4)

Having argued the metaphysical superiority of art over prudence, further implications inherent in Gill's condemnation of the industrial system emerge. If it can be said

> that the workman has as much right to make and to act upon an aesthetic judgement in his work as he has to act upon a moral judgement in his life, or as he has to make an intellectual judgement in his thought', (UT3-4)

then clearly the industrial process represents a curtailment of the workman's freedom in two ways. Since no appeal to conscience is made in a process that rests on the division of labour and mechanical procedures, not only is the free will of the workman denied, but so also is his intellectual responsibility. Since the making of things is the normal and legitimate province of the exercise of both faculties, their denial represents a curtailment of the workman's freedom to perfect his will in the service of God.

Not only the production, but also the consumption of things produced by the mechanical system tends to undermine the exercise of art and prudence by weakening the ethical and moral ligatures that must bind a society together in the production of things for the common good. Machine goods are, after all, made for 'profits' and 'markets' rather than good use. And since the makers of things are also the consumers of things, then in the industrial market-place prudence is contaminated by ill-will on the part of the workman and

foolishness on the part of the purchaser. The hope that 'market forces', left to themselves, will eventually determine the goodness of what is to be made by machines must go unfulfilled. For the sense of what is a right and proper service of our needs pre-supposes a rectification of taste that the industrial system itself precludes. As Gill would have learned by both observation and from William Morris, industrial shoddy imposes a social standard as of necessity. 'The consumer is perfectly helpless against the gambler [the middle man]; the goods are forced upon him by their cheapness, and with them a certain kind of life which that energetic, that aggressive cheapness determines for him.' (Morris, *How we live and how we might live*) Such a standard is imposed as a result of the unrestricted 'free enterprise' of the merchant who gambles on whether or not he sells to fool or wiseman as it should *chance*: 'Fool or wiseman' in respect of the true knowledge possessed by the experienced maker and user of things offered for sale. (This refutes Ruskin's argument, in *Unto This Last*, that all workmen, good or bad, should receive the same wages on the grounds that the consumer will not pay the same for poor or bad work as he must for good work.) Those who are 'sensitive to the formal values' (Herbert Read's phrase) that make for the good and the true in what is made must be those who have a long experience of making things by means other than mechanical. And such 'sensitivity' as is acquired by this means can only be sustained by the same method.[6]

The metaphysical superiority of art to prudence must, then, be admitted because man is first and above all a maker of works *of* art—a co-creator with God *before* he is a man of charity, of good deeds, a prudent being. But, according to Gill, he is a prudent being only on condition that he loves the maintenance of the goodness of those things. The making of good things is the vocational standard by which

6. The situation is related exactly by Bernard Leach: 'I have often sought for some method of suggesting to people who have not had the experience of making pottery a means of approach to the recognition of what is good, based upon common human experience rather than upon aesthetic hair-splitting. A distinguished Japanese potter, Mr Kawai of Kyoto, when asked how people are to recognise good work, answered simply "with their bodies"; by which he meant with the mind acting directly through to the senses, taking in form, texture, pattern and colour, and referring the sharp, immediate impressions to personal experience of use and beauty combined,' *A Potter's Handbook*, (1940), p.17).

prudence is educated for, 'as making has need of doing—so prudence has need of art'. In the final analysis work and prudence cannot be separated since 'each seeks the perfection of its own'. (BLH16). They are 'one flesh'—'with good art prudence should have no quarrel'. (BLH28)

Doubtless Gill learned much from Morris, one of his early masters, but he was to go beyond the older man's idealist position. Morris saw the goodness of work but, having no effective doctrine of prudence, assigned no place to sin in the operation of human creativity. He had, therefore, to attach to the reform of society a quasi-religious value—a paradise on earth in some future time: Utopia, in fact. This was forced upon him by his vision of man and history as unending process:

> Socialism does not recognise any finality in the progress and aspirations of humanity; and that we clearly understand that the furthest we can now conceive of is only a stage of the great journey of evolution that joins the future and the past to the present. (*Four Letters on Socialism*)

Gill, on the other hand, knew that 'the kingdom of heaven is within', and that sin can only be understood in terms of a falling short of that perfecting of the will that it is the very characteristic of man to undertake in the sphere of doing and making. While it may end in that 'perfect freedom' that is the 'service of God', it none the less has its beginning in and through the things that come immediately to hand. For Gill man reaches this 'characteristic expression'[7] when the mind is moved 'to its highest'. (BLH81) For Morris the characteristic of art will be reached when the 'the people' (that is, the average, not the *normal*, man) are free to possess 'aspirations' towards the beauty and true pleasure of life'. (*Art and the Future*)

No consideration of Gill's philosophy of art and work can avoid his

7. I.e., approaches the *norm* of his humanity: Latin *norma*—conforming to a rule of conduct. 'Objection to such rules has often been made, ostensibly in the interests of freedom of the spirit, practically, however, on behalf of the freedom of the affections. But ascertained rules such as we speak of, having been evolved by the organism for its own ends, are never arbitrary in their own environment; they may better be regarded as the form assumed by liberty than as restrictions.' A. K. Coomaraswamy, *Selected Papers*, (1977), Vol. 1, p.114.

doctrine of beauty, a subject that greatly occupied him. As usual his point of departure was traditional doctrine. 'The beauty of God' says St Thomas, quoting Denis [St Dionysius], 'is the cause of the being of all that is'. (BLH25) That is to say, the simple and superessential essence of all things derives from God, every beauty and every beautiful thing pre-exists in Him in the manner in which multiple effects exist in a single cause. Beauty thus addresses the cognitive power since, as Maritain comments, 'beauty is essentially the object of *intelligence* [the sapiential intellect], for what *knows* in the full meaning of the word is the mind.' This is awkward for the modern mind, accustomed as it is to thinking of beauty not as objective order but as the subjective response of pleasure to some external stimulation. This, as Gill saw (and which is the whole point of his prolonged pre-occupation with the concept of beauty), divides beauty from intelligibility and loses the intellectual rigour of the traditional doctrine for which beauty and truth are inseparable concepts. ('Subtract the mind and the eye is open to no purpose', as Eckhart put it.) Gill followed St Thomas in seeing beauty as a transcendental, an absolute and objective property in things. Though the apprehension of beauty in things may occasion the stimulus of aesthetic pleasure, none the less such stimulus is not the cause of the beauty of a thing.

From St Dionysius and St Thomas, Gill, as it were, steps down into the incarnate world of the artist, the maker of things. 'The beautiful thing is that which being seen pleases'. Gill holds this to be 'an obvious fact. It is neither a definition of beauty nor of beautifulness. It is simply a statement of fact'. (AAC127) Man's appetite for beauty is his most significant appetite since, as beauty is connatural with being, it is his most immediate apprehension of being—an apprehension that transcends reason. As such, beauty is without need of proof: 'It is to be regarded as a leap of beings capable of *seeing* the truth'. (NB55)

This 'seeing' is also an objective grasping and knowing of things in their ultimate causes, for if mental activity in itself was wholly adequate to and coincident with the Real, then anything whatever thought or conceived in the mind would be true and there would be no occasion for error. On the contrary, if intelligence is what it is then its purpose must be to ascertain truth, its function to *take in* reality. That a subject must grasp an object is a necessary condition of intelligence or else, as Philo says, 'my own intellect the author of its

own intelligizing, how could that be.'? We do not expect sight to be an object of seeing.

So, as Gill says, 'The search for truth is not invention; it is the search for what *is*. All good deeds are but means to ends; they are not ends in themselves'. (BLN250) The metaphysical primacy of beauty, from the point of view of man as co-creator with God, resides in the fact that the apprehension of beauty joins the mind to the permanent essence of existing things. Such apprehension transcends both conceptual thought and sensory perception by plunging the mind into a real and objective order beyond subjective response. That is why 'beauty can have no proof', and it is why, Gill concludes, 'we are artists because we believe in Beauty, and not that we believe in Beauty because we are artists'. (AN102)

> Beauty is the *Splendour of Being*. The primary constituent of visible Being is Order.
>
> Beauty ... is conspicuous order—order shining out. Hence it is of the mind. It is the mind that is pleased by things called beautiful. (BLH66-7)[8]

Art is the right ordering of matter 'in accordance with the demands of the mind. *Mind*... the faculty of reaching out to things, grasping them, acting, ordering, governing in accordance with what is known', so it is that in the beauty of a thing well-made and ordered the mind partakes of a kind of pleasure. Not the intermediate pleasure of the senses, but an intuitive act of consciousness that is a 'tasting' (as a Hindu might say), of its brotherhood with beatitude. This inscrutable delight is immediate in being unqualified by the reasoning mind and unmitigated by the senses. 'It is the result of the mind's recognition [re-cognition] of what is after its own kind. In things of beauty the mind comes into its own'. (BLH67-8) (Conversely,

8. '"It is knowledge that makes the work beautiful", St Bonaventure, *De reductione artium ad theologiam*, 13. It is of course by its quality of lucidity or illumination (*claritas*), which Ulrich of Strassburg explains as the "shining of the formal light upon what is formed or proportional", that beauty is identified with intelligibility: brilliance of expression being unthinkable apart from perspicacity, vagueness of any sort, as being a privation of due form is necessarily a defect of beauty".' A. K. Coomaraswamy, *Why Exhibit Works of Art?* (1943), p.102.

in the recognition of ugliness the mind experiences a curtailment of its full being.)

'Beauty consists in due proportion': Gill quoting St Thomas again.

'DUE' signifies a debt, so that to say that a certain thing has DUE proportion signifies that it has the proportion DUE to it—the proportion which it ought to have on account of its being what it is, and underlying the material (time and space) measure of things there is the spiritual (true and good) measure of justice. (AN148)

Thus, when an artist (and on Gill's terms, obviously, each and every one of us is essentially an artist) takes mental pleasure in a thing well made, a thing that is right and good, that is whole and not lacking in what is due to it, then that is a holy pleasure, for it is a recognition that a thing is

in harmony with the good which is the object of his will and with the truth, the reality which is the object of his intelligence. Truth is the conformity of the mind with things. Good is the conformity of the mind with the purpose of things. And beauty is the conformity of the mind with things and their purpose(NB216)

Here again Gill is careful to avoid confusing means with ends. This 'holy pleasure', this recognition is not merely a mental pleasure since it is

man who is illumined by the illumination of beauty—the man, body and soul. For it is by means of objects of sense that he knows, and the fact is that things are not so much known in themselves as that they are means to knowledge. (NB216)

That is a knowledge of Being itself as it is participated in the integral unity of the truth, the goodness and the beauty of things. Here, the will comes to rest, seeking no longer that which momentarily, it possesses.

There is yet another clarification in Gill's treatment of the theme of beauty, one more or less demanded by the habit of the modern mind in thinking that the difference between *art* and *not art* is the difference between beautiful and *not beautiful*. (WP8–9) Such an equation is only possible when art is thought to be a special category of feelings that act *sensa*tionally towards their object. But this is to forget that

'the word *art* does not in itself mean anything to do with beauty'. (WP9) 'Beauty is not the object of making. Beauty is an accident of *right* making. Beauty is that which attracts us to the truth'. (WP128) Just as the *object* of the art of the chef is to make such meals as are good for our bodily health, so it is an accident of his art and not its goal, that our appetites are whetted by the sight and smell of the thing he has prepared.

Gill had the habit of first principles that allowed him to see the end *at* the beginning with no confusion of means with ends. It was so in his discussion of beauty. Although he returned to the subject again and again—augmenting and refining his thoughts—he was, finally, reluctant to let it assume a position of overall dominance. It was never an obstacle for him in the way it had been during four centuries of humanist aesthetic—one that tried in vain to locate beauty as a vital constituent of 'art'. It eventually proved to be a chimera as a measure of artistic value, and with the advent of modernism beauty was jettisoned altogether as an irrelevance. In the end, beauty must take care of itself. And in the end Gill's view seems the only realistic one possible in the operation of the habit of art that is the norm of workmanship.

> The feebleness of man's spirit, his proneness to self-aggrandizement, his sensuality, his silliness, always lead him astray. He cannot commonly be left to indulge his proper appetite for beauty unalloyed. Beauty comes to his work unasked when he works in a spirit of plain justice; when he considers simply the use of what he is making and the service of his fellows. (AN295)

Gill lived in a world in which, as he saw it, much seemed topsy-turvy: first things put last and things contingent, incidental, subordinate, raised to the level of unquestioned dogma. A world of false gods, chief among them the idolatry of art and the religion of leisure as an anodyne to a false industry. Nor have these gods been displaced. What art is, what it is for, and its relation to man's needs both spiritual and material, and above all, how these matters can be identified with what is ultimately Real—God!—these were the terms of Gill's thesis. Reiteration of argument was his way of getting to the root of these matters. Since he believed first things should come first

his remains a very principled challenge, meant as a rebuttal to an unprincipled situation.[9] Today the technology is more sophisticated, often but not always cleaner, and its sheer convenience may have banished much drudgery. But these facts serve only to chart its insidious progress, not to explain its demise. We should be in no doubt that the same system of providing the material infrastructure of life is basically the same anti-human one that Gill set out to challenge.

It is no use arguing (*pace* Mumford, Mairet, Herbert Read, *et al.*), that machines have developed ahead of our wisdom and understanding of how best to use them. Apart from begging the question as to where the knowledge and understanding to create them came from in the first place (only men make machines), it is a refusal to see that technology is inherently progressive, not according to human wisdom, but according to economic opportunity. Not for the good of the thing to be produced but from the need to reduce the risk of incurring economic penalties—to be left behind in the market-place. Man *creates*, the machine *duplicates*. In each case a different principle is appealed to, a different characteristic, called into being. To create is to cause to exist a thing that is unique. To duplicate is to cause to exist a thing that is uniform. When the artist, the workman, creates the diversity of what he makes is ultimately explained by the fact that as life flows through him he is never the same at two different moments. However similar the things he makes they will always betray minute differences. On the other hand, the duplications of the machine (through which no life flows!) are not expected to differ. Much of the purpose of the machine is to minimise the risk of diversity. Hence the lifeless, deadening effect of machine products.

For the most part Gill's arguments do not rest on a call for reforms in such things as customarily occupy the time and effort of trades unions and social reformers. Such measures, desirable as they may

9. '"Modern capitalism", writes Mr Keynes, "is absolutely irreligious, without internal union, without much public spirit, often, though not always, a mere congeries of possessors and pursuers". It is that whole system of appetites and values, with its deification of the life of snatching to hoard, and hoarding to snatch, which now, in the hour of its triumph … seems sometimes to leave a taste of ashes on the lips of a civilisation which has brought to the conquest of its material environment, resources unknown in earlier ages'. R. H. Tawney, *Religion and the Rise of Capitalism*, (1980), p.280.

be, are concerned to rectify, within the industrial system, injustice between man and man. Gill was concerned to rectify the system's injustice to man *as* man. On that basis alone can the industrial system be judged as to its in-humanity; its de-humanising effect be measured. Gill wanted every man to be an artist, that is one free and willing to exercise the norm of his humanity. The argument that there is no time or money to allow the workman to be an artist can be disposed of simply by asking what time and money are for if not to facilitate human life.

Time and money, in the industrial system, tend towards the production of goods beyond satiety, for which over-production no natural precedent can be found—not even in the 'abundance of nature'. Nature does not produce for the rubbish tip!

> God and nature makes nought superfluous, but all that comes into being is for some function. For no created being is a final goal in the intentions of the Creator, as Creator: but rather is the proper function of that being the goal. Wherefore it comes to pass that the proper function does not come into existence for the sake of the being, but the latter for the sake of the former. (Dante, *De Monarchia*)

Gill saw that it was the very nature of the Real that was in question. the Real as it is known to *homo faber*. He also saw that modern man is profoundly unrealistic in his inability and unwillingness to acknowledge the transcendant source of his humanness.

> The whole of our trouble is the secularization of our life, so that we have descended to an animal condition of continual struggle for material goods. By sin—sin, that is to say, self-will and self-worship—by sin man does not descend from the superhuman to the merely human, but from the superhuman to the sub-human. Strange fact! Man cannot live on the human plane; he must be either above or below it. (AU282)

Since Gill's death the forces of secularism have shaped the lives of two or three generations towards a 'standard of living' that is diametrically opposite to the life he argued for. It has involved living day-to-day among things—called 'necessities'—that the greater part of the human race would never have recognised as necessary. This

standard of living has been maintained by the subjection of man to an industrial economics on the assumption that his 'needs' must be supplied by the application of modern technology. It has meant the proliferation of objects that could never have been made at all by men. Our 'standard of living' exists now due to an elaboration of technology far beyond what any workman, artist, or craftsman could conceive and execute. Its objects are certainly beyond the understanding of most of their users. Yet the whole process moves in a never-ending circle, the demand for such 'necessities' being stimulated by the same mechanism that supplies them.

The secular modern world makes a fool of religion by pretending that the religious life is just one option among others for the purposes of physical life. The religious life has given way to the 'economic life' or the 'artistic life'. But from Gill's standpoint these are all impoverishments of the religious life. While it may be the case that for all 'life styles' this earth 'is a training ground ... a place where we are all educated', (LE42) only in the religious life are we true to our proper destiny which affirms that, far from being at one with our environment, '"by the conviction of experience" we know we stand outside, above, beyond, independent and aloof from [it]'. (SS33)

Gill's 'crusade' against industrialism ended in apparent failure. But that 'apparent' judgement conceals a short-term perspective. The truth is Gill's philosophy has yet to be taken seriously in a world content to measure and define man according to an industrial economics that drives, him, relentlessly, further and further into a social and ecological crisis that now threatens his very existence on the face of the Earth.

David Jones's View of Art

We already and first of all discern him making this thing other. His groping
syntax, if we attend, already shapes:
ADSCRIPTAM, RATAM, RATIONABILEM...and by preapplication and
for *them*, under modes and patterns altogether theirs, the holy and vulnerable
hands lift up an efficacious sign. Opening of *The Anathemata*

'Primitive' man knew nothing of a possible divorce of function and meaning:
all his inventions were applied meaning.
A. K. Coomaraswamy

READING through David Jones's occasional writings one is
quickly made aware of the sense of cultural crisis that pervades
them: that the practice of art is fraught with problems that are
perhaps unsolvable, and that the theory of art is hedged about with
perplexing considerations that we cannot be certain we have firmly
grasped. In his 'A Note on Mr Berenson's Views', for instance, Jones
points out the quite radical difficulties that attend the use of even
such basic terms as 'real', 'represent', 'form', 'finish', 'shape', 'compo-
sition', and the like. (276–77)[1] This crisis becomes at times the sub-
text, and on occasion *the* text as Jones tentatively probes the cultural
fabric of the Christian tradition in order to determine what might
be the terms on which twentieth century art can validly proceed.

The crisis is rarely explicit in the paintings and drawings, where it
has to be construed from the imagery—for instance in the late work
Aphrodite in Aulis, where it becomes apparent from a reading of the
juxtaposition of images drawn from widely separated periods of
western (cultural) history. Or, in the poetry, in *The Anathemata*, where
the comprehensive intricacy of the poet's attempt at an 'effective
recalling' at times threatens to overwhelm the reader.

Going yet deeper into the occasional writings it soon becomes

1. These bracketed figures refer to page numbers of *Epoch and Artist* (1959). Other
abbreviations are: DG, *The Dying Gaul* (1978); DGC, *Dai Great Coat* (1980); and SL, *The
Sleeping Lord* (1974).

clear that the cultural preoccupation of Jones's own 'groping syntax' is a profound concern for the interactive natures of art and man; in particular, the essays that deal more specifically with this theme— 'Art and Sacrament', 'Art and Democracy', 'Religion and the Muses', 'Use and Sign', and 'Art in Relation to War'. These demonstrate a mind acutely sensitive to the nuances of meaning, association and consequence that attach to our understanding of precisely *what* human nature can be said to consist in. In taking stock, and 'in spite of the dissolutions and disillusions inherent in this present phase of the decline of the West' (274), Jones saw that we must begin to find answers to our problems by starting, not from *where* we are, but from *what* we are.

Although it was axiomatic for Jones that the artist must begin with the materials of one's own time this does not make him a modernist—except in a nominal sense, and then only in the period of the late 1920's and early 1930's, up to his first nervous breakdown in 1932. During this period he was most responsive to the innovative energies of his contemporaries.

Jones did not believe it to be the task of the artist simply to reflect his particular phase of history. For him no lasting veracity could be given to cultural activity on the level of history alone since history— that product peculiar to man—no less than man himself, is by its very nature in need of redemption. The criteria by which the arts of man are to be judged must ultimately come from values and meanings that originate in a domain that transcends history as such.

Jones's whole view of art, like that of Gill,[2] rests firmly upon a body of wisdom that is immemorial—aboriginal with man himself. To this extent it rests upon objective criteria. His occasional writings are not what one commentator has called Jones's 'special theories'. It is true they are in part personal. But this is incidental and not for the

2. There are obvious temperamental differences between the two men. Having hold of fundamental principles Gill regards himself as one fully-armed and ready for action, to the exclusion of some subtlety in dealing with related matters. Where Gill is dogmatic Jones is tentative, being more prepared to take account of man's current predicament in the face of the impoverishment of the sacramental in the modern world and what this implies for man-the-artist and his attempt to create a *valid* art form. In Jones's work the terms 'valid' and 'effective' are heavily loaded with denotative and connotative resonances as we shall see below.

sake of self-expression and arises from the sheer diversity of the artist's *materia poetica*. The style of his pictures and of his poetry is resolutely objective, at one and the same time highly—often bafflingly—idiosyncratic, but non-subjective. They have the quality of things made to demonstrate an integral perfection.[3]

The assumption that Jones had 'his own special theories' could only come from one unfamiliar with the scholastic doctrine of art, itself a western formulation of a universally true 'normal view of art', as Coomaraswamy has called it. This scholastic formulation is strongly coloured by its sources; the logic of Aristotle's category of the intellectual virtues in which the principle of art is a practi-

3. A recent commentator asserts that Jones developed his very own individual version of Clive Bell's theory of Significant Form. This is a misleading simplification. It is pointed out that Jones thought it an unreasonable reaction of Eric Gill to respond to the same theory, 'significant to what?' But Jones himself wrote in 'Art and Sacrament', 'a sign then must be significant of something, hence of some "reality", so of something "good", so of something that is "sacred".' Now apart from the pertinence of Gill's question, as well as the fact that Bell's theory can hardly be interpreted as accounting for art as a vehicle for the transmission, via the supra-sensible archetype of the 'Good', of a sacred truth, Jones's terms the 'real', the 'good' and the 'sacred' must be understood in the context from which they derive, that of scholastic metaphysics. This alone can explain the series of 'leaps' from 'real' to 'good' to 'sacred' as a movement towards a goal that is in some sense a revelation of the Divine.

Jones's words are very close to a passage from Coomaraswamy's essay 'Is Art a Superstition': 'If we sometimes make use of such high-sounding expressions as "significant form" we do so ignoring that nothing can properly be called a "sign" that is not significant of something other than itself'. Bell's theory is tautological in seeking to establish a 'significance' on the basis of a generalisation extrapolated from individual sensibility. But the generalisation inferred does not go beyond the specific realm of aesthetic emotion. It refers to nothing outside of the artistic process itself. Moreover, his theory is based on the notion of 'art' as an *external product*, an aesthetic category of things set aside from other works on the supposition of their superior aesthetic content. This subjectivism was exactly what Jones fought to free himself from in following the scholastic doctrine that 'art' is an *interior principle*, 'a strategy', 'an activity', 'a fitting together', 'a human skill', whose exercise is nothing other than to perfect the operation of making. Something of Jones's effort to avoid propounding a subjective theory of *poesis* can be seen from his letter to Harman Grisewood (13.4.40) in reference to his reading of W. F. Jackson Knight's *Cumean Gates*: 'It's *so* hard to find any detachment within oneself'. We might also recall his strictures, in his essay 'Art and Sacrament', against 'self-expression' as well as his welcoming the 'objective views' of Maritain's treatise *Art and Scolasticism* as a bulwark against the struggle with 'the tide of subjectivism'.

cal wisdom involving a true course of reasoning. And then by the scholastics themselves in their attempt to present a thorough, rational analysis of this operational habit or virtue as it resides in the mind as being the informing skill *by* which all works are made. This principle was eventually assimilated (by St Bonaventure, for instance), to the light of the Logos as ultimately a Divine manner of understanding. It need hardly be added that the scholastic formulation was wholly consistent, both spiritually and practically, with Jones's profound Catholic faith. The self-authenticating intelligibility of the traditional doctrine had an objectivity that appealed to Jones as answering his need to free himself from the subjectivist dilemma posed by modern abstraction, which amounts to an evasion of the question of the relationship of form to content on the one hand, and the diminishments of *signum* in representing natural appearances on the other.

From the point of view of Jones's understanding of the relationship of form to content, the form of a work of art is determined by the 'inner necessity' of a thing that has to be *re*-presented. The specifically modernist aesthetic is no more than a will to display technique. But technique exists as a result of intention. So what of an intention to display technique? The so-often posed question, *What is it?*, indicates a cognitive necessity to penetrate beyond the inadequacy of defining a thing in terms of what it does. The mind needs to know what a thing—a work of art—*is*! Jones's insistence that *signum*, as an order of signs in the domain of art, binds man to the transcendental order exposes the circularity of the modernist, abnormal aesthetic in which a work of art cannot point to anything beyond itself. What could be more reductive for the spectator than for the artist to innovate for the sake of innovation?

Jones's occasional writings on art in the main came about as a result of his attempt to apprehend the complexities and 'show forth' the implications of the Catholic wisdom with regard to the nature of man and his works. That being so his claim that art 'does not need to be justified by metaphysical argument' (DG164) is somewhat disingenuous. Justified no. But any art worthy of the name (and certainly art on the terms that Jones would acknowledge) embodies substantial values. And we can hardly doubt that Jones's work, taken as a whole, invites our assent to a credible and substantial thesis that of its nature must be either true or false: and that truth ultimately

metaphysical. The present chapter will concentrate on those parts of Jones's exposition that are illuminated by being seen in the light of the metaphysical doctrines they rest on.[4]

The artist has stated clearly his intention to

raise the question of what is involved *for all of us* in the notion of sacrament and the sign-world in its multifarious aspects.

The technocracy in which we live and which conditions us all, tends, in all sorts of contexts and at every level, to draw away from this sign-world. I feel that almost all of us, indeed all of us, duck this issue. People speak of sacraments with a capital 'S' without seeming to notice that sign and sacrament with a small 's' are everywhere eroded and in some contexts non-existent. Such dichotomies are not healthy. (12–13)

Everybody has at some time experienced the sense of a restored inner harmony, a re-alignment and balance of the faculties, after successfully undertaking some practical task the end product of which is only incidentally aesthetically pleasing. Such a sense gives us the most direct experience of how the practical intelligence can provide the means to draw upon our deeper resources. In contrast to the

4. For this purpose I have drawn heavily, as with Gill, from Jacques Maritain's *Art and Scolasticism* (1930), many traditional sources, and especially from the writings of Coomaraswamy. We will presumably never know why Jones does not mention the latter's work. The parallels of symbolic and doctrinal understanding are so numerous and mutually illuminating that it seems impossible Jones was not in some degree influenced by the scholar Gill corresponded with and indeed eulogised with the words: 'I believe that no other living writer has written the truth in matters of art and life and religion and piety with such wisdom and understanding'. Some of these parallels would, of course, be inevitable given the nature and source of the doctrines. But I recall a conversation with René Hague in London in the summer of 1978 in which he told me that David did (at least) read the offprints of articles that Coomaraswamy was in the habit of sending to Gill. It seems more than likely that some subsequent discussion of these would have taken place between such close associates as were Jones and Gill. In a letter to Harman Grisewood (DG95) Jones eulogised the scholar W. F. Jackson Knight: 'If there were one or two more Jackson Knights who combined real slap-up scholarship with a nose for the patterns and eternal correspondences of this with that, it would be jolly nice and helpful'. Why did Jones not recognise in Coomaraswamy just such a scholar—*par excellence?* A critical review of Jackson Knight's *Cumean Gates* (which sparked off the eulogy) by René Guénon is published in his *Fundamental Symbols, The Universal Language of Sacred Science,* (1995), chapter 31.

modern artist and the modern 'worker' the traditional artist-crafts-
man operates within a metaphysical context that provides the spiritual
and practical continuities needed for the experience of his craft to be
an effective agent in the realisation of these resources. By this means
the individual is able to go beyond the limitations of the ego in order
to link his entire being to a deeper order of reality. This traditional
conception of work as the application and extension of metaphysical
principles provides the objective criteria for Jones's assertion that 'in
the arts "the best" can only easily and naturally be available to the
hierarchic, corporate, symbolic demands of the Church if the epoch
itself is characterised by those qualities'. (97) The implicit recog-
nition that such 'qualities' are not readily accessible to the twentieth
century artist should not escape notice.

The importance of art for any society cannot be over-emphasised
and is at all times taken for granted by Jones for whom, as from the
traditional standpoint, 'the terms "man" and "artist" can be said to be
interchangeable: Man is the only artist and only artists are men'. (94)
The product of the artist is not therefore a luxury enjoyed in order
to indicate a progressive refinement of individual sensibility, but is
the fruit of an analogy that visualises the creative act of man in terms
of the Divine Act of Creation. Among the creatures man occupies a
central position—half-divine, half-animal. Man alone carries within
himself the possibility of intellectual certitude and spiritual per-
fection. Man himself is a work of art by virtue of his being an image of
God, and an artist by virtue of his ability to imitate the operative
manner of the Divine Intellect in producing works ('art imitates
nature in her manner of operation'—St Thomas). This analogy of the
artist with the Divine Creative Act is so envisaged since the artist's

> first gesture is an interior and contemplative act in which the
> intellect envisages the thing (to be created) not as the senses
> know it, nor with respect to its value, but as intelligible form or
> species; the likeness of which he afterwards proceeds to embody
> in the material.[5]

The act of the human artist in identifying himself with the intel-
lectual prototype that is the likeness of the thing to be made is in

5. A. K. Coomaraswamy, *Figures of Speech or Figures of Thought*, (1946), p. 80.

imitation of God, who, from His limitless love, creates the world out of nothing that is exterior to Him to become the object of His own 'vision'.

The specific achievement of the Renaissance was to dismantle the analogical wisdom of the scholastic doctrine in order to establish the illusory autonomy of man from the sacred. The three hundred years from 1400 to 1700 were witness to a progressive deprivation of the image of God and the representational forms of the sacred. In the following centuries the metaphysical corollary of this new condition worked its way to the surface in an inevitable and progressive degradation of the image of man. From man as the image of God to God in the image of man and, finally, man in the image of purely physical processes. From the seventeenth century all mediation between man and the sacred has been effectively eroded so that man has become estranged from a nature and history become increasingly profane.

As Jones repeatedly points out, forms in art are of vital importance as an indication of man's own image of his creaturehood. What man represents man becomes. The arts are the final intercessionary instrument between man and God as they represent the external limit of a mutual, sacred partnership outside of which the forces of profane, brute utility begin to engulf man and his works.

It is man's ability to contemplate the infinite that characterises the unique nature of his being and sets him apart from the angels and the animals. But from the point of view of his works it is the sacramental nature of artefacture 'that is the very quality by which "man" is distinguished from "animal" and from "angel".' (178) Moreover, if 'theology supposes man to be, first and foremost, a sapiential mammal' (147), then this *sapientia* by which man proceeds implies—since 'it is axiomatic that the origin of things conditions their ends' (45)—'that this mammal has an end other than that of the other mammals ... must have a supernatural end. In catechismal terminology this is expressed by asserting that the natural end of man (i.e., the end conformable to man's nature) is eternal felicity'. (147–48)

Sacramental works, then, have the specific function of serving as an adjunct to that perfecting of intuition that is the realisation of the 'eternal felicity' that is man's last end, since by the law whereby extremes meet, the works that man makes are the very manifestation that in turn shapes the mode and manner of his innermost

resources. 'The more man behaves as artist and the more the artist in man determines the whole shape of his behaviour, so much the more is he man'. (86) In this reciprocal relationship we have the true meaning of forms in art—not a mere formalism of shapes but a real science of symbols that translates, according to and in recognition of certain cosmic laws of correspondence, the essentially sacred reality at the heart of all created things. From Jones's standpoint, if art is free to elaborate and extend its technical and expressive means arbitrarily, in ignorance of these laws of correspondence that inform both the objective criteria man's *sapientia* demands and the 'supernatural end' to which his nature is conformable, then we are simply conditioned by what is *beneath* our nature and any talk of *signum* becomes meaningless.

If art were indeed inaccessible to any criteria of objective truth, then there would be no grounds for the apprehension that underlies an essay such as 'The Utile'. It is just such a formalism of shapes, having no correspondence with the spiritual needs of man, that Jones refers to in this essay, and elsewhere. The recognition that the 'characteristic forms of our present technology' seek as their highest objective the merely 'utile' requires us also to recognise that when 'man's works seek utility only they can appear to become "utilitarian" in a most derogatory sense, that is to say they appear "sub-human".' (181) Were we able to suffer this utilitarian imposition entirely without conscience the question of form would be of no importance, and a seeking for more than the utile would be 'an aesthete's faddishness'. Our misgivings persist for good reason:

> for in the age of technics the tendency is for creativeness to become dehumanised, for contrivance to usurp imagination, for the will toward shape to become almost indistinguishable from a mere will toward power. There is a deflection, a mass-deflection, from the proper 'habit of art' towards forms which owe their existence and meaning to what they *effect* rather than to what they *are*. Power-extension and multiplication become the objectives, and the utile is the sole factor determining the forms, and the symbolic loses altogether its central and presiding position. (104)

The problem is further compounded by the fact that the modern 'maker' is no longer man the 'sacrament-maker', and has grown

accustomed to standards of behaviour that require the distinction of needs from desires. What he *needs* (that which supports the realisation of his last end) is one thing; what he may *desire* (that which merely facilitates his appetites) quite another. For man the 'sacrament-maker' desires and needs ought to coincide. It is these, man's *real* needs, that for Jones—as for tradition (see *Republic* 369–70)—are the proper occasion of art. But in the industrial society we have an art that is a formalism of shapes, textures and colours that offers aesthetic stimulation for its own sake, standing in opposition to sub-human standards of manufacture applied to technical contrivances from which our spiritual needs have been expressly eliminated. The debilitating effects of this dichotomy, the spiritual questions it gives rise to, and the practical problems it poses, run like a leitmotif throughout Jones's critique of our particular cultural phase.

The coincidence of needs and desires in the sense in which they have been used above presupposes that art, as the norm of workman-ship, can be the instrument whereby every 'maker' can so harmonise inner and outer faculties as to bring about the conformity of his being to an order of reality that goes beyond his individuality. Such a norm is the ultimate referent of Jones's equating 'man' with 'artist'. 'Sign and sacrament are to be predicated not of *some* men and their practices but of *all* men and their practices'. (166)

> Unless man is of his essential nature a *poeta*, one who makes things that are signs of something, then the central act of the Christian religion is totally without meaning. How can there be a manual act that makes *anamnesis* unless man is man-the-maker, and thus *poesis* his nature and authentic mode of apperception and in the end his only mode? (13)

One is reminded of Eckhart's 'No person can in this life reach the point at which he is excused from outward works'; therefore 'work in all things' and 'fulfil thy destiny'.[6]

Jones made use of Gregory Dix's definition of the meaning of

6. Quoted by Coomaraswamy, *The Transformation of Nature in Art*, (1934), p.92. Eric Gill, writing to thank the author for the gift of this volume wrote, 'I am really overwhelmed by it...it seems to me splendid, magnificent, marvellous and altogether excellent'. It is almost inconceivable that Jones did not see this volume and read its chapter 'Meister Eckhart's View of Art'.

anamnesis which tends to emphasize the temporal connotations of the word. In his Preface to *The Anathema* Jones, in a footnote, quotes from Dix's *The Shape of the Liturgy*:

> It (anamnesis) is not quite easy to represent accurately in English, words like 'remembrance' or 'memorial' having for us a connotation of something *absent* which is only mentally recollected. But in the Scriptures of both the Old and New Testament *anamnesis* and the cognate verb have a sense of 'recalling' or 're-presenting' before God an event in the past so that is becomes *here and now operative by its effects.* (126)

Dix has in mind here the celebration of the Mass in which the celebrant is occasioned to 'do this in remembrance of me'. But this is not fully helpful in understanding the relation of *anamnesis* to the application of the practical intelligence that is art in Jones's thinking. In this context the significance of *anamnesis*, as Guénon and Coomaraswamy have shown, is rather that of *metanoia*, a real 'change of heart' involving a 'wakening up' of the latent spiritual resources such as man possesses within himself. On this reading *homo faber*, as *poeta*, is not so much a 'rememberer' (141) of past events, as one whose making and doing effectively recall the supra-human criteria on which, ultimately, human nature rests.

Undoubtedly the central motif of David Jones's work was to understand art in relation to the Eucharist: '... the crucial question is: Why did the Lord employ art-forms and establish a tradition commanding the continued employment of those forms?' (162) What is here initiated is a ritual action that rests ontologically upon the incarnate Logos in which, through His love of His own creature, God assumes man's nature in the person of Christ. Given that we understand by 'form' the sense of *forma*, that is the qualitative imprint of a being or a thing, this may be expressed in symbolic terms as the Divine nature of Christ, as the principle of form, giving immanent form to all that is formless.

> According to this spiritual view, the participation of the human form of the Christ in His Divine Essence is (as it were) the 'type' of all symbolism: the Incarnation presupposes the ontological link which unites every form with its eternal archetype; at the same time it safeguards that link.[7]

The Eucharist sacrifice, at the centre of the liturgy, is thus the means to grace instituted by Christ Himself and so belongs to the order of Divine Art, an art made possible on the basis of the science of symbols, itself based on the qualitative essence of things and which, by a real and effective ontological correspondence, concedes the transparency of the existential world to the transcendental order. This same law permits man to see himself as one eternally begotten in the likeness of His exemplary image in the sense of a prior imitable prototype. 'It is in-as-much as God knows his essence as being imitable by this or that creature, that he knows it as the particular reason and idea of that creature'.[8]

Christ's statement, 'do this in remembrance of me', represents the institution of a sacrificial rite—a ritual performance that makes sacred or holy. The performance of this rite becomes for Jones the paradigmatic performance of *all* acts of making: 'For in the Cenacle the Victim himself did something and said something which no matter how it is theologically interpreted ... was unmistakeably and undeniably a sign-making and a rite-making and so an act of Ars; moreover an act to be, in some sense, repeated'. (168) This rite, therefore, institutes a form of comprehension that, to make use of a passage from Coomaraswamy, 'reduces the whole distinction of sacred from profane and the opposition of spirit from matter, a perception of all things at the same time in their temporal and in their eternal significance'.

God's sacrifice of Himself in order to generate a world that is 'other' than Him as He is in Himself, is mirrored in the ritual mimesis of Christ's Passion. But the procession of the Divine Substance from potency to act on the Divine plane, on being reflected on to the human plane, is inverted so that man the 'sacrament maker' is called to an act of remembrance (*anamnesis*) of that which was his original substance. This necessitates the death or sacrifice of the outer man or ego—the illusion of self-autonomy. By so acting man 're-collects' the deiform prototype or 'foretype' of his nativity in his sacrament-making. Which is why the poet wrote, in *A. a. a. Domine Deus*, 'I have felt for his Wounds in nozzles and containers'.

Jones's insistence that *homo faber* must find 'His presence' in the

7. Titus Burckhardt, *Sacred Art in East and West*, (1967), p.70.
8. Coomaraswamy, *Figures of Speech or Figures of Thought*, (1946), p.76.

actual substance of material artefacts before they can be used as 'signs' is guaranteed by the Incarnation. That they can be 'valid' signs of man's redeemability is guaranteed by the Resurrection. The incarnate Logos, present in and uniting all things, is the decisive sanction for the artist's task. Such 'signs' as the strategy of art 'shows forth' can only be

> radiant with form and abhorrent of vacua by the action of the Artifex, the Logos, who is known to our tradition as the Pontifex who formed a bridge 'from nothing' and who then, like Brân in the *Mabinogion*, himself became the bridge by the Incarnation and Passion and subsequent Apotheoses. (160)

Jones sees the crisis of our technocratic civilisation as one in which the resonances of the Logos—'abhorrent of vacua'—are effectively emptied out of the things we make and do; which things, in a sense, *make us* in that we feel, see, touch and love through the particularity of things made and done. In this sense also art 'knows only the unique'.

This should prepare us to understand more fully what is involved when Jones writes:

> If, in the Cenacle, forms of words were used and manual acts employed involving material substances these things can have been done only by virtue of the doer being a man along with us; more explicitly, by his being man-the-artist along with us. What was done would have been neither necessary nor possible unless man is man-the-artist. (167)

Here we return to the question of forms being able to translate truth according to the hierarchy of cosmic values. The qualitative essence inherent in things at the level of formal manifestation permits the analogous expression of the Divine Essence in man's making, so that Christ, as the incarnate Logos, becomes the first cause of all that is created by the agency of *ars*. The analogy between 'Divine Art' and human art operates through this reciprocity of inner essence and outward manifestation. Such a reciprocity is common to all men since the human intellect, in its intuitive ground, is a mirror of the Divine Logos. As the traditional formulation of this doctrine reminds us: the artist is not a special kind of man but every man is a

special kind of artist and represents the 'normal' (that is, conforming to an inner rule or standard) man. As Maritain puts it in *Art and Scholasticism*, 'If Christ willed to be an artisan in an insignificant village, it was because He wanted to assume the common lot of humanity'.

Hardly less central to his thinking is Jones's concern with the gratuitousness of art: 'It is the intransitivity and gratuitousness of man's art that is the sign of man's uniqueness; not merely that he makes things, nor yet that those things have beauty'. (149) Kenelm Foster has complained that Jones does not closely define what he means in using the terms 'intransitivity' and 'gratuitousness'. However this may be, it is clear that Jones, in using these terms, is consistent with the traditional doctrines of free will and the gratuitousness of the Creation.

In the act of creation God is free from any external determination or imposition, the Creation being none other than the outward realisation of a potentiality in the Divine plenitude that permits, so to say, the manifestation of those parts of God that are manifestable. This emanation from potency to act is akin to a light giving forth light by the very nature of light itself, illuminating all things yet without diminution of itself. In the same way there is in God a material cause *in principle* that becomes outwardly a material cause as the origin of created things. Wholly consistent within the nature of the instantaneity of this free act of creation, and proceeding from the deiform prototype in which man is created in the image of God, is man's free will—the bestowal of a freedom wholly undetermined and without imposition. This freedom is not so much the granting of a choice to the soul, as it is the gift of a condition of being that permits man to divest himself of the illusion that he has an autonomous nature apart from God: a state of being which, in its perfect realisation, wholly unites the will of the individual with the will of God. In other words, the soul is granted the freedom to become what it essentially *is*—in theological terms to *be* what is was before the Fall.

But given man's fallen nature, any such 'freedom' to divest oneself of an illusory autonomy, in order to be fully operative, must of necessity involve commitment to a discipline, albeit entered into freely. This is the function of religion. So, as Jones concludes,

with regard to the etymology of the word *religio* ... a binding of some sort is indicated. The same root is in 'ligament', a binding which supports an organ and assures that organ its freedom of use as part of a body The binding makes possible the freedom. Cut the ligament and there is atrophy—corpse rather than *corpus*. If this is true, then the word *religio*, no less than the words *prudentia, ars* and *signum*, means nothing, makes no sense, unless we presuppose a freedom of some sort. (158)

Were this freedom not present then all man's efforts to attain truth, love, and justice, would be set at nought as governed by a prior command upon his nature. And as we all recognise, love under the yoke of compulsion is impossible.

As with the will of *homo faber*, so with his works. That 'art is the sole intransitive activity of man', is indicative of the freedom of man, in perfecting his works, to perfect himself, as 'intransitivity and gratuitousness in man's art ... is the sign of man's uniqueness'. Moreover, 'the animals, lacking choice, are excluded from Prudentia and though they share man's corporeality they are excluded from Ars, again for lack of this power of choice which man alone shares with the incorporeal intelligences'. (150) It is true 'that works of meticulous perfection and beauty of many kinds are commonly produced by beasts of many kinds'. (149) But such works are more the product of a creature 'subject to a pure determinism ... e.g. the reflexes of its own instincts'. (148) In such 'animalic making' there is no 'evidence of the gratuitous, nor is there any evidence of "sign". This making is wholly functional, these activities are transitive'. (149)[9]

This gratuitous character of man's making can be thought of as a kind of play since 'this "intransitive activity" called art' seeks of its nature to evade the consequences of the "fall", (DG156) in that unity and harmony of inner and outer faculties that results from an act of perfectly realised making. Such intransitive activity 'passes over' to another order that is beauty made manifest, a 'felicitous quality', (154) shown forth in the work itself by means of that sense of 'fun' or 'play'

9. However, this does not rule out the possibility that such 'animalic making' might be made subsequently intransitive by man, as this passage from *The Sleeping Lord* indicates: 'the tall, tapering, flax-cored candela of pure wax (the natural produce of the creatures labouring in the royal hives but made a true artefact by the best chandlers of the royal *maenol*'. (SL76)

that is not the goal of man's making but none the less perfects the productive operation. It is the immanent Logos that permits such 'showing forth', for 'it is Holy Wisdom herself who says *ludo* She was with the Logos when all things were formed, "playing before him at all times" and as the Knox translation puts it: "I made play in this world of dust, with the sons of Adam for my play-fellows".' (154)

This sense of play is far removed from any notion of 'art for art's sake', for, even though 'it must be understood that "art" *as such* is "heaven", it has outflanked "the fall"' (DG164)—as he says earlier in his essay 'Art in Relation to War'—in its operations in the world of fact [*ars*] only makes the fall more obvious'. "(DG156) For the Fall incurs the misalignment and disharmony of our inner and outer faculties in which human making becomes a burden of sin that disrupts the proper ordering of the Logos.

This clarifies what Jones means when he refers to the 'disinterested-ness' of art: 'I understand the theologians to say that God's creation of the cosmos was a gratuitous act: it is interesting therefore that it is that very quality of gratuitousness which we recognise in the creative works of man'. (275) Here, we must make a distinction between the practice of art as instrumental cause and the artist as creative agent. It is said of the former that its work is done 'disinterestedly' for no other reason than the good that is the integral perfection of the task in hand. However, the artist, as a creative agent, is not similarly 'disinterested', for as a rational and moral being he may act to other ends unconnected with the exercise of his art. The work of the Creation was certainly a gratuitous act, but in so acting God had in mind an end which was, in Maritain's words, 'of an order superior to the art—the communication of the divine Goodness'.

It is instructive to consider Jones's many statements on the gratui-tousness of art alongside those of Meister Eckhart collated by Coomaraswamy. As we have seen, and as Jones holds, 'Man is either in some sense and to some degree a free agent or he does not exist'. Thus it can be said he is 'a creature which is not only capable of gratuitous acts but of which it can be said that such acts are this creature's hall-mark and sign-manual'. (148) And further, there is a real analogy between such a 'showing forth again under forms' (177) and the works of God, for art is alike in man and God, human 'making being the agent of God's creativity in the sense that, as Eckhart says,

'finding thee ready, he is obliged to act, to overflow into thee; just as
the sun must needs burst forth when the air is bright, and is unable
to contain itself'. And, as Coomaraswamy adds,

> the 'being ready' is otherwise expressed as matter's being 'insati-
> able for form'; so God 'must do willy-nilly', according to his
> nature, without a why. In man this becomes what has been
> called the gratuitousness of art: 'man ought not to work for any
> why, not for God not for his glory nor for anything at all that is
> outside him, but only for that which is his being, his very life
> within him'.[10]

Such a passage throws into sharper relief Jones's statement that,
'man is a creature whose end is extra-mundane and whose nature is
to make things and that the things made are not only things of
mundane requirement but are of necessity the signs of something
other'. (150) 'At the root of the matter', he argues further,

> Ars knows only a 'sacred' activity. I believe this must be so once
> we grant that the notion of 'sign' cannot be separated from this
> activity of art. Why, granted the sign-making nature of man's
> art must those signs be 'sacred'? Is 'sacredness' implicit in 'sign'?
> I think it to be so if we assent to what philosophers say about
> 'being', *esse* ... for anything to be real it must have esse'. (157)

If, as Jones subscribes, man is 'understood to be a creature whose
informing principle of soul is rational; a creature who is unlike any
other corporeal creature in having a measure of freedom of will
and hence committed, of its nature, to what is labelled "faith and
morals",' (148) then the gratuitousness of art only makes sense in
respect of a freedom to perfect his actions in relation to the demands
that pertain to his 'extra mundane' and 'last end': absolute freedom—
'the state of eternal felicity'. (148) This is the territory of prudence.

The relation of art to prudence 'is a degree of freedom of some
sort that causes man to be, of necessity, an artist and the same
freedom of sorts commits him of necessity to Prudentia'. (150) But we
must understand that, 'the one is concerned only for our intentions
and dispositions, and the other only for the formal dispositions that

10. *The Transformation of Nature in Art*, (1934), p.88.

comprise an artefact. One cares for us and our final condition, the other for the work and *its* final condition'. (125) Here Jones is echoing St Thomas, and Gill, in seeing that the whole of the active life of man comprises a doing governed by prudence and a making governed by art, prudence being the norm of conduct, art the norm of work-manship and both depending for their correction upon the con-templative life.

From the standpoint of practical action, Jones continues,

> our final condition or last end is not yet, whereas our artefacts have their completion now or never. For which reason, while Prudentia is exercised about our intentions, Ars is concerned with the shape of a finished article. She *cannot*, as the other *must*, wait till the Judgement. (125)

At which Judgement the question of sin becomes relevant, for just as there is a moral sin so there is an artistic sin, the former allowing discernment to be overridden by illusion and wickedness, the latter by an insufficient reason. Sin arises in connection with art when there is, as St Thomas says, a 'departure from the particular end intended by the artist' and in connection with doing when there is a 'departure from the general end of human life . . . for the former sin the artist is blamed as an artist; while for the latter he is blamed as a man'. So, as Jones observes,

> it emerges that both [Ars and Prudentia] are concerned with the proper integration and perfection of shape, in the one case that of persons and in the other of perishable things. Both then are concerned with what is patient of being 'devoted', 'laid up from other things', 'consecrated to divine use', made anathe-mata in some sense or other'. (125)

If it is art that discerns and applies the means of attaining the 'proper integration and perfection of shape' in the good of the work to be done, then as Maritain concludes, it is prudence that 'discerns and applies the means of attaining our moral ends, which are them-selves subordinate to the ultimate end of all human life—that is to say, God'. Implicit in this 'perfection of shape' is the perfecting of one's self, for as 'man is a maker he, in one sense, makes the shape even of himself'. (86)

Here again Jones restates traditional doctrine. The final attainment envisaged in all sapiential wisdom is that vision of man as he is in God—knowledge of the Self. This remains the perennial quest of human life. Art, in the final analysis, must in some way endorse this end if it is to avoid, on the one hand, the mere exercise of sensibility, and on the other labour undertaken merely for the sake of utility; this later achieving 'the vacuity and deprivation apparent in the thousand-and-one utensils and impedimenta of our daily lives, domestic or public'. (181) For all progress towards knowledge of 'our final condition' it is self-evident that 'the workman must be dead to himself while engaged upon the work, otherwise we have that sort of "self-expression" which is as undesirable in the painter or the writer as in the carpenter, the cantor, the half-back, or the cook". (110) The artist is not 'necessarily, a person vastly more aware than his friends and relations of the beauties of nature, but rather he is the person most aware of the nature of an art'. (29) In his possession of the 'habit of art' he is *moved by the nature of whatever art he practises*, (29) which is his by convention and training from 'some artist or some existing art-form', the exercise of which is corrected by that Self of which he makes himself the creature—an inspiration for which he is the 'vessel' never the author. And this lest he be, in Blake's words, 'seiz'd and giv'n into the hands of his own selfhood'—the empirical ego that is possessed *of* will but never in possession of free will.

The artist, '*homo faber*', 'sacrament-maker', as Jones variously calls him, is not a self-sufficient 'genius intent upon upsetting accepted values and conditions on the basis of personal innovation', but one whose 'self-possession' is the unifying principle in the integration of not only his own individuality but also the collective body politic. The immanent order to which art is signally conformable has its life ultimately in a transcendent, supra-human spiritual authority, and so cannot be imposed from outside the act of making by any temporal power—

> Any order, new or old, 'ours or theirs', local or a world-state, which binds the Muses, breaks the totems, and withdraws the people from contemplation, is already dead in the judgement of history, no matter what fanatic vitality shines in its morale, or however reputable its ethic. (100)

Again and again Jones drives home the nature of modern man's

crisis as the fundamental breakdown of a vision of man as *homo faber*, a breakdown that, so far as the modern world is concerned, has all the signs of being the death of true humanity. 'What shall it profit a community of men if it gain the whole world of political and economic and social rights and equalities and loses the "habit of art"?' (90)

Considered in relation to the tendency of our age to make something of a religion out of art, Jones's remarks on Wilde's dictum, 'Art for Art's sake', remain salutary. 'If not *the* truth the dictum at least contains '"a truth", if properly related to the whole behaviour of Man and not to the behaviour of special sorts of men such as can only exist in the tired and artificial phases of late civilizations'. (95) Certainly, as Jones points out, 'the "aesthetic" in man will out', seeing that a need and longing for the beautiful are natural to man. But the beauty man needs is connatural with his intelligence—what the scholastics termed the 'radiance of truth' that inspires a liberating joy. Rightly, as Jones, echoing Gill, acknowledges, 'the true aesthetic nature of man ... must find an unconscious fulfilment'. Whenever and wherever art is granted its natural role as the norm of workmanship there is a justice and harmony in man's 'sacrament-making' in which the specific aesthetic need of man is taken care of. But, as is the case with what Jones calls 'megapolitan man today', the aesthetic as such has become that eccentricity, an end in itself.

> If the art of some men is abnormal it is because most men have been made so *sub*-normal as to have no art to practise ... only it is well that this deprivation should be understood to be eccentric and not concentric in Man. We may be forced to accept the situation in the world of fact, but to accept it as normal is the final capitulation. (95)

Are the Crafts an Anachronism?

IN this chapter further consideration is given to the question of what might be the deeper implications of the fact that, in a world in which they have only a marginal social role and almost no economic justification, the handicrafts never entirely concede defeat to the by now global industrial method of manufacture. In essence this amounts to asking whether the crafts are an anachronism or whether they have an intrinsic significance for a society that is sustained minute by minute by a highly sophisticated array of technological products that are about as far away from the world of traditional handicrafts as it is possible to get.

Yet that slow, painstaking, time-consuming method of making things by hand will not die even in the face of a system of production, distribution and consumption that by all reasonable estimates should long ago have eradicated it. Have we not, after all, solved the problem of making sufficient things for our needs? Surely our machines do that for us? And as a result are we not freed to engage with higher things? Somehow a stubborn, nagging doubt persists.

The current state of our post-industrial society would seem to suggest that the 'higher' things have eluded our grasp and we have been left empty-handed. There is a widespread sense that the 'leisure-society' does not provide us with those long-promised—yet so often postponed—life-sustaining satisfactions. And alongside this there is the growing realisation that the material wealth of our society has been achieved at the expense of meaningfulness in the workplace.

In asking whether or not the crafts are an anachronism are we not tacitly admitting to the fact that there is something more to them than simply the methods and procedures they employ: that they are more than an outmoded way of making things? For if the whole question of *how* things should be made could be answered without reference to the question, by *whom?* and for *what?*, then we would scarcely be interested at all in any particular method of manufacture. Each improvement in efficiency would automatically make any previous method obsolete and, except for a certain antiquarian application, the crafts would certainly have disappeared in the face of two centuries of industrial enterprise and all that that implies.

The fact that the crafts have never been entirely done away with as a way of meeting certain of our needs must suggest that they involve a dimension of human experience that goes beyond the complex interplay of intuitive, imaginative and manipulative skills which go toward mastering the material substance of the craft itself. And this in turn suggests that our enquiry as to the significance of the crafts must address itself not so much to the actual method of production as to the agent whose task it is to master and deploy the method of skill in question. For a thing to have significance it must signify something. It must be a sign of something, and signs point to values. And it is the unique gift of men and women to recognise values and the necessity to act upon them.

In view of our possession of this gift it is little use our arguing that the modern world has progressed beyond a crafts-based civilisation, as if the mere passage of time itself were capable of imposing upon human activity a value and a significance it would not otherwise have. For the world that surrounds contemporary urban man is in reality man's own construct, itself the result of adopting or rejecting certain values in favour of others. It cannot be argued that history makes us what we are, unalterably and inevitably, and therefore that history has decreed that the crafts have no necessary place in human affairs. For history is nothing more than the sum of human activities. Any world we make we can just as surely unmake. The fact that we currently express deep misgivings about the condition of the environment, a condition we ourselves have created, points to the fact that we are able to make an objective assessment and judgement from beyond the evolutionary process that is simply historical change as

such. We are not, in other words, hapless victims of our time and place; we do have access to a set of values that transcend what would otherwise be our total confinement to historical causality. This tells us more about the nature of man than perhaps it does about the nature of any process of manufacture. And it points to the importance and the necessity of our asking the fundamental question, 'What or *who* is man?'

This question, posed in one way or another, has been at the root of that now lengthy and continuing school of radical thought that has seen fit to call into question the direction and goals that industrial—and now by extension, post-industrial—society has set itself. This school of thought has, with reference to the manual trades and handicrafts, challenged the very foundations of modern society, built as it is on the almost total monopoly of industrial, mechanised production. What each of its dissenting voices has sounded is a warning against the danger of allowing the mechanical system a free rein in satisfying our human needs. These dissenters have seen, sometimes wholly, sometimes in part, that it is inherent in the very nature of such a system that it would eventually enslave men to those monetary and quantitative considerations that nourish merely the gods of economic efficiency. Such a system must inevitably lead not only to the dehumanisation of man but also to widespread social manipulation of the factors that determine what a 'need' is. That their fears were not ill-founded should by now be obvious. In every exhortation, in every forecast, in every appeal from our leaders as they urge us along the path of progress, the inducement is almost always exclusively that of 'economic growth'. And this in the face of a daily experience of life in which for great numbers of humanity 'the economy' is as vengeful a god as was ever dreamed of by our ancestors. (It was recently reported that one-and-a-half per cent of the workforce is displaced annually as a direct result of technological innovation and development.)

Even to pose our initial question is, of course, to admit to our conditioning by an environment which is almost entirely the product of the machine: an environment which harbours an inherent confusion as to the intrinsic merits of art, craft and work. For industrial man the distinction between art and work is quite clear. Art is the domain of aesthetic sensibility and work is the domain of productive effort.

And modern crafts inhabit an ill-defined terrain between the two, uneasily drawing from both. On the aesthetic side, the modern craftsman (seduced by the 'prestige' of the fine arts) sees temptation in the fact that the accidents of individual sensibility weigh favourably in the judgement of artistic success. On the side of skill, he recognises the necessity to demonstrate a disciplined mastery of materials as a mark of mature accomplishment. But because he is forced to operate within a society in which he has no natural patron (one who knows what *ought* to be made), the craftsman is marginalised by two dysfunctional conditions: on the one hand, the wide acceptance that 'artistic freedom' has a value in isolation from moral, rational and practical criteria, and on the other hand, the almost unquestioned assumption in the market-place that the necessities of life are taken care of by a method of production that places little or no value on manual skills. All this is symptomatic of a conflict in industrial society *because* it is a conflict within industrial man himself. For the modern worker is obliged to seek a livelihood in a system where the justice that is due to his humanity is in direct conflict with his economic survival. For we have set in place a society where the artist in us is free to work for the good of his feelings provided he does not expect, in so doing, the right to earn a livelihood. At the same time the workman in us is free to work for the good that is material necessity provided he does not thereby expect the right to an inherent satisfaction from the work he must do to secure a livelihood. What has been made all but impossible by the industrial system is that men and women can attain a livelihood by doing what is both aesthetically and morally sound and economically and practically valid, by a means that allows them both intellectual and spiritual responsibility.

We can perhaps sense more vividly the degree of impoverishment imposed by such a system if we contrast it with the value accorded the handicrafts by our ancestors, whose artifacts fill our ethnographical museums where they are revered for their skill and ageless beauty, and whose concept of the handicrafts is one that grants them nothing less than a sacred function. For it was traditionally the role of the crafts that, over and above serving practical ends, they were to serve the maintenance of the subtle link that binds together beauty and being, the severance of which has had such devastating consequences for the modern world. Unlike the situation that faces the

modern worker, in the traditional and sacred context of the crafts each member of society, in so far as he or she practises an art, is responsible as a moral being for the good use of the community, while at the same time being personally responsible for the intrinsic good of the thing he or she makes.

In *Ecclesiasticus* (38) it is said of the craftsman that in trusting to his hands 'every one is wise in his work', by which wisdom he 'will maintain the state of the world'. We can hardly fail to notice the parallel between such words and those quoted by the Indian scholar Stella Kramrisch, who says that according to traditional Indian belief and practice, every creature has a function (actually a craft vocation) which is fulfilled in the universe and deviation from which 'might even endanger the order of the universe'. This suggests that if the crafts have become an anachronism in our time this is not due to any inherent weakness or fault in the crafts themselves, but that we have assigned them a status that is considerably beneath the full dignity of their normal function.

The juggernaut of modern industrial enterprise is based upon the moral neutrality of capitalist investment which exploits the nature of usury to exert unrelenting pressure towards a purely quantitative, economic expansion. This essentially 'blind' process has created a society in which it is all but impossible to determine what qualitative criteria might apply to the concept of human needs and how those needs might best be met. In other words we are embroiled in a pattern of life that is hardly able to distinguish between what is a *real* need and what is an artificially stimulated appetite and so cannot distinguish satisfaction from superfluity. This makes it virtually impossible to determine what *must* be done (as opposed to what *can* be done) in order to unite our everyday life of making and doing with the reality that is the ultimate nature of our humanity. Indeed, such a system has an obvious vested interest in seeing that such divisions are never healed, all the better to manipulate the confusion and disharmony that inevitably manifest themselves in a demand for material consolations.

All men and women make things, and it is by skill, by the deliberate intent of the mind and its exertion towards what is other than mind— some occasion or material circumstance outside of the mind—that things get made. And since each and every one of us makes things by

the exercise of skill (which is the root meaning of art) each and every one of us is in some degree an artist. But behind our doing and making there is an agent or being who remains free and objective in relation to what is produced by the action that is applied skill. How we do and make does not determine our being so much as how we do and make is the very signature of our humanity. For if, by our 'fruits' we shall be 'known', then work, far from being nothing more than a utilitarian process must in some sense be capable of revealing the proper nature of our humanity. In other words action follows being. The converse would be to propose that action possesses within itself its own sufficient reason. The metaphysical objection to such a proposition is clearly stated by Eckhart:

> the work has no being, nor has the time in which it occurred, since it perishes in itself. Therefore it is neither good nor holy nor blessed, but rather the man is blessed in whom the fruit of the work remains, neither as time nor as work, but as a good disposition which is eternal with the spirit as the spirit is eternal in itself, and it is the spirit itself.

So we perhaps begin to see that work is not something we must be freed from—indeed cannot be freed from unless we are freed entirely from action—but something we must engage in in such a way and at such a level that it is revealing of our deepest nature. It must contribute to our spiritual life while serving our bodily needs.

The very opposite is the case with the industrial pattern of work which is part and parcel of a social ethos that continually holds out the promise of leisure as the reward for the time and effort put into work. But this escape to a state of freedom *from* work is not offered as something that will serve our spiritual needs. Far from it. The so-called 'leisure' of our consumer society is a parody of that spiritual condition of true inactivity, the contemplative interiority of a state of being in which we must finally acknowledge that we are only truly 'free' when we are released from the necessity to re-act to the demands of the external world.

The idleness that characterises the leisure society (where no one has time to do nothing) is a condition of sloth in which the will to act to some meaningful end is, as it were, suspended in a state of restless neutrality. The medieval schoolmen understood this to be

acedia which, as Josef Pieper explained in *Leisure as the Basis of Culture,*

> means that a man prefers to forgo the rights, or if you prefer, the claims, that belong to his nature. In a word, he does not want to be as God wants him to be, and that ultimately means that he does not wish to be what he really, fundamentally, *is* Metaphysically and theologically, the notion of *acedia* means that a man does not, in the last resort, give the consent of his will to his own being; that behind or beneath the dynamic activity of his existence, he is still not at one with himself, or, as the mediaeval writers would have said, face to face with the divine good within him.

From the Christian perspective the starting point of all discussion of work has to begin with man's expulsion from Paradise—the loss, or rather 'annexing', of the spiritual domain entailed by our being brought into our bodily life. Here the 'sweat' of labour is made necessary by our material needs and is suffered in the knowledge that it may form a channel or path along which the original undivided unity of being of our nature may be traced and re-made whole. In this primary sense the work of right-livelihood (it is the traditional role of the crafts to foster and preserve the sanctification of labour) is analogous to adopting the vocation of the contemplative life of prayer: the life of true inactivity. Work is prayer. Man at prayer and man at work, both turn in an inward direction away from the diverging, multiple impulses of the external world in order to effect a convergence of the soul's faculties towards a state of equilibrium that is an internal act of harmony and unity.

But whereas the 'work' of contemplative prayer is a withdrawal from the world, the work of making and doing necessarily involves us with the world. It is given to very few to withdraw from the world to live a life of prayer and solitude. The mass of men and women, unable to surmount the inevitable distractions and entanglements of their bodily and social existence, need the concentration and discipline of a practical vocation in order to restore the inner balance and harmony that is their proper being.

So we may recognise that at its highest point of efficacy, inspired work, as with prayer, arrests the scattered sentient powers of the soul so that the workman becomes by degrees dead to his empirical ego

as he approaches a state of perfect action. In this convergent movement of his being, initiated by the discipline of a skill (the very words 'discipline' and 'skill' imply of necessity a mastery over something 'other' that is the opposite of *self*-indulgence), the subtle process whereby the workman comes 'face to face with the divine good within him' can begin. Thus, by degrees we become detached from the contrary states that constitute the dualistic nature of our existence; life and death, spirit and matter, inner and outer, subject and object, pain and joy, so we are less the passive recipient of these contrary demands and more the instrument of the harmony and balance that transcends them. Thus conformed to the intelligible order of the Logos within, we become more the subject and vessel of the Creator and less the object of external contradictions. To use apophatic, Eckhartian terms, it is already a step towards God to see the Creation as his abundant gifts to us. It is another step nearer to want Him more than his gifts.

But, it is one thing to allow that because the mass of men and women are more or less excluded from the state of contemplative perfection, so they must be allowed the relative 'freedom' of exploring their creativity, and quite another to claim that such creativity must proliferate on its own terms. For human action, let it be repeated, cannot be its own justification. For man is, primarily, called upon to understand the reason for his existence. Without such an understanding he cannot hope, beneficially, to relate his thoughts and subsequent actions to the underlying order of the reality of which he comprises only a part. Action cannot be free from the rigour and necessity of the primordial qualities of beauty and perfection if it is to take account of the 'divine good within'.

All traditions speak of human intelligence as having a sacred function precisely because the human *per se* is indefinable except in terms of the Divine. Suspended as he is between celestial and diabolic forces it is in turn only man's capacity to recapitulate what transcends him that grants him a legitimate dominion over the world of nature. Which is why only man can conceive of an earthly paradise and why, conversely, in denying what is above him, only man can create a hell on earth.

While it is certainly true that the crafts, in their material aspect, have their foundation in the external necessities of our existence

which demands that we feed, shelter and clothe our bodies, none the less, the origin of the crafts is rooted in the cosmological idea that the very substance of the world, in virtue of its being part of the Creation, is the 'body' of God—the manifest aspect of the unmanifest Divine Principle. It is the reflection of this on the human plane that permits the analogous symbolism of the craftsman as one who creates in imitation of God's act of creating the world. The sacred crafts re-enact, at the existential level of the material creation, the primordial act of cosmo-genesis. That is to say, on the human plane, perfect doing and making consists in the true alignment of mind, eye and hand as a recapitulation of the Divine perfection of the world that is the true alignment of the spiritual, the psyche (of the soul) and the bodily in a movement from potentiality to act.

If the crafts were not able to effect such a true alignment then we would not find in all traditional texts (such as we have already quoted from Christian and Hindu sources) passages that speak of the crafts-man as upholding and maintaining the order of the universe. What is implied in all such texts is the idea that one's first and immediate duty and one's last or ultimate end must become coincident as comprising a unity. *Justice* is that which is conformable to a law, or to a rule, *order* is due place or rank and *proportion* a due share or order of a part in relation to a whole. These ideas are semantically related in signifying a relationship of harmonious unity among disparate parts, a unity that reflects the equilibrium of the universal order. Obviously there can be no right-livelihood in the things of injustice, disorder and disproportion any more than it is conceivable that men and women could consecrate to God work that is flippant, indulgent and superfluous.

Even the most cursory glance at the contents of our ethnographical museums will give abundant evidence of the symbolic aspect of the crafts. For not only in those things produced by the crafts—pottery, weaving, building, clothes, carpentry and so on—but also in the very instruments of the crafts themselves, we find a rich language of symbolism indicative of their spiritual status. For instance, Christ, as the incarnate Divine Principle, and thus 'in whom all things are made', was a carpenter—one who works wood. Owing to its ubiquity as the primary substance to be worked in meeting so many practical and material needs, as well as its plasticity in accep-

ting so many diverse forms, wood symbolically conforms to the *prima materia* of the Creation. (Swedenborg received a revelation of wood as the symbol of the celestial goodness in its lowest corporeal plane.)

St Bonaventure points out in his treatise *The Reduction of the Arts to Theology*, that St Augustine said the Son of God is the 'art of the Father': through whom, it may be added, we are enabled to see the beginning and end of all things; that is, what is right and true. As St Bonaventure also points out, one sense of the word 'right' is that a thing's middle is not out of line with its extreme points. In the similar way a carpenter works a piece of wood, checking to see that it is *true* (from 'fidelity', 'trust', OE *tréo*, giving English 'tree'—'as firm and straight as a tree'), by the use of a *rule* (from 'regular', measuring-bar, pattern of conduct, a discipline) that tells him if the middle is aligned with its beginning and its end. His tools are no less symbolically assimilable to the Divine process or causes that shape the *materia* of the universe. Moreover, Christ, as the 'beginning' and 'end' of all things, was sacrificed on a wooden cross, in turn assimilable to the tree of life or world axis that holds heaven and earth together. The richness of such symbolic correspondences, which could easily be elaborated, should be sufficient to illustrate the cosmic function of the craftsman.

What we do not find is that the mass of men and women in remote ages satisfied their material needs in some unsophisticated and brutish fashion with an eye only to efficient and pragmatic solutions. On the contrary, in serving material needs the maker keeps his ocular vision on the immediate and contingent requirements of the task at hand. But at the same time he keeps the inner eye of spiritual vision on those things that relate to his final end—the fact that he is a created and creative part of that sacred reality that is the world. By so doing he produces an environment that forms the living context for the human spirit to participate in the cyclic rhythms of nature that are themselves a reflection of the cosmic rhythms of the universe. For just as the principle of nature is rhythmic organisation and order, so the principle of manufacture is the ordering of matter according to an intelligible pattern. By his most common and repeated actions the craftsman integrates himself with the vast, powerful, fructifying sources of reality so that his individual existence is not projected into a meaningless expanse of time and space. For, essentially, the arts and

crafts are the application of a science of rhythm, as René Guénon has pointed out; the phonetic arts being the application of the rhythm of succession deployed in time and the plastic arts being the application of the rhythm of simultaneity deployed in space. By contrast, in the industrial milieu, time is speeded up and space becomes merely indefinite extension. In so doing they erode, and eventually abolish, the meaningful relationship of the temporal with the eternal and the finite with the infinite. Time and space lose their spiritual signifi-cance as the primary ordering principles of orientation for the 'place' and 'direction' of human vocation and destiny.

The technological environment projects man into a progress that disrupts the cyclical and periodic rhythms of time, to replace them with the open-ended future of an indefinite development. In such an environment, space that is normally experienced as locally qualified extension—as the 'container' of events—becomes the generalised field of a 'freedom' paradoxically experienced as oppressive and where man is subject to the forces of inertia and compression in the physical realm and acceleration and dispersion in the psychological realm.

The sacramental and ritual character of the traditional crafts, on the other hand, actualises the numinous context of time and space by formalising and embodying the link between the inner contempla-tive domain of the soul on the one hand and the outer active domain of the body on the other. These two domains are, however, not dis-crete or disjunctive but complementary, dual facets of the one same reality in its transcendent and immanent, objective and subjective modes. This sacramental character places a heavier emphasis on the agent of action—the quality of the humanity of the maker—in the productive process than it does on the technical means of manu-facture. This is again quite the opposite situation facing the industrial worker whose complicity is with a mechanised technique in which almost his entire work function has been systematised as a result of someone else's conception and design. This is to devitalise the work process, emptying it of precisely those external, manipulative chal-lenges and internal, psychological satisfactions that give meaning and value to the experience of work. And what else could what we call soul-destroying work be but just such an absence or devita-lization? Seen in this light we can better appreciate what is lost in the

progressive model of industrial production, where the worker is always prey to the indiscriminate development of the working environment, a process that anaesthetises his soul as the price demanded for its own survival.

With the traditional crafts the means of production are kept as close as possible to the fundamental interaction of hand and mind, with the eye as intermediary, sight being the agent of both perception and action. This economy of instrumental means allows the manipulative and visual faculties their closest collaboration with the intellect, which then acts as the motive source of the worker's skill.

The intimate link between the crafts and ritual, work and prayer, action and spirituality, has been fostered and transmitted by the guild societies in all traditional cultures. In India, for instance, the presiding god of craftsmen is Visvakarma, sum total of consciousness, knowledge and inspiration, the architect of the universe, in whom resides the Divine skill that is revealed to the craftsman through the sacred texts and oral transmission of traditional doctrines and disciplines.

In the Christian tradition, all wisdom, knowledge and ability ultimately descends through Christ, from the Father. St Bonaventure, for instance, conceives the mechanical arts as resulting from the illumination of knowledge, which illumination (or light) is, in the final analysis, coterminous with the Divine Light that is the Logos that illumines each and every being and goodness present in the world.

From the Islamic perspective, the arts and crafts are like so many formal crystallisations in the realm of multiplicity of the Divine Unity that is the inner reality of the Koran made manifest by the Prophet and his companion 'Ali, the founder of Islamic calligraphy and patron of all the guilds.

The existence of the guilds, in both East and West, was for the purpose of nurturing and sustaining an initiatory knowledge in which art, craft, work, science, mechanics, dynamics, geometry and so on are all categories of thought and forms of wisdom—*sapientia*. This illumination of the mind corrects and perfects the intuitive knowledge of a thing's essence and how it is to be realised in some outward form and is analogous to the trans-mundane light of the Divine Intellect throwing an illuminated pattern on the mirror of

the human intelligence. The rays or threads of this transcendent light can be likened to translucent states of being held in hierarchic suspension from their ultimate source in the infinite perfection of the Divine Principle that is the spirit of God.[1] The purpose of the activity that is the particular craft skill is to follow the rigours of a discipline such that, in accomplishing inner and outer mastery, there is a perfect integration of bodily activity, imaginative conception and spiritual illumination—wholeness of being, in fact. This traditional practice of the trades presupposes that each thing to be made, each action to be undertaken, has itself a norm of perfection—that which enables it, through the agency of intellectual determination and manual skill, to attain its true and essential nature.[2]

1. That such a doctrine was still dependably current among his readers could be assumed by George Herbert when in the 1630's he wrote in the last stanza of his poem 'Mattens',

> Teach me thy love to know
> That this new light, which now I see,
> May both the work and workman show:
> Then by a sunne-beam I will climb to thee.

However, by around 1810 perhaps fewer of William Blake's readers would have recognised the allusion to the same doctrine in these famous lines:

> I give you the end of a golden string,
> Only wind it into a ball:
> It will lead you in at Heaven's gate
> Built in Jerusalem's wall.

2. 'The Tea Ceremony signifies that we ought to perform all the activities and manipulations of daily life according to primordial perfections, which is pure symbolism, pure consciousness of the Essential, perfect beauty and self-mastery. The intention is basically the same in the craft initiation of the West—including Islam—but the formal foundation is then the production of useful objects and not the symbolism of gestures; this being so, the stone mason intends, parallel to his work, to fashion his soul in view of union with God. And thus there is to be found in all the crafts and all the arts a spiritual model that, in the Muslim world, often refers to one of the prophets mentioned in the Koran; any professional or homemaking activity is a kind of revelation. As for the adherents of Zen, they readily seek their inspiration in "ordinary life", not because it is trivial, to be sure, but because— inasmuch as it is woven of symbolisms—it mysteriously implies the "Buddha nature".' Frithjof Schuon, *The Eye of the Heart*, (1997), pp.140–41.

From the foregoing observations it will be clear that an answer to the question 'are the crafts an anachronism'? cannot be simple, for it depends upon what we admit is involved in their practice. If we see all work as simply the pragmatic means by which we satisfy our material needs, then of course the crafts are outmoded as a way of producing the necessities of life. But any study of the traditional conception of the crafts, and of the human self-image that is integral to them, reveals a more complex picture; one that touches upon spiritual factors that at best have been obscured or debased in the way work is understood in the modern world. However, such a study obliges us to recognise that there are social, economic, as well as spiritual conditions required for the traditional conception of human vocation to function properly; conditions hardly in providential alignment in the modern world. Indeed, it should be said that the modern world is the result of having these conditions misaligned. But that does not permit us to dismiss as speculative fancy what a study of the crafts is capable of revealing, both about the nature of the human agent of the crafts and about the spiritual milieu the crafts are capable of embodying. From the standpoint of contemporary conditions we are in the position of one who, faced with a mountain and not having the full means to ascend it, is none the less neither in a position to deny that the ascent is possible, nor to deny that the view from the summit is what it is.

The story of the Fall, of man's expulsion from the Heavenly Paradise, is the story of man's having to live 'by the sweat of his brow'. That much is inescapable. But does it follow that we are condemned to a life of brute exertion without redemption? Machines may have relieved us of a good deal of physical hardship but at the price, to say the least, of introducing a scale and pattern of work that makes for much soulless drudgery. And we know ourselves to have a soul as surely as we register when our soul is not given its due. As to our redemption, from the standpoint of a study of the crafts as the instrument and repository of sacred culture, the answer is unequivocal. In their natural habitat the crafts presuppose an analogical and effective relationship between labour and spiritual edification in which work has both dignity and sanctity. To work in this context is to seek purification through discipline. And because there is no freedom without discipline, so it is possible for our vocation to be

exemplified in the mastery of a practical skill as the best and most natural means to dispose our salvation.[3] This makes it possible for our first duty as spiritual beings to be coincident with our responsibility as social beings. For as surely as 'rights' incur responsibilities, so ultimately we can only concede our neighbours' 'rights' on the basis of their spiritual freedom to realise his or her deiformity. We are surely entitled to ask whether the industrial system presents a more dignified, and in the end, a more realistic paradigm.

But if we insist that the answer to our initial question—Are the crafts an anachronism?—is yes, then what have we admitted? We have admitted to there being no possibility of an inner perfection in whatever we labour at. With that confirmed and in the name of consistency, we must go on to admit that labour is a monstrous encumbrance without value, and that learning is a mere gathering of information without meaning, the final goal of both being mechanical efficiency. In which case both had better be dealt with by machines, as indeed we see is attempted, by the 'leisure industry' on the one hand and by the computer on the other. But this does not answer, so much as shelve, the question of *why* we should labour and think at all! As we have already suggested, it is precisely spiritual and qualitative values and meanings[4] that determine what *ought* to be done as opposed to what simply *can* be done.

The extensive range of mechanised contrivances we call modern industry assumes the destruction of the crafts as inimical to its survival. Such indeed is its very *raison d'être*. It is not in the interests of such a system to awaken in those it enslaves any intimation of possibilities the system itself cannot satisfy. There is an exact common measure between the fact that in the post-industrial society the body, no longer challenged as the instrument of creative work, has become a complex of organs appealed to only in as much as they are able to

3. 'Let every man abide in the same calling wherein he was called. Art thou called *being* servant? care not for it: but if thou mayest be made free, use *it* rather'. 1 Corinthians 7:20–21

4. To mean something is to have in mind a cognitive intent. Hence it is to signify the actual and effective penetration of the intelligence by a cognitive value. The value of anything implies an equivalent exchange of something; here a cognitive worth that enters a given state of being by that which is adequate to it. In such an effective penetration Beauty, Goodness and Truth presuppose the possibility of our elevation from lower to higher states of being.

feel. How else can we explain that the blandishments of the advertising industry are directed almost exclusively towards convenience and gratification—the stimulation and indulgence of bodily sensation. A consumer society such as we know it could not function except in a world where the body has little to do but concern itself with its appetites—and these a mere palliative.

What alienates us from an environment made up almost entirely of the products of industrial technology is the fact that such products could not exist except by means of a system of manufacture that is first and foremost founded upon the destruction of the sacred status of human vocation. And, as an entailment of that destruction, the erosion and eventual obliteration of the natural context of that vocation—the direct, vital experience of birth, death, generation, the natural and lunar cycles, the whole panoply of the heavens and the earth, water, land, river, tree, stone and flower through which the order of the sacred is mediated to man's experience.

If we look to the beauty of the crafts and all that they have engendered, it is to seek liberation from the enslavement of our own misdoings. Nothing is more natural to man than that he should achieve a lasting standard as a bulwark against the inevitable transience of his earthly life. What is that standard to be? That is the real question posed by the crafts.

Why do the crafts continue to occupy our attention? Surely it is because we are still capable of recognising in them a mirror image, however faint, of what it is we might yet become. We do best to honour that image by acknowledging that, in all but abandoning the crafts in favour of industrial means of production, we have lost a significant portion of what it means to be fully human. The anachronism of the crafts is achieved at the cost of our own disfigurement.

Michael Cardew:
The Potter as Primordial Maker

A vessel is hollowed by moulding clay, but the empty space where nothing
exists makes the pot effective Therefore, whereas the tangible [the existent]
serves for the possession, it is the intangible [the non-existent]
that makes it effective.
Adapted from the *Tao Te Ching*

As we have seen from the preceding studies, those who have
radically questioned the prevailing status of industrial production
have all recognised that the ultimate value of work is as much related
to the needs of the soul as to the needs of the body. They have sought
to re-awaken in the modern mind the idea that it is essential to
human well-being so to arrange the production of necessary things
that the spiritual aspiration that is at the heart of work is defended as
its guiding principle. In attempting to locate and arrest the pro-
gressive dehumanisation of man, those voices have been raised not
out of some misplaced nostalgia for the past, but out of a funda-
mental conviction that the industrial method is deeply flawed and
represents a distortion, a curtailment, of what it means to be human.
It is hardly surprising that the defence of manual skills as a repository
of human values has been made, in many cases, by practitioners of the
crafts.

To the practical and polemical challenge of those who have al-
ready been mentioned must certainly be added the name of Michael
Cardew. To turn to his example as a demonstration of the organic
unity of manual skill, material substance and productive method is
possible because the art of the potter represents the condition of
human work in its most primordial mode. For the potter brings man
into the closest possible contact with material substance as such. Not
only does he utilise the four elements—fire, air, earth and water—
but for the most part not even a rudimentary tool intervenes bet-

ween the worker and the substance that he works. In foregoing the usual intermediary of an instrumental technique the potter makes of himself the tool needed to effect his purposes. He above all others most directly experiences the demands placed upon his inner resources as a workman.

The true potter establishes his workshop where nature provides a plentiful supply of clay. He digs the substance of his trade himself from the immediate environment. The raw clay must be made ready for his work, a process that is demanding of his physical effort. This bodily effort of blending and de-airing the clay allows the potter to establish a rapport with his material, feeling for its possibilities, testing its readiness to receive the imprint of its final shape. For the possibilities of clay belong to clay as to no other substance. Its potentiality for form is unique to itself. The pulse of its life is different from that of wood or stone or metal. This pulse the potter feels and absorbs in the preparation of his material. What might seem to the outsider to be a physical drudgery that could be dispensed with by the use of a machine, once the tension of aching muscles and the stubborn matter of the clay are fused, becomes a subtle process of physical transformation whereby the resistance of the body is resolved and energised and the demands of the ego are stilled. The soul of the potter and the soul of the clay must, after all, become one if there is to be harmony between the worker and his work. In this necessary transmutation the ego has no place.

The potter works on the clay as if on himself. Intuitively he is possessed by the 'not-self' of the clay's substance, drawing it into his own being. What the clay comes to express is nothing other than the potter's being, at the same time as it expresses what it is its own nature to be. The inner form of the worked clay becomes the substance of the potter, as the soul of the potter is made malleable by the outward, physical effort of preparing the clay. The prepared clay becomes the receptacle of the potter's intention as the potter's skill becomes the vehicle for the realisation of the clay's final outward shape. By means of this interchange the potter and the pot are drawn towards that perfect formation that is their mutual fullest potentiality for being. The qualitative imprint of the pot is within the potter in so far as it is renewed endlessly through the potter's skill in exploring the clay's very plasticity. The perfect form of the operative

action resides in the clay in so far as the clay variously provides the occasion for its embodiment. This intuitive reciprocity of maker and made, physical and mental, inner and outer, form and substance, imposition and receptivity, is brought about by that self-denying discipline that is the informing principle of consummate skill.

By developing the habit of prolonged concentration upon his repetitive tasks the potter induces in himself a state of physical and mental integration, a state of receptivity whereby the conscious effort of actually forming his material becomes effortless and unconscious. This state permits his inspiration to flow unheeded and for the resulting work to embody those hidden possibilities of formal beauty that reside, as it were, objectively in the clay. For the artefact that is true to its archetype must be free from the idiosyncrasies of the personality of its maker. It must eschew innovative contrivance for its own sake, and all painstaking effort must evaporate in a beauty and creative joy that are at one with the nature of the materials in question.

In working 'objectively' upon the outer product of his skill, so the potter must equally concentrate 'subjectively' upon the inner substance of his being. For the potter inner and outer are literally two faces of the same reality while his hands manipulate the clay. In his exploration of space he works continually with the sphere—the most perfect symbol of unity—as the guiding yet unmanifest paradigm that informs his every move as he brings given centrifugal force and applied physical pressure into creative interplay. For the potter the 'face' of reality is the complementarity of convex and concave. The convex surface radiating outwards is complemented by the concave surface that concentrates inwards. The concave nurtures the inner potentiality of the form's coming into being—the seed of fertility and growth hidden in the darkness of what is unseen. The convex presents an outward, light-reflecting surface—applied knowledge drawing out and imposing limitations of being upon material substance. Nothing intervenes between the creative agent and the character of the material that is in the process of being formed. The challenge upon the potter's inner resources is due to the fact that clay, in its working state, is formless and yet is receptive to all forms. As Cardew notes, all the discipline to form must come from the potter, who has to overcome the paradoxical fact that because clay will easily respond to any treatment it is most difficult to control.

It was from the Japanese potter Shoji Hamada that Cardew first learned that 'technical accomplishment counts for little beside inner life'.[1] In learning, during his apprentice years with Hamada and Bernard Leach, that there is more to pottery than being merely an efficient producer, Cardew also learned that 'whatever you made would have its own indelible character, good or bad; and this character was the most important part of the pot, and necessarily came straight out of "the real you".' This does not mean that 'moral beauty necessarily produces artistic beauty—it obviously doesn't', but that an operative and harmonious balance between technical mastery, aesthetic beauty and 'ethical rightness' is only achieved by maintaining a standard of utility in repetitive, practical work: 'You must make pots unceasingly even if they betray—as they almost certainly will—the worst as well as the best in you'.

This repetitive work, an essential part of the potter's craft, has a fundamentally important function. Cardew claimed that a man who gets bored making the same pot over and over again was not fit to be a potter at all. But more than this the very act of repetition imparts a sort of non-conscious condition into the creative act itself. The self-conscious, contriving part of the mind is stilled sufficiently for the clay to respond immediately to disciplined bodily action, so that the potter will 'find himself making pots as naturally as a tree makes leaves or fruits', as he put it in his essay 'The Fatal Impact'.

There is considerable significance in the fact that in inducing this state of 'no-mind', as we may call it, Cardew rejected the 'fallacy in the gospel of labour-saving devices'. It was doing the 'donkey work' with his own hands and muscles that brought him into a deeper rapport with his materials, as well as polarising his mind in preparation for the task in hand—the rhythm and tempo of kneading the raw clay, drawing the potter's being into the pre-formal essence of the pot soon to come to life at his finger tips. From this process it emerges, as with all the elementary crafts, that 'every touch by the potter is *physiognomic*—that is, it is an infallible guide to his real character, to

1. The quotations from Cardew's writings for which no sources are given are taken from his posthumously published autobiography, *Michael Cardew: Pioneer Potter* (1988), and 'Michael Cardew at 75', compiled by Len Dutton, *Ceramics Review*, No 40, July/August 1976, pp.4-10. A bibliography of his uncollected writings can be found in *Michael Cardew, a collection of essays*, Crafts Advisory Committee, (London, 1976).

the state of his mind (or his soul)'. Moreover, 'the more you enter into a long campaign of exploring the inner character of even a simple form, the more completely and excitingly it reveals itself with each new realisation on the wheel'. As Cardew himself put it in his essay 'Stoneware Pottery', the revelation of form is a living reciprocity of inner and outer worlds, of 'technique and inspiration ... as much one as the inner and outer faces of a crystal surface.' The potter

> starts by thinking he wants to express something in clay, but after a time (if he is any good) the clay takes charge and expresses something through him ... it is a right and proper state of affairs—the technical processes and materials are not a category distinct and separate from the expression the artist makes from them. On the contrary, they are themselves part and parcel of the meaning which he can only express by end-lessly studying their structure and the minutest subtleties of their behaviour: finding out what the material wants to say is the only way to say anything through the material. A good potter loves clay disinterestedly, for its own character, not because it is an obedient mirror for his own personal ideas, however, interesting they may be.

If, at the start, the potter senses there is something missing from his work, it is likely that he will feel an impulse to put something there by means of a 'deliberate willed injection of personality'. In 'Potters and Amateur Pottery', Cardew warned against this:

> It's a mistake because the something which is missing—call it character or personality or originality or whatever you prefer—is in fact a very mysterious and elusive thing, which cannot be pinned down and captured by a direct assault. The only chance of catching it is by stalking and taking it by surprise; you have to approach the mystery by an indirect road. This indirect road is skill, or craftsmanship—not only manual control, dexterity, efficiency, and all those things, but also expertise, learning how to overcome all sorts of technical difficulties and all the various obstacles which nature puts in the way of art ... skill is the channel along which your creative juices can flow.

Skill, he wrote elsewhere, 'like any other regimen or course of

training, is not an end in itself but a means to something beyond it'. In other words the workman does not work to express his 'skill' for its own sake, or a 'style' for its own sake, or work merely for the sake of work alone, for all these 'accidents' of his activity will inevitably express what little of his 'personality' needs to be present in the finished work.

Not only is it obvious that by the industrial method it is the machine that overcomes the 'technical difficulties and obstacles which nature puts in the way of art', but also that the channel of skill is by the same method circumvented and so forecloses on the exercise of art. The notion of difficulty implies *that* by which it is overcome. The good workman values difficulty in his work, not for its own sake, but in so far as it challenges his powers of invention and accomplishment. This points to the presence in work of something more than the efficient and routine manipulation of matter. Difficulty is a form of self-revelation through conquest, by the human person, over the brute nature of matter. It is a momentary conquest of those exterior circumstances that impose themselves upon us and which obscure or distort the mirror of our self-knowing. These contingencies deflect us one way or another away from the simple and direct experience of that timeless self-absorption in which we are at one with ourselves and our actions but without which, paradoxically, we so rarely achieve that self-absorption. That is surely the heart of true work; true art. And is that not the reason why we are reluctant to give our heart-felt assent to work easily done, work that has not passed through the refining fire of discipline to emerge its triumphant master?

The 'willed injection of personality' is an attempt to introduce from outside the process of making something of a self-conscious aesthetic element that does not arise integrally from its production. It does not conduce to the realisation of the work's first cause, the bringing to perfection of what is first conceived in the mind's eye— the revelation of the maker's art. For just as the soul is the form of the body, so the art in the artist is the form of the work. No less false than this intrusion of self-consciousness into the proper integral order of workmanship is the ruthlessly imposed industrial idea of functional efficiency. In his essay 'Design' Cardew spoke of the effect such an imposition would have, of the pain and destruction it could cause, if the delicately balanced polarity of man's sensual and intellectual

involvement in the making process is denied. He thought that the deprivation and frustration would eventually drive people mad, and noted that it 'seems to some people to be exactly the way we are going at the present moment'.

Cardew's life and work have always been associated with the epithet 'pioneer', and it is necessary to an understanding of his achievement to remember on what this association rests. Cardew joined Shoji Hamada and Bernard Leach at the latter's St Ives pottery in the early 1920's. This was the beginning of the Studio Pottery movement in England which was itself the revival of pottery-making on the handicraft basis. It was also a challenge to the deadening and sterile methods of the factory system which had instituted a productive process on the basis of a division of responsibility between the designer and the producer of pottery ware. In other words, as Gill never tired of pointing out, the workman is by this method only responsible for doing what he is told and has no 'responsibility for the form or quality, the intellectual quality, of what he takes part in making'. It was this division, made necessary by the tyranny of economic opportunism, that the Studio Pottery movement sought to heal. Cardew's belief was that the living root ('art', as he defined it, the unconscious well-spring that animates the will to create) of craftsmanship would gradually emerge to 'repudiate the false ideal of servile obedience', as he hopefully announced in 1942 in 'Industry and the Studio Potter'.

Even if he rejected this 'false ideal' Cardew was never prepared to go to the same lengths as Gill in condemning the factory system. Late in his life he acknowledged that the first machines 'degraded and dehumanised the work of the skilled craftsman and turned him into a machine minder'. In the light of this it is difficult to see what evidence he might have brought to his claim that 'in retrospect we can see that the nineteenth century factory system carried within itself the means of curing its own faults and shortcomings'.

However, he had to acknowledge that the very efficiency of the industrial system inevitably

> did violence to the character of the material itself: something of its potential beauty has to be sacrificed in order to obtain the necessary efficiency combined with economy. Whether it is hand-made or machine-made, pottery needs another element

in addition to form, colour and decoration. This more vital something is what potters call quality, or warmth or depth. The penurious and cold quality of industrial earthenware is due to the technique itself, which for anyone trained in the Oriental school amounts to killing the body before you glaze it.

In 'Industry and the Studio Potter' of 1942 (which Katherine Pleydell Bouverie called his 'fighting manifesto'), Cardew is still optimistic that there could be a fruitful collaboration between the studio potter and industry. However, in that same essay he also outlined what he thought were the criteria for good design in pottery; criteria obviously inimical to the factory system.

> Good design in pottery is the product of tension or 'dialectic' between the demands of pure utility and those of pure beauty, and only long experience and continual struggle enable you to achieve a successful fusion of the two You only get good designs for pottery from potters [rather than industrial pottery operatives!], because they are the only people who understand art by experience and with their whole personality.

Wherever the human norm of manufacture through personal skill is allowed to operate naturally—as in the case of Cardew's work—the idea of beauty is 'only achieved by a balance and a synthesis of use and beauty'. Beauty in manufacture is not achieved automatically, as the factory system falsely supposes, by attending to the demands of 'consumer appeal': 'You cannot, by making use of Design impose beauty on the objects of utility. It is their birthright. If they are not born right, nothing can help them', he wrote in 'Stoneware Pottery'.

If the factory system had achieved some excellence of beauty in the past—the seventeenth and eighteenth century Staffordshire industry for instance—that was because individual potters were still able to work on a handicraft basis. And their designs were 'a synthesis of traditional thrower's shapes, inherited from the Middle Ages, with the idea of convenience and refinement acquired in the eighteenth century'. But the factory system is 'based on a foundation that does not exist ... the assumption that there is no such thing as "pure craftsmanship" into which no element of originality ['art'] enters'. Therefore, Cardew finally concludes, 'the factory system is based on

the existence of the operative as opposed to the true workman'.

The rejection of the factory system and of the self-consciously aesthetic (this 'Narcissus-dream, which ought to be just a temporary phase in the evolution of a craftsman seems [today] to have become a fixation, elevated into an idea or an orthodoxy'), approach to the making of pots was, then, for Cardew the necessary rejection of complementary aspects of the same falsehood. He could not have been more categorical in his repudiation of it than when in his later judgement (in his essay 'Stoneware Pottery'), he came to reject the idea that the studio potter could be a designer for industry—the 'Art in Industry fallacy', as he called it.

> The fallacy is, that there is a 'department' or category called Utility, and another called Art. Utility is for Utensils, Art is for Delectation—'a kind of noble play' and all that talk.
>
> Those who think this fill both their departments with objects of horror. They fill the world with Well-Designed Utilities, but the essential meaning of works of art will always (though they will never know it) elude them.

So the stream of true creative work is unstopped in a state of 'no-mind'; a state that from the depths of the workman's being releases the hidden potentiality towards the creation of outward shapes. Along the pure channel of skill, unvitiated by aesthetic sentiment and unhindered by mechanical intervention, flows the profound rapport between the mystery of the 'person' and the unconscious sources of 'art': that 'person' whose paradoxical nature it is both to localise the subjectivity of the creative act yet whose identity is never the occasion for what is created.

But who is this 'self' that the workman knows himself to be? Firstly,

> you know nothing about it, it's the mysterious inside of you which you cannot know any more than you çan know what you look like by looking in a looking glass. Secondly, it's something that's *not* self that you are dealing with. When concentrating on the form of something you are unaware of being yourself, yet you are nourishing yourself, and the form that you do produce *is* yourself. No power on earth can prevent it from being

yourself..... It comes out absolutely naturally and inevitably when expressed in the majesty of form.

There's a very significant thing about shapes. Some shapes are perfectly correct and don't say anything; other shapes seem very odd but pack a great deal of significance, definitely say something, are expressive.... Significant of what? The simple answer is we don't know, it's too big a question.

So we are led full-circle to the primordial wisdom for whom the workman, artist, craftsman (ultimately these are, at worst, confusing, at best, illogical distinctions) is one whose productive method is in keeping with the natural rhythms and substance of nature—a nature of which the workman is himself a part. What began as a discovery of the doctrines of Zen Buddhism with Hamada and Leach in the 1920's—not gainsaying a temporary reaction against the notion that 'Oriental peoples are always right and western man is always wrong'— Cardew later found to be true from his own experience. This reaction was no doubt set in motion by an early discovery of the 'great impetus which Catholic Neo-Thomists brought to all the old arguments of John Ruskin and William Morris in favour of craftsmanship and against the industrial system'.

A quotation from Aristotle was axiomatic for Cardew: *Ars imitatur naturam in sua operatione.*

A fatal idea but properly interpreted it means that art imitates nature in her operations, or as Eric Gill translated it, 'art imitates nature by working as nature works'. That's a very illuminating remark. The art referred to by Aristotle was the art of medicine—you tried to cure people by imitating the methods which nature uses—and it's absolutely splendid as applied to what we call art, which includes pottery.

A great maxim from the Middle Ages—translated as 'The essence and existence of everything on earth is derived from the beauty of God' ['The Beauty of God is the cause of the being of all that is', St Dionysius]—sums up the absolutely irrational [a-rational] feelings of confidence that a long regime of working on art engenders in you.

In 'The Fatal Impact', and as a result of his experiences in Africa,

Cardew was moved to challenge the argument against the incursions of materialist progress. Whatever the extent of the 'lost potential for happiness', he wrote, 'the family lives, ethnic traditions and ancestral arts of the slaves—their descendents achieved a great moral power... of more value than any art or craft or even than happiness itself'. This argument is in effect the argument in favour of the advantage of material progress come what may the disadvantages. But the argument will not bear much examination since it is founded on the pretence that material progress is guided in its encroachments by a vision of the final good. But such progress has blind impetus as its master. That it is also the expression of all that is contrary to human nature is no less true, if far less obvious. On the level of its operation such progress does not present society with any option, only an all-encompassing imperative whose obligations and persuasions have no properly human counter-balance. As Cardew noted, it is an argument 'human beings ... are not entitled to use not being competent to judge the balance of loss or gain in such tremendous matters; we do not possess the scales in which to weigh them'.

There are, none the less, things we are obliged to judge because of our nature:

> these are the data of ethics, and of aesthetics. Ethics is about our duties to our neighbour; but aesthetics is about our duties to all the things and creatures of the world we belong to. Our aesthetic conscience is therefore just as tender and just as imperious as the ethical conscience. Anyone who has felt the value—that is, *the meaning*—of primitive arts feels also that we must try to do something to defend them, because they are necessities, not just academic curiosities. We need them, not as dead specimens, but as things which have the power to make us grow and change and to nourish us in the future.

In other words the crafts are, in his judicious phrase, 'a depository of the soul'.

The proper significance of progress, as he finally saw, is a question of 'where to' and on what terms. Its value is essential not consequential. As he confessed in his Autobiography; 'progress is both necessary and supremely desirable to man, because all real progress is a progress of the soul.'

Index

Made in the USA
Middletown, DE
26 September 2021